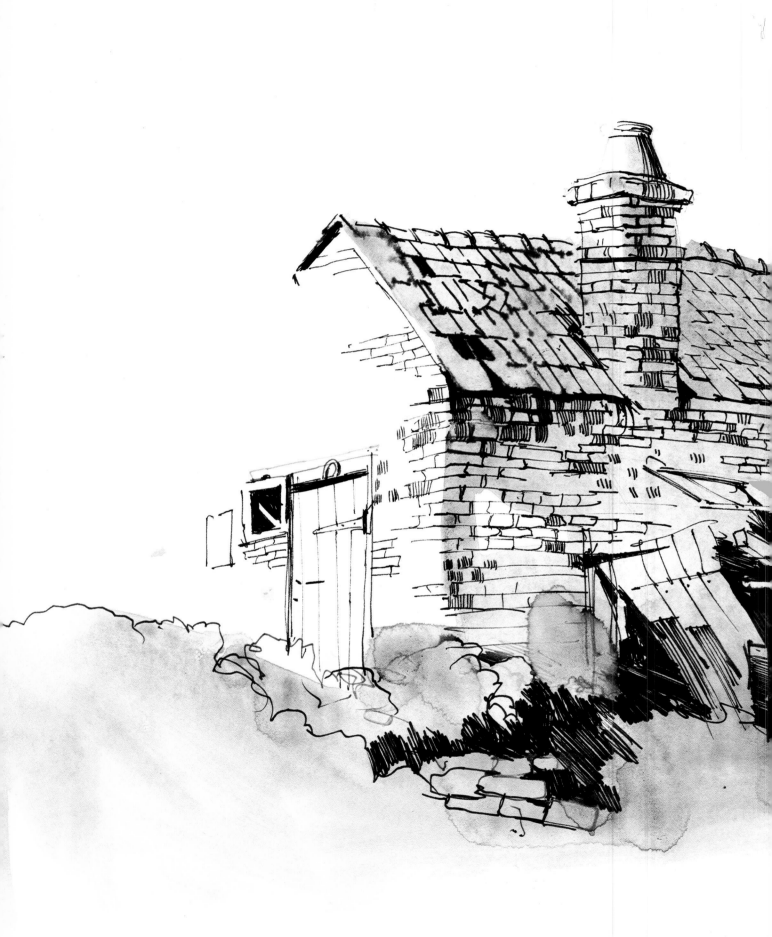

Weathered Texture Workshop

BY RICHARD BOLTON

WATSON-GUPTILL PUBLICATIONS/NEW YORK

Copyright © 1984 by Watson-Guptill Publications
First published 1984 in New York by Watson-Guptill Publications,
a division of Billboard Publications, Inc.,
1515 Broadway, New York, 10036

Library of Congress Cataloging in Publication Data
Bolton, Richard, 1950–
 Weathered texture workshop.
 Includes index.
 1. Water-color painting—Technique. I. Title.
ND2420.B64 1984 751.42′2 83–25901
ISBN 0–8230–5697–X
Distributed in the United Kingdom by Phaidon Press Ltd., Littlegate
House, St. Ebbe's St., Oxford

Manufactured in Hong Kong.

2 3 4 5 6 7 8 9 10/89 88 87 86 85 84

Edited by Candace Raney
Designed by Bob Fillie
Graphic production by Hector Campbell
Text set in 10-point Zapf Book

CONTENTS

INTRODUCTION

Nature presents to the artist a complex scene, where a multitude of patterns, textures, and colors combine in an almost frightening profusion of detail. The aim of this book is to take you, the watercolor artist, through an intense workshop process of simplifying this complexity, so that you can take a cluttered scene or an intricately patterned object and break it down into only those elements that you want to emphasize.

Weathered Texture Workshop begins, naturally enough, with my watercolor palette and brushwork, because they are the very foundation of painting. When I sit back and contemplate these colors, I realize that they reflect my own interest in weathered textures, which is nature's turning inward and away from the high-keyed, bright bloom that inspires many artists. (I have even taken a summer landscape and painted it winter—see page 143). And because I am attracted to these muted, somewhat somber colors, my palette tends to lean toward gray-blues and browns; even my yellows and greens are often toned down by washes of sepia and pale rose. These colors are, of course, an individual matter. The specific mixtures of rust, foliage, sky, background, and shadow colors illustrated here work well for achieving a certain weathered look. Try them out and see how they work for you. You may find, like I do, that they are very effective; or you may find that other color combinations and schemes work equally well. In either case, these mixtures will give you a color foundation on which to base your own palette.

A wide range of specific brushstrokes for a variety of weathered effects is also illustrated in the first section, from the blurred wet washes that convey a line of trees on the horizon line to the rough-textured drybrush technique used to dab in the stubbled look of a ploughed field. All these brushstrokes are made by the two brushes I rely on almost exclusively: the 1-inch flat and my all-time favorite, the Japanese bamboo brush. Their attraction lies in their extreme versatility: the 1-inch flat lays down an evenly graded wash, or produces a soft but lively blending of color; and the bamboo gives me an endless variety of elegant, articulated strokes.

Following the first section on color mixtures and brushwork for weathered textures, the book divides into three distinct parts: small watercolor studies, finished paintings, and painting projects based on actual photographs of scenes and objects that inspired the paintings.

The studies make a good beginning for exploring the basic painting problems presented by naturally weathered things. Many of these are simple subjects that rely on very few brushstrokes; what's important here is thinking out the composition first. Small painting studies are an invaluable introduction to painting because they are very good at showing you how to take a relatively uncomplicated scene, and then simplifying and refining it into an interesting image on paper.

The selecting/refining process is even more important when you are undertaking a finished painting. The key here is knowing just what you want to take from the highly complex scene before you. Some artists want to incorporate almost all of what they see (for example, the photo-realists); but in most cases, artists select what they want to see. So, before you even lift a brush, stop and think about what you want to put down on paper and what you *don't* want. For example, think about what you want to dramatize: an angry sky, a lush expanse of grass, curling strips of dried paint peeling off a wall. Then go in with your color and brushes. You'll find this preliminary work will reap you all sorts of rewards and form the thinking basis for your painting.

The photograph section of the book takes you through the actual scenes that were used as subjects for the paintings and studies found in the book. As they are real life references, they show a typical scene or object *before* it has been painted, so that you can analyze how you might go about planning your own painting. Here, you can actually see the tangled pattern that the natural world unfolds before you, illuminated by the various techniques used for handling the painting problems encountered in a particular type of scene.

So let's begin our journey through the natural world as revealed by the studies, paintings, and photographs. All these are intended to enrich and strengthen your technical and compositional abilities to paint the weathered texture landscape.

THE WEATHERED TEXTURE PALETTE

Although possible color combinations are literally endless, most artists come to rely on certain mixtures that work for them and the particular kind of painting that they do. And over the years, I have developed reliable mixes that are successful in achieving the muted colors found in weathered objects and wintry landscapes. For instance, because I often paint rusty old farm machinery, I need a ready palette of browns, yellows, and oranges; or, as a landscape painter, I need to know useful mixtures for skies, backgrounds, and foliage. The following swatches are examples of color mixes that work well for weathered texture effects.

Rust Mixtures

A. burnt sienna
 rose madder

B. burnt sienna
 cobalt blue

C. yellow ocher
 burnt umber

D. burnt sienna

E. Naples yellow
 burnt sienna

F. Naples yellow
 burnt umber

G. cadmium orange
 ultramarine blue

H. burnt sienna
 cadmium yellow

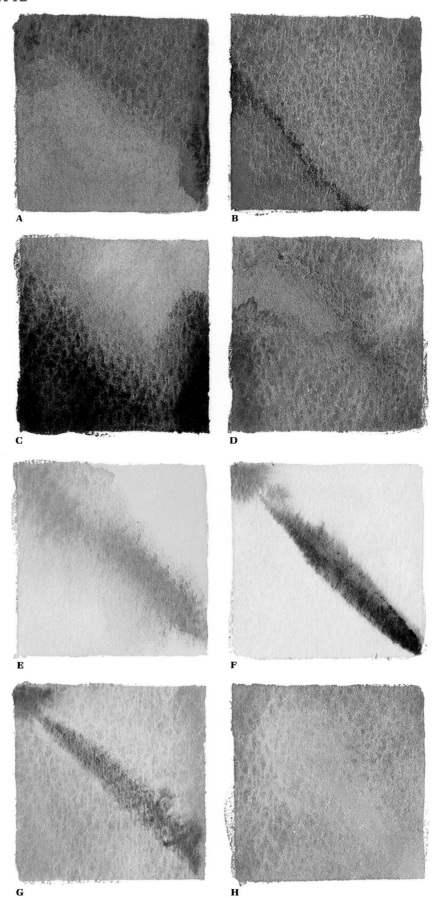

A

B

C

D

E

F

G

H

Dark Mixtures

These combinations are useful for capturing the dark areas in a painting, such as winter branches or objects and areas in deep shadow.

A. burnt umber
ultramarine blue

B. Prussian blue
rose madder

C. Prussian blue
burnt sienna

D. black ink

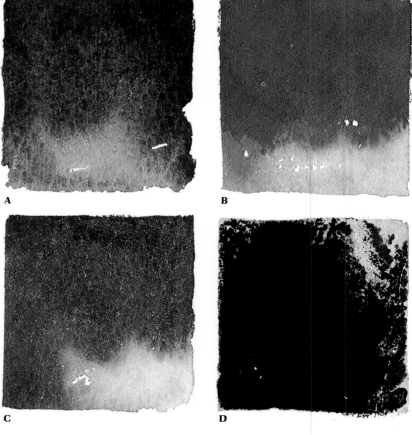

A

B

C

D

Foliage Mixtures

A. sap green
burnt sienna

B. burnt umber
sap green

C. leaf green
Naples yellow

D. cobalt blue
cadmium yellow

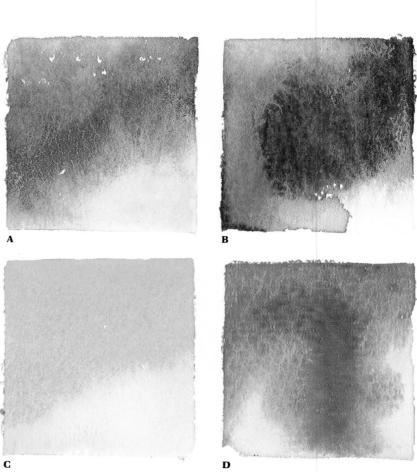

A

B

C

D

Sky Mixtures

A. Naples yellow
 rose madder
 ultramarine blue

B. Winsor and Newton Gray No. 2

C. Winsor and Newton Gray No. 2
 burnt sienna

D. cobalt blue into
 opaque white

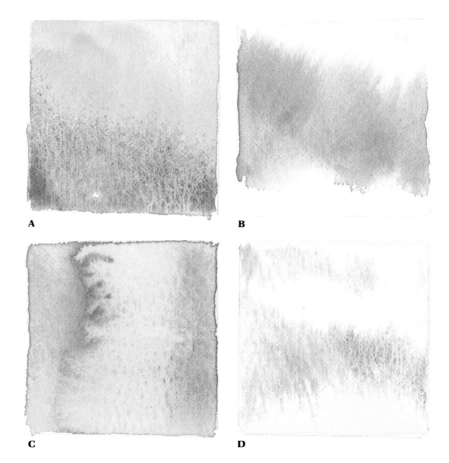

A

B

C

D

Background Mixtures

Background colors can be made to look softer and more pastel-like by adding Naples yellow or opaque white.

A. Naples yellow
 rose madder
 burnt sienna

B. ultramarine blue
 opaque white

C. Naples yellow
 cobalt blue

D. Winsor and Newton Gray No. 2
 rose madder
 ultramarine blue

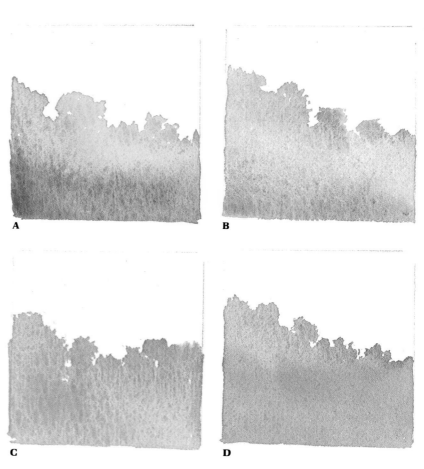

A

B

C

D

BRUSHSTROKES FOR CAPTURING TEXTURE

In the same way that single notes make up a song, paintings are composed of brushstrokes—which is why they are perhaps the key element in painting, particularly watercolor painting. For unlike oil, where paint can be built up over time or reworked, watercolor painting typically must be executed fast. Often, a single brushstroke or just a few must suffice to suggest important parts of a painting.

The following brushstrokes are those I've come to rely on over the years. The techniques used to execute them can be simply divided into the two basic ways to apply transparent watercolor to paper: wet into wet and drybrush. To simplify matters even more, I generally use only two kinds of brushes: the 1-inch flat sable for wet-into-wet techniques and the bamboo brush for drybrush effects. These two provide me with almost all the brushstrokes I need to achieve any number of textural effects.

So, take a look at my repertoire of brushstrokes, and then see if you can spot them in the paintings and studies that follow. Once you can recognize how these brushstrokes work within the context of a painting; and then, more importantly, tried them out for yourself, you'll have no trouble applying them to your own paintings.

Drybrush Effects

With the paint mixture loaded thickly on the brush, it is possible to rub the paint on the paper in the same manner as you would apply shading with a pencil. These examples illustrate how useful the paper's own texture is when using drybrush.

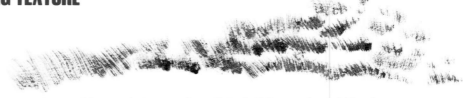

This scrubbing technique works well for building up the stubble of grass.

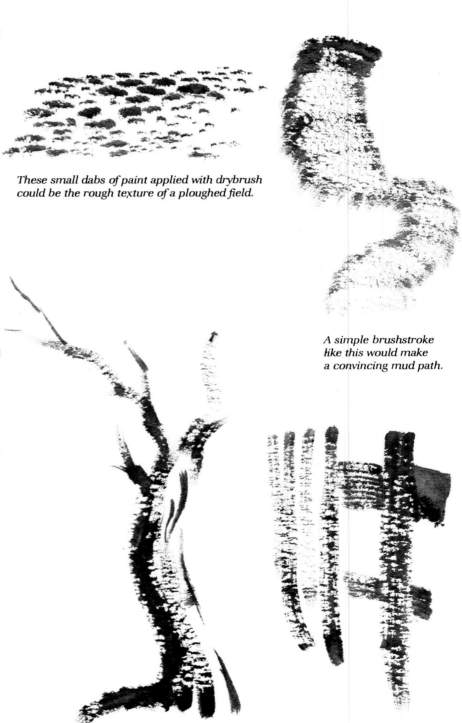

These small dabs of paint applied with drybrush could be the rough texture of a ploughed field.

A simple brushstroke like this would make a convincing mud path.

These almost calligraphic brushstrokes could easily represent wooden fencing or some spindly branches in a background.

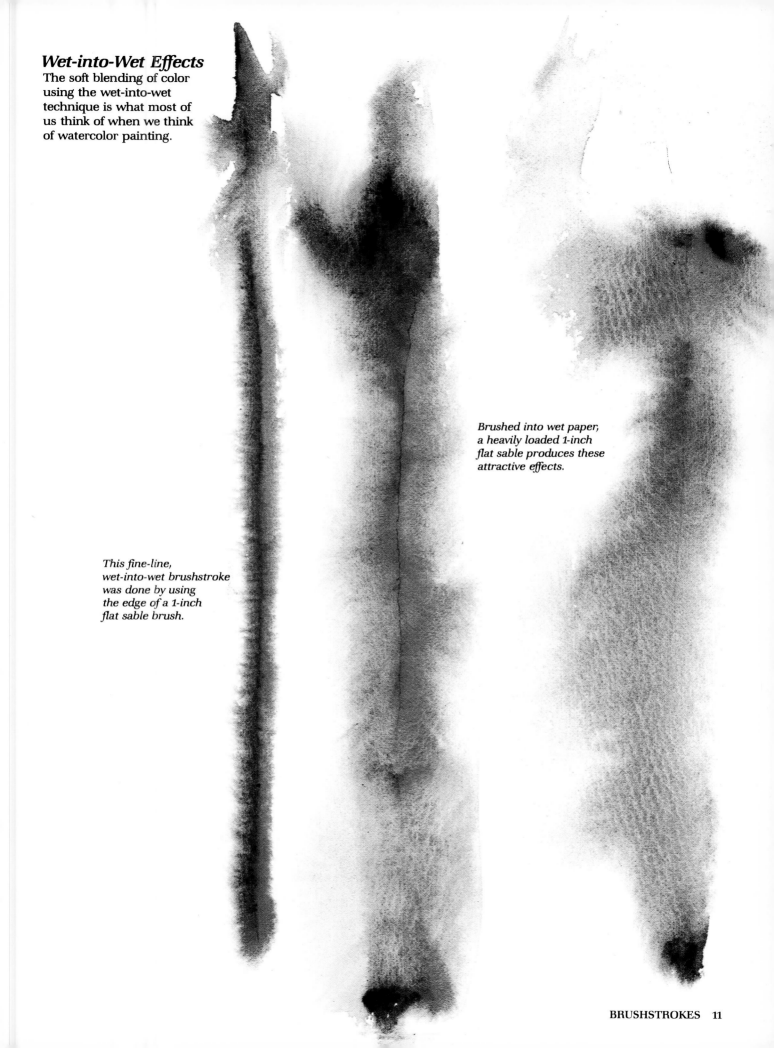

Wet-into-Wet Effects
The soft blending of color using the wet-into-wet technique is what most of us think of when we think of watercolor painting.

Brushed into wet paper, a heavily loaded 1-inch flat sable produces these attractive effects.

This fine-line, wet-into-wet brushstroke was done by using the edge of a 1-inch flat sable brush.

Japanese Bamboo Brush

The bamboo brush is capable of producing a multitude of useful brushstrokes.

Both thin and thick brushstrokes are possible with the bamboo brush.

The bamboo brush is the best brush for descriptive brushstrokes.

A bamboo brush rolled on its side is very effective for capturing the rough texture of vegetation.

Here's a bamboo brushstroke with its bottom edge softened by a brushful of clear water.

A fully loaded brush dragged upward creates this look of long blades of grass.

This tube-shaped brushstroke is composed of two brushstrokes with clear water brushed between them— a useful technique for painting cylindrical effects.

To achieve this foliage effect, I jabbed the tip of the brush headfirst into the palette, then dabbed gently on the paper with splayed, spikey bristles.

Rapid brushwork adds sparkle to painting. It looks quick and unlabored on the paper.

A bamboo brush used wet into wet. Note how these roughly mixed colors stay lively.

1- Inch Flat Brush

Together with the Japanese bamboo brush, I find the 1-inch flat brush more versatile than any other. It is useful for both wet-into-wet and drybrush techniques.

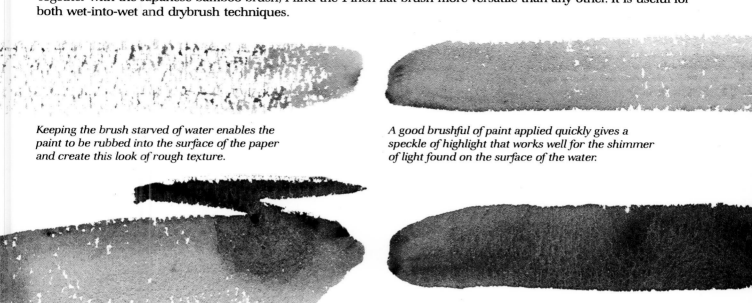

Keeping the brush starved of water enables the paint to be rubbed into the surface of the paper and create this look of rough texture.

A good brushful of paint applied quickly gives a speckle of highlight that works well for the shimmer of light found on the surface of the water.

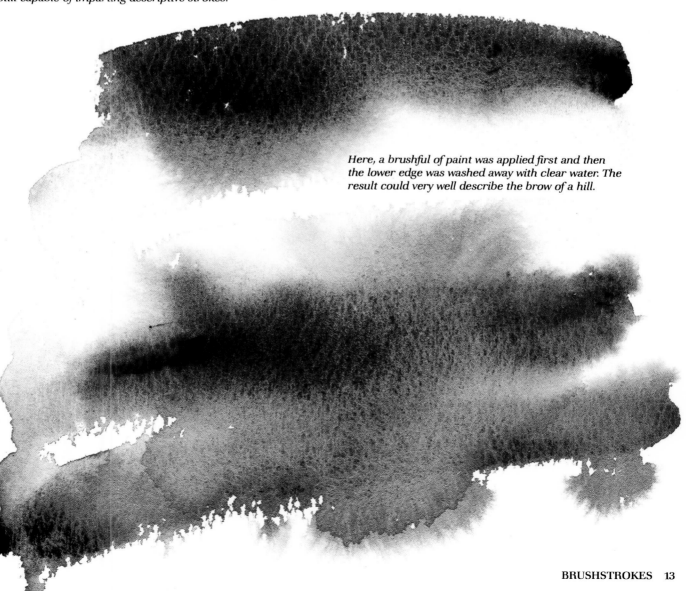

Although rather large, the 1-inch flat brush is still capable of imparting descriptive strokes.

For the deep, rich effect shown here, this brush was heavily loaded with paint.

Here, a brushful of paint was applied first and then the lower edge was washed away with clear water. The result could very well describe the brow of a hill.

PART ONE
Watercolor Studies

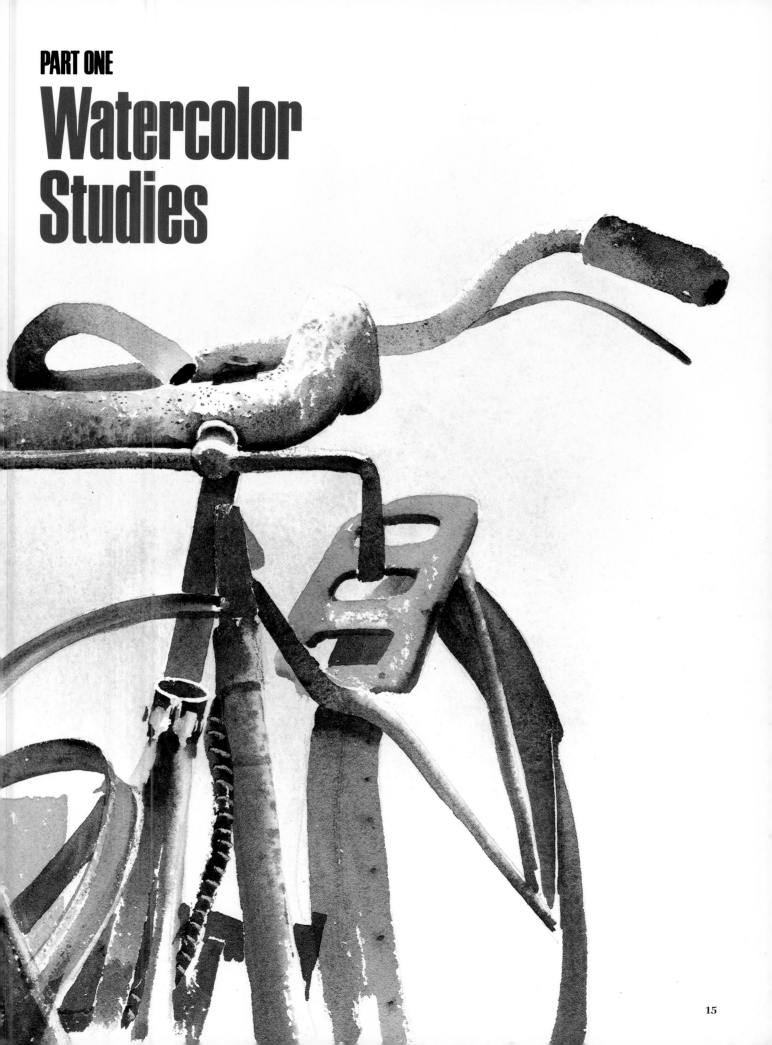

WOOD DETAIL

Creating Wood Effects:
Economy of Brushwork

By painting this small piece of wood, I can demonstrate clearly the main techniques involved in capturing the effects of wood. My working technique is based primarily on simplicity and economy of brush use. Broadly speaking, the more you fiddle around with a watercolor—making alterations, correcting mistakes, and introducing detail—the more likely you are to lose sparkle and spontaneity. So what I try to do is use the brush as little as possible and never use two brushstrokes where one will do.

In the final stage of the study, I used a brush and spotted in the rusty nail holes, whirls, and stains in the grain, edges, and cracks. With another small brush and clear water, I softened the edges of wet paint by running a brush along them.

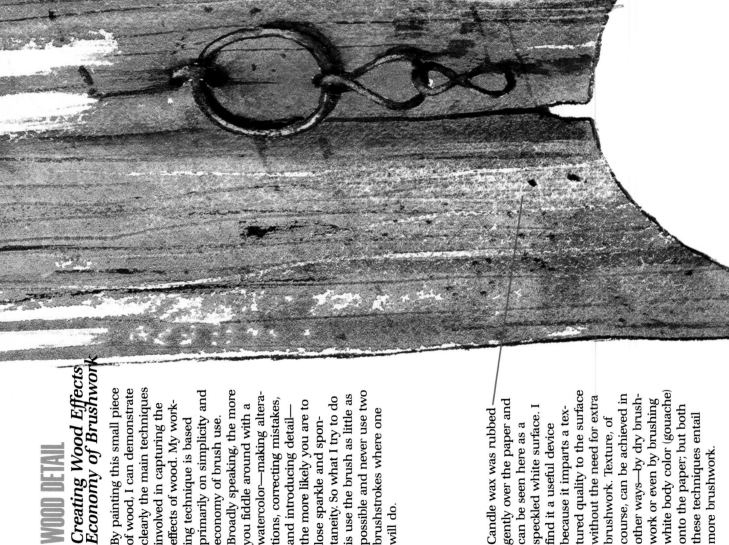

Candle wax was rubbed gently over the paper and can be seen here as a speckled white surface. I find it a useful device because it imparts a textured quality to the surface without the need for extra brushwork. Texture, of course, can be achieved in other ways—by dry brushwork or even by brushing white body color (gouache) onto the paper; but both these techniques entail more brushwork.

To add to the wood effect, I used the sharp corner of a razor blade to scratch out the thin highlights of grain. Timing is very important when using this technique, because if the paper is still wet, the lines will fill in with color. The technique also won't work if the colors have dried; however, it is possible, if the colors have dried too quickly, to brush some clear water across the paper and then scratch out the lines.

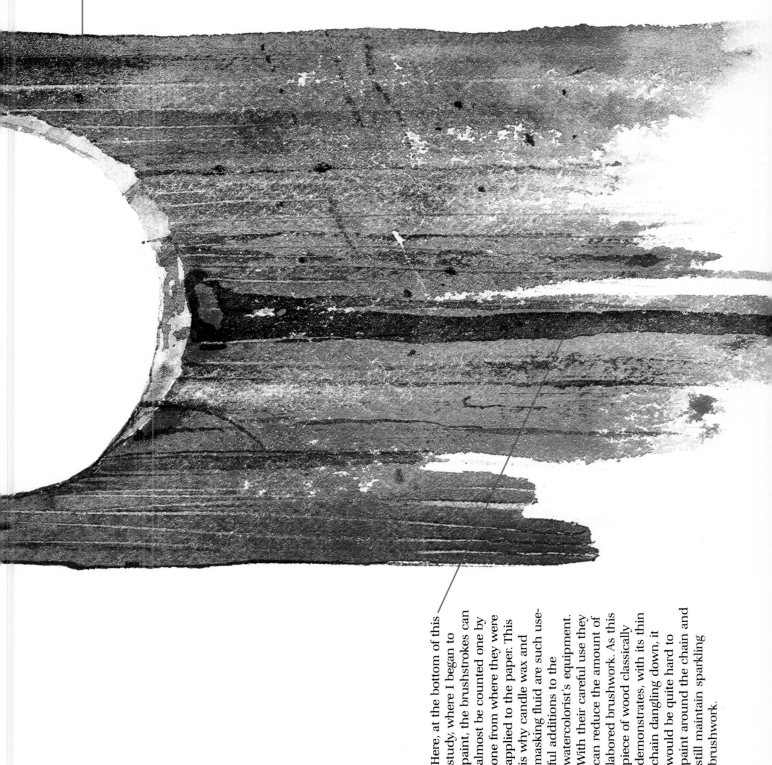

Here, at the bottom of this study, where I began to paint, the brushstrokes can almost be counted one by one from where they were applied to the paper. This is why candle wax and masking fluid are such useful additions to the watercolorist's equipment. With their careful use they can reduce the amount of labored brushwork. As this piece of wood classically demonstrates, with its thin chain dangling down, it would be quite hard to paint around the chain and still maintain sparkling brushwork.

HANDLEBARS

Sculptural Forms
Wet Washes

There is a wonderful sculptural quality to these rusty old handlebars. As with many purely functional things, they take on a dramatic quality when taken away from their surroundings and presented in isolation.

The white of the paper plays an important part in this painting by giving the image of the handlebars a stark intensity. To add to this quality, I also maintained a hard-edged outline throughout.

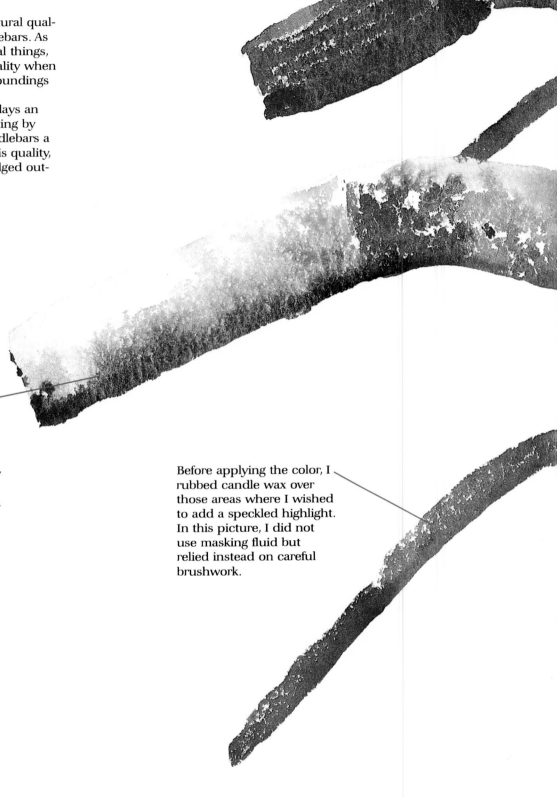

This study was quickly executed by painting loosely with wet washes. Using a lot of water helps to sharpen the outline because colors tend to flow out to the edges of the wet area, as is often seen with a stain on clothing or paper where a circle of color will gather around the outer edge.

Before applying the color, I rubbed candle wax over those areas where I wished to add a speckled highlight. In this picture, I did not use masking fluid but relied instead on careful brushwork.

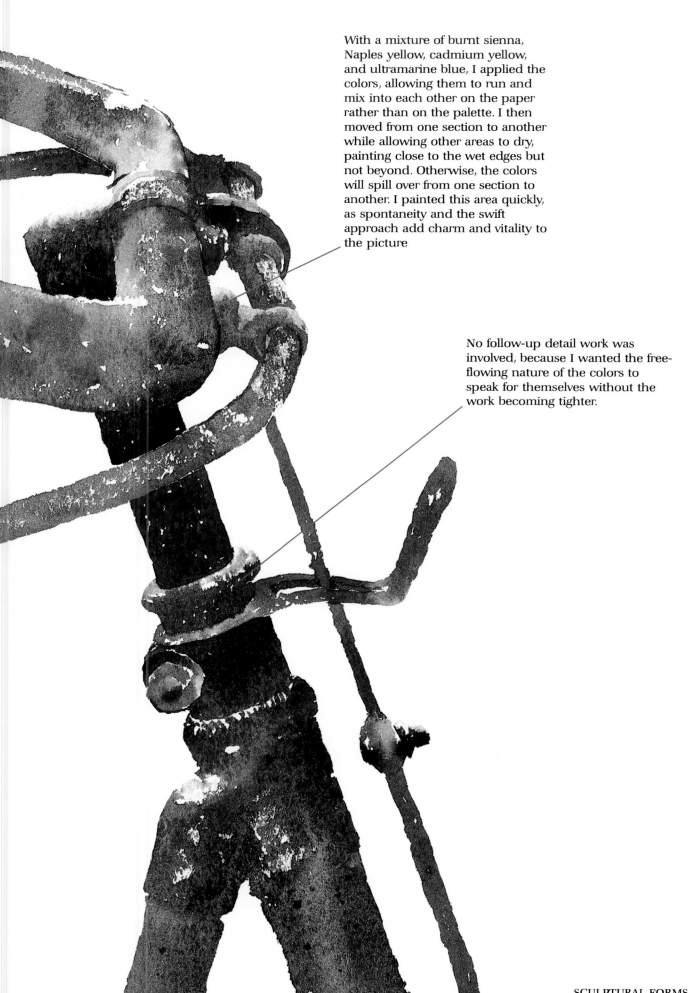

With a mixture of burnt sienna, Naples yellow, cadmium yellow, and ultramarine blue, I applied the colors, allowing them to run and mix into each other on the paper rather than on the palette. I then moved from one section to another while allowing other areas to dry, painting close to the wet edges but not beyond. Otherwise, the colors will spill over from one section to another. I painted this area quickly, as spontaneity and the swift approach add charm and vitality to the picture

No follow-up detail work was involved, because I wanted the free-flowing nature of the colors to speak for themselves without the work becoming tighter.

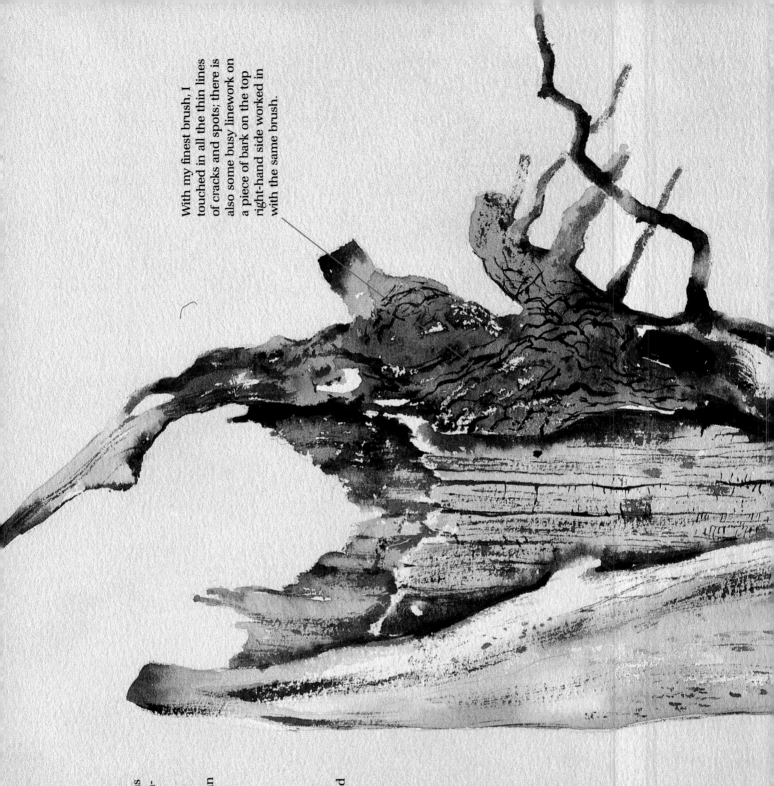

With my finest brush, I touched in all the thin lines of cracks and spots; there is also some busy linework on a piece of bark on the top right-hand side worked in with the same brush.

DEAD ELM TRUNK
Cracking Wood
Diluted Washes

Unfortunately, dead and dying elms are a common feature in my neighborhood, but there are certain advantages to this for the artist. Decaying wood breaks down into unusual patterns and the result can be very sculptural, as in this elm trunk with its long split running down the side. Weathered wood changes its color from the usual oranges of freshly cut wood, to a beautiful silvery shade of gray.

When I began this painting, I masked out the outline of the tree trunk, though I suspect that I could have painted it without the mask because the background is such a light tint.

The background consists of a very dilute wash of cobalt blue, blending into cadmium yellow and yellow ocher. The colors were mixed so thinly that they provide no more than a mere tint.

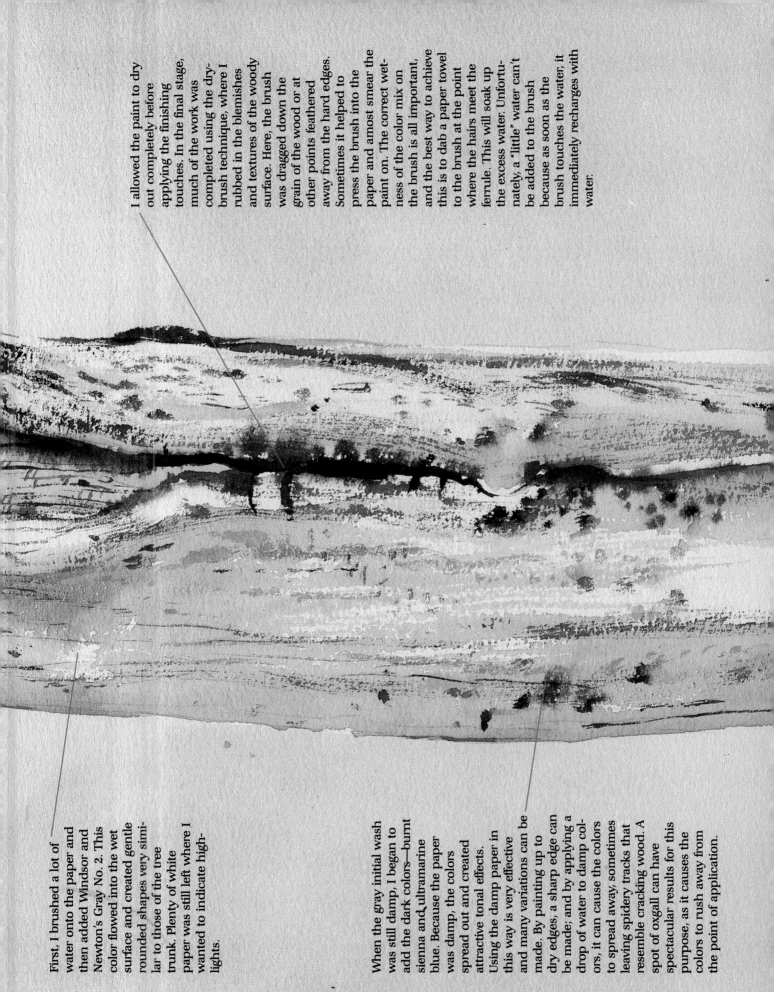

I allowed the paint to dry out completely before applying the finishing touches. In the final stage, much of the work was completed using the dry-brush technique, where I rubbed in the blemishes and textures of the woody surface. Here, the brush was dragged down the grain of the wood or at other points feathered away from the hard edges. Sometimes it helped to press the brush into the paper and amost smear the paint on. The correct wet-ness of the color mix on the brush is all important, and the best way to achieve this is to dab a paper towel to the brush at the point where the hairs meet the ferrule. This will soak up the excess water. Unfortunately, a "little" water can't be added to the brush because as soon as the brush touches the water, it immediately recharges with water.

First, I brushed a lot of water onto the paper and then added Windsor and Newton's Gray No. 2. This color flowed into the wet surface and created gentle rounded shapes very similar to those of the tree trunk. Plenty of white paper was still left where I wanted to indicate high-lights.

When the gray initial wash was still damp, I began to add the dark colors—burnt sienna and ultramarine blue. Because the paper was damp, the colors spread out and created attractive tonal effects. Using the damp paper in this way is very effective and many variations can be made. By painting up to dry edges, a sharp edge can be made; and by applying a drop of water to damp colors, it can cause the colors to spread away, sometimes leaving spidery tracks that resemble cracking wood. A spot of oxgall can have spectacular results for this purpose, as it causes the colors to rush away from the point of application.

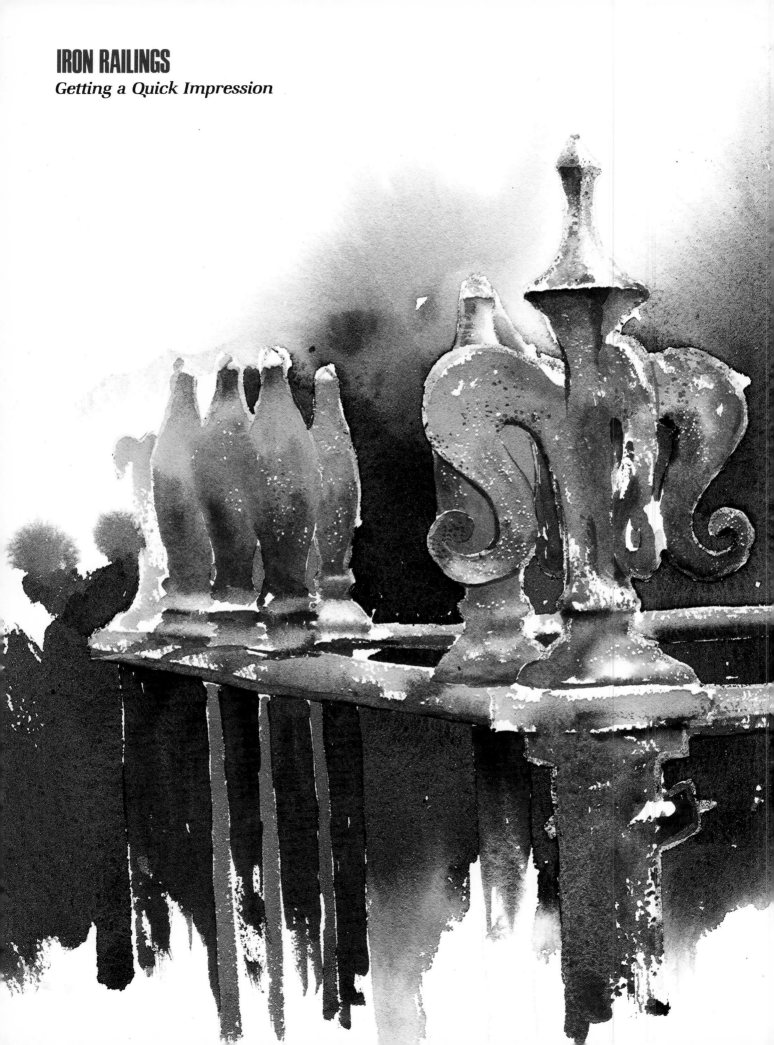

IRON RAILINGS
Getting a Quick Impression

This is a simple study of iron railings in a churchyard. I often cycle past them and for a long time noticed the vividness of the colors—bright orange at the tips fading down to mauve at the base. The bright colors are made more vivid by the dark background of shade beneath the trees.

The emphasis in this painting was on speed and getting a quick impression. I tried to get this painting down in one go. To me, the great advantage of watercolor is that it can be treated this way, and what may seem like a very haphazard technique often produces a more accurate, sensitive painting than hours of meticulous work in another medium.

Perhaps the greatest difficulty in painting is learning how to look properly. The eye is easily caught by detail, and it can be difficult to see things as a whole. My way of doing it is to squint. Sometimes I even walk around the countryside squinting, looking for good subject matter. By squinting the vision is blurred, and because it's blurred, I can't see detail; instead, I see blocks of shape and color.

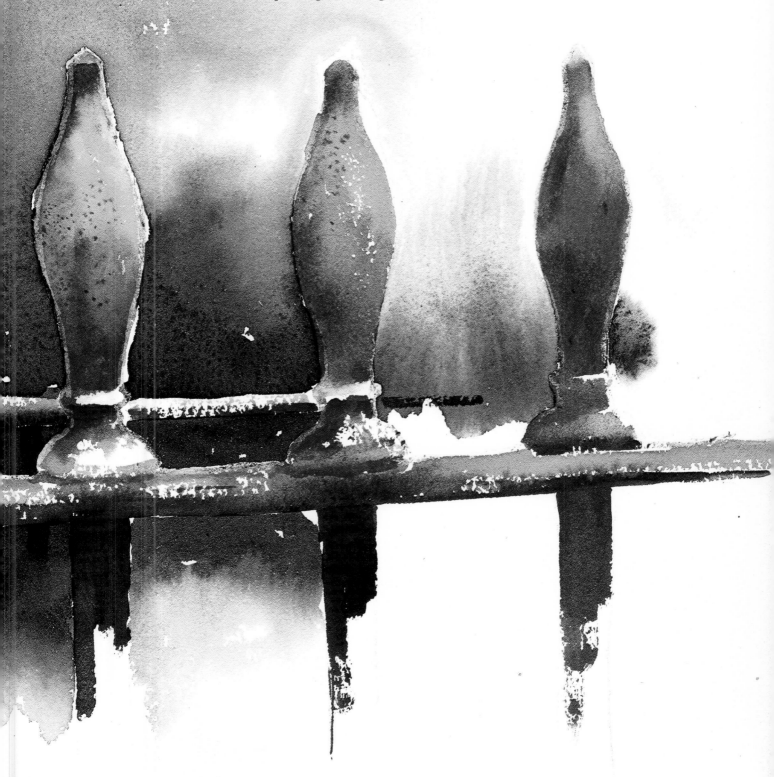

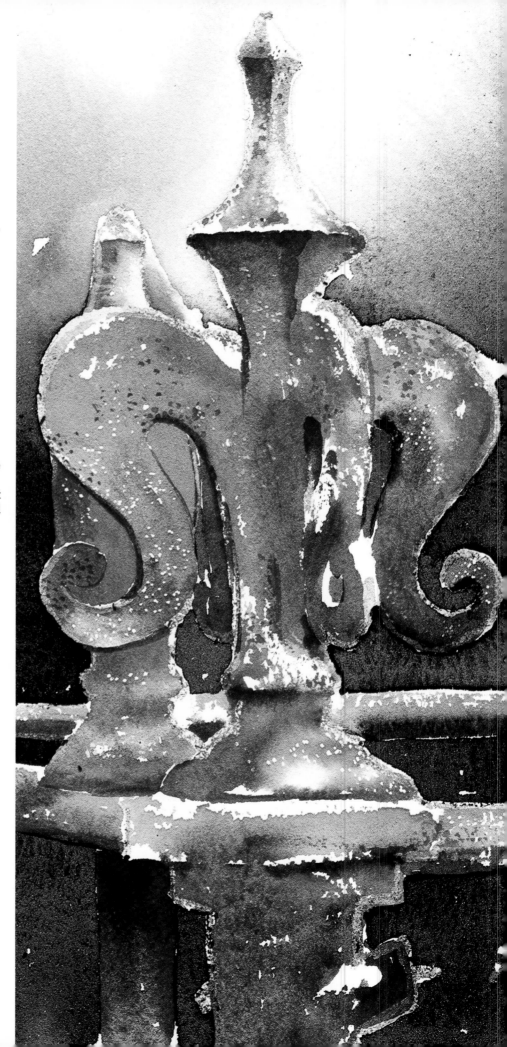

This rather ornate spike was first masked out with masking fluid, as were the railings and other spikes. Rather than mask them out completely, I simply outlined the shapes, which makes the removal of masking fluid a lot easier afterward.

Clear water was brushed over the paper and the background colors introduced—Prussian blue with some sap green. These colors spread across the paper where it had previously been soaked.

When the Prussian blue had dried, I removed the masking fluid. I never leave masking fluid on a painting too long. I find that the longer it is on the paper, the more difficult it becomes to remove. I have also discovered that old, half-used bottles of masking fluid are less effective and rather difficult to remove.

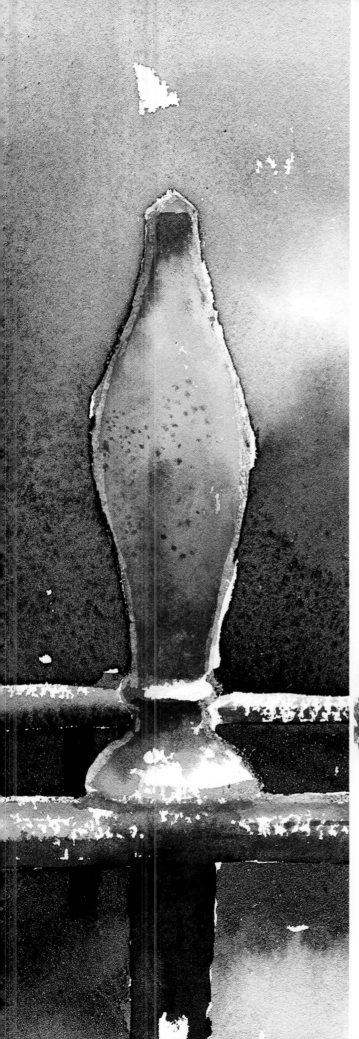

The spike on this railing was painted in briskly, starting at the top with cadmium yellow. Keeping the colors very wet, I added burnt sienna and, below that, Indian red and ultramarine blue. The lower half of the railing was painted in a mixture of rose madder and ultramarine blue.

DOORKNOBS
Creating Dramatic Backdrops for Simple Subjects

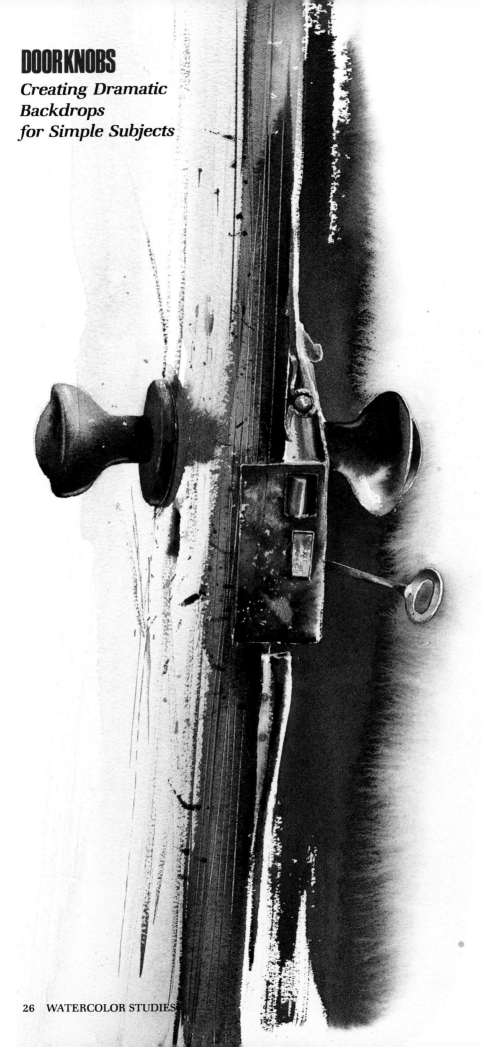

The simplest, most ordinary things can make a good painting. Much of it depends on how your subject is seen and composed on paper. This painting is of my back door. From where I was sitting, I was struck by the way the sunlight from the window lit one side of the door but left the other side dark.

I knew that in order for this painting study to have impact, I would have to treat it in a dramatic way. I relied heavily on the reverse image: light and dark, rich coloring, and the angled sweep of the door. Most important, I used a limited amount of paper—the painting being little more than a scar down the center of the paper. By letting the doorknobs extend outside the picture area, the painting is lent a degree of power; and the edge of the door feels as if it is leaning toward us.

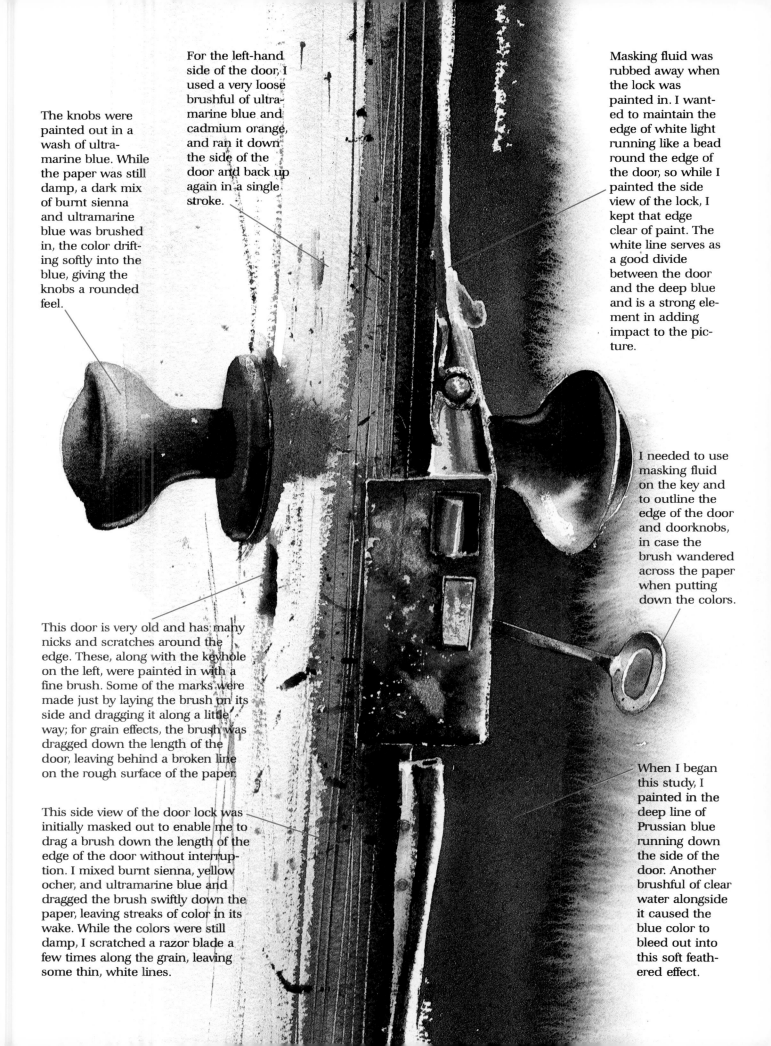

For the left-hand side of the door, I used a very loose brushful of ultramarine blue and cadmium orange, and ran it down the side of the door and back up again in a single stroke.

The knobs were painted out in a wash of ultramarine blue. While the paper was still damp, a dark mix of burnt sienna and ultramarine blue was brushed in, the color drifting softly into the blue, giving the knobs a rounded feel.

Masking fluid was rubbed away when the lock was painted in. I wanted to maintain the edge of white light running like a bead round the edge of the door, so while I painted the side view of the lock, I kept that edge clear of paint. The white line serves as a good divide between the door and the deep blue and is a strong element in adding impact to the picture.

I needed to use masking fluid on the key and to outline the edge of the door and doorknobs, in case the brush wandered across the paper when putting down the colors.

This door is very old and has many nicks and scratches around the edge. These, along with the keyhole on the left, were painted in with a fine brush. Some of the marks were made just by laying the brush on its side and dragging it along a little way; for grain effects, the brush was dragged down the length of the door, leaving behind a broken line on the rough surface of the paper.

This side view of the door lock was initially masked out to enable me to drag a brush down the length of the edge of the door without interruption. I mixed burnt sienna, yellow ocher, and ultramarine blue and dragged the brush swiftly down the paper, leaving streaks of color in its wake. While the colors were still damp, I scratched a razor blade a few times along the grain, leaving some thin, white lines.

When I began this study, I painted in the deep line of Prussian blue running down the side of the door. Another brushful of clear water alongside it caused the blue color to bleed out into this soft feathered effect.

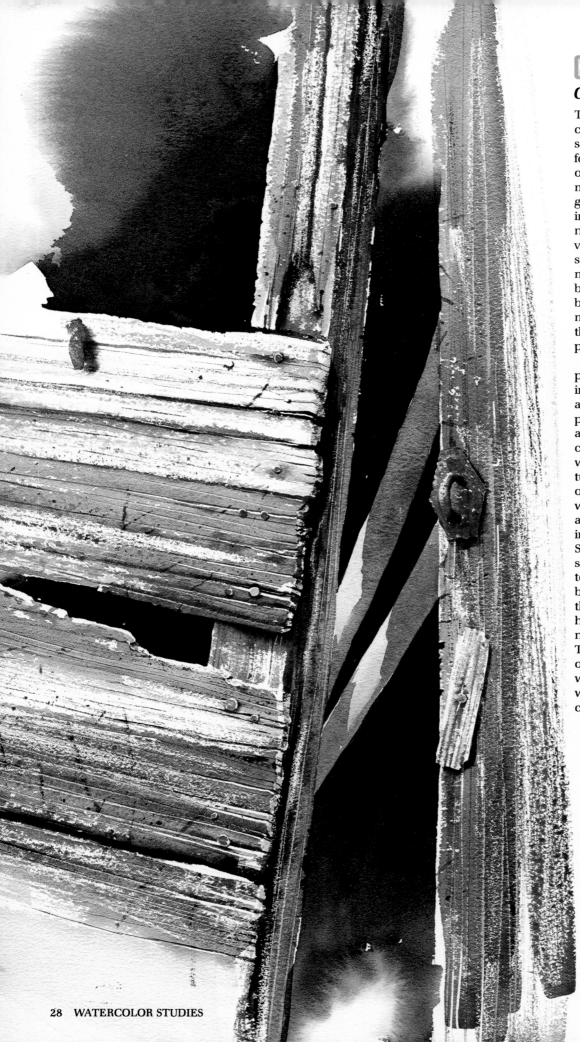

CHICKEN SHED DOOR

Close-up Views

This is the door to a chicken shed. It may seem a strange subject for a painting, but it is often the simplest, most mundane things that give us the best paintings. In other words, it is not always necessary to visit the local beauty spots for inspiration; much good material can be found in one's own back garden, where many of the paintings in this book have been painted.

An interesting composition presented itself in the diagonal lines created by the posts and panel leaning at odd angles. However, in this case, the surface of the wood needed to be captured completely; otherwise the painting would fail, because, after all, there is really nothing else to look at. Simple though it may seem, the wood here tells a story: nails have been banged in, splitting the grain; a simple latch, has been devised by a nail and sliver of wood. The effects of weathering on wood provided me with a patina that was worthwhile trying to capture on paper.

The basic technique of using candle wax and a few brushstrokes was used here on the wood boards, where I was careful not to overmix the colors so that they wouldn't streak on the paper. Large areas of white were left where the surface of the wood catches the light; this painting would have become dull if every square inch had been covered in paint.

I watched the paper carefully as it dried; and when the wet gloss left the surface, I scratched a razor blade down the lengths of wood to create the fine lines of grain. If I had scratched the paper while it was still "glossy" wet, the lines would have filled in with paint, and in fact would have had the opposite effect by making the lines dark and thick.

During the final stage, masking fluid was rubbed away and detail painted in with a fine brush; dark lines along the splits become very effective alongside the thin white highlights. Nails and rusty bits of metal were also painted in; the all-important shadows behind them make them stand out from the paper. Lastly, some more textured effects were added to the wooden panels; these grazes and scratches were rubbed on by dragging the brush along on its side with the paint as dry as possible.

The dark interior of the shed was painted in with Prussian blue. The outer edges had been wetted to encourage the colors to bleed out into the white paper. A candle was rubbed up and down the lengths of wood to cause the paint to speckle; this technique does a good job at imitating the surface quality of the wood. With a fine brush, I also masked out thin highlights along the edges of cracks, around nails, the wooden latch, and pieces of rusty metal.

For the board that the small wooden latch is attached to, I

mixed sap green, ultramarine blue, and burnt sienna with about the equivalent of a tablespoonful of water. I used a 1-inch flat sable brush for this part of the painting, filling it and sweeping it up the paper in a swift stroke. At the base of the board, you can see exactly how many brushstrokes were taken—six in all, though only four were really needed. The economy of brushwork was essential; otherwise, the white speckled effect would have been destroyed.

SHUTTER
Creating Textured Patterns

Something that has been in daily use for as long as this old shutter takes on a fascination for me. It almost tells a story of its own: how years of use have rounded its edges off, ragged splits have appeared, nails have been tapped on randomly, holding long-forgotten bits of string or fastenings.

I have taken a straight-on view of this shutter, intending to see it more as a two-dimensional pattern rather than as a complete composition. The most important factors are the textures and weathering, such as all the little nail heads and fastenings.

I spent quite a lot of time masking out, painting the masking fluid round the edge of cracks, nail heads, iron hinges, and the latch. I also masked out the thin strips of wood pinned onto the wood surface. Candle wax was rubbed into the paper to create a grainy texture.

With all the detail masked out, it left me free to sweep my large 1-inch flat sable brush down the length of the panels with a mixture of burnt sienna, cerulean blue, and ultramarine blue. While the paper was still damp, I brushed in some sap green and cadmium orange; the rounded lower edge was shaded with burnt sienna and ultramarine blue; and the paint was then touched in along the edge of the panel and allowed to bleed into the picture.

The same process was used for the wooden framing, where I masked out that area to allow me to sweep a large brush along the length of the grain; where the color is dark, I scratched thin highlights out with the corner of a razor blade.

The paint was allowed to dry and the masking fluid removed. I then started working in all the little scratches and blemishes that the years had wrought. With a fine brush, thin leaves of grain were painted in. The brush was dragged across the paper on its side to create the grazes and scratches across the grain. Where nail heads show through, I dampened the paper around them and touched burnt sienna onto the damp paper to stain the paper, as the rust itself has done to the old wood.

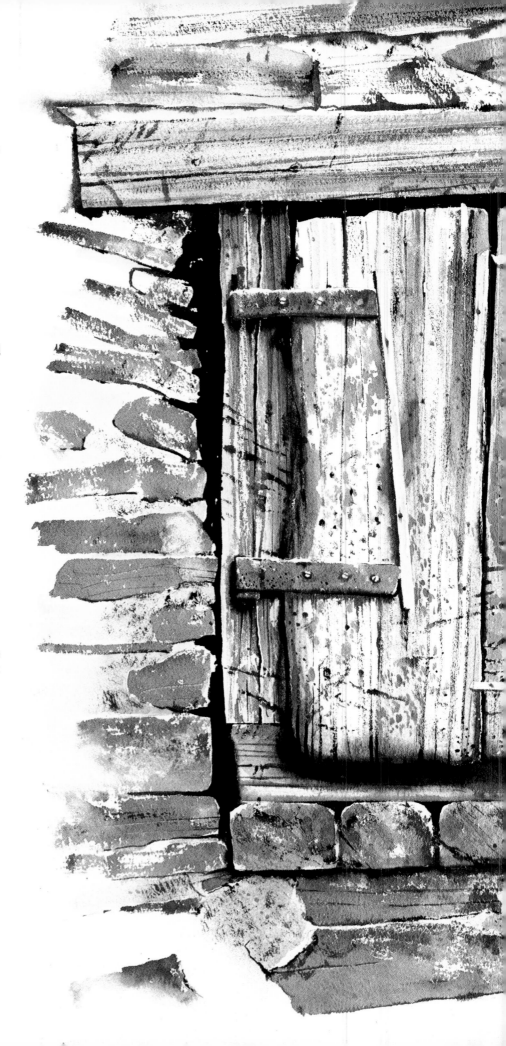

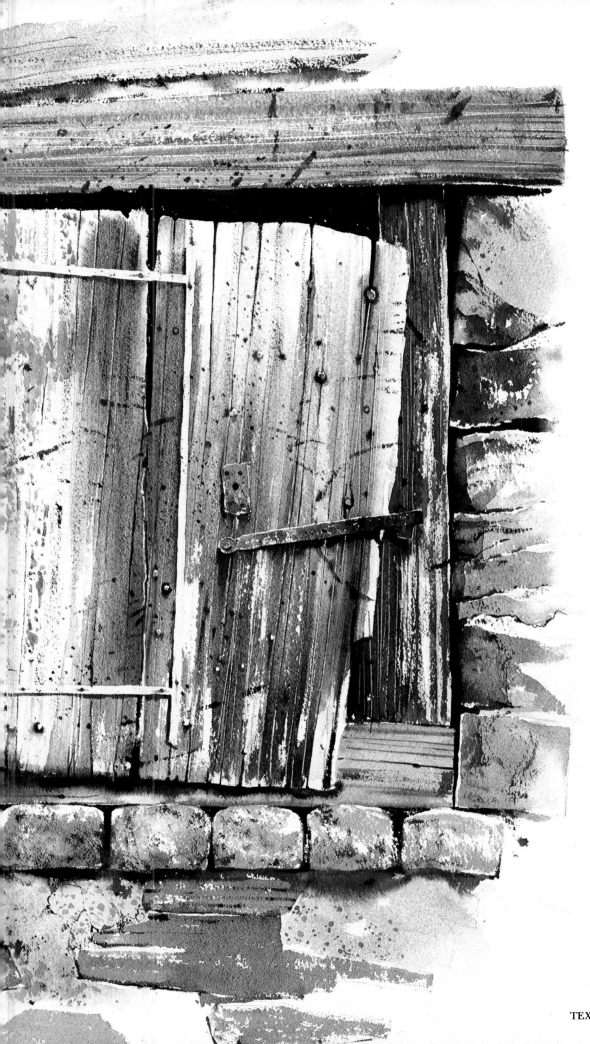

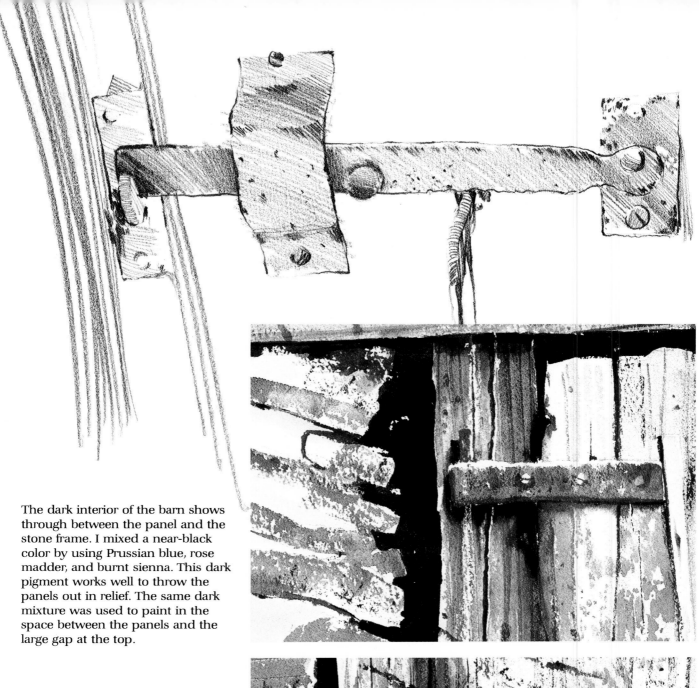

The dark interior of the barn shows through between the panel and the stone frame. I mixed a near-black color by using Prussian blue, rose madder, and burnt sienna. This dark pigment works well to throw the panels out in relief. The same dark mixture was used to paint in the space between the panels and the large gap at the top.

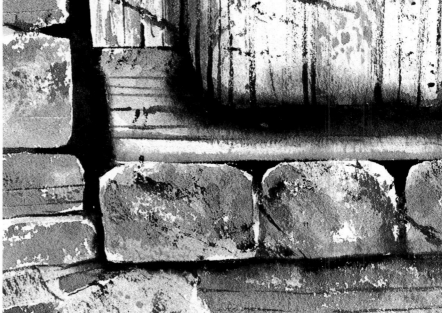

Highlights were left along the top edges of the stones; the lower edges have a line of shade drawn in with a fine brush. Textures and tints were added until a quality of stone and mortar was achieved.

The latch and hinges were painted in last. The old iron has a bluish hue turning to rust here and there. The color was created from rose madder and ultramarine blue, with touches of burnt sienna dabbed in for the staining effects of rust. Clear water was painted in, too, forming areas of gentle highlights.

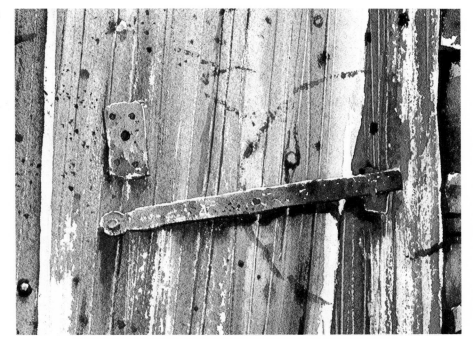

The brick and stone wall provides another interesting surface in the painting and also adds to the disjointed quality of the picture. At right, I have allowed the stonework to fade off in a vignette, helping to draw attention to the center of the picture. The colors were painted in quite loosely, where I sometimes scrubbed the brush on its side to create broken texture and used clear water to soften edges leading out of the picture.

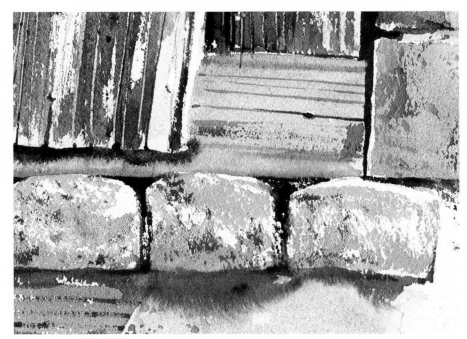

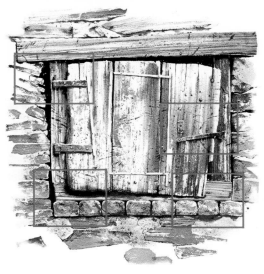

WHEELS
Subtly Colored Curved Surfaces

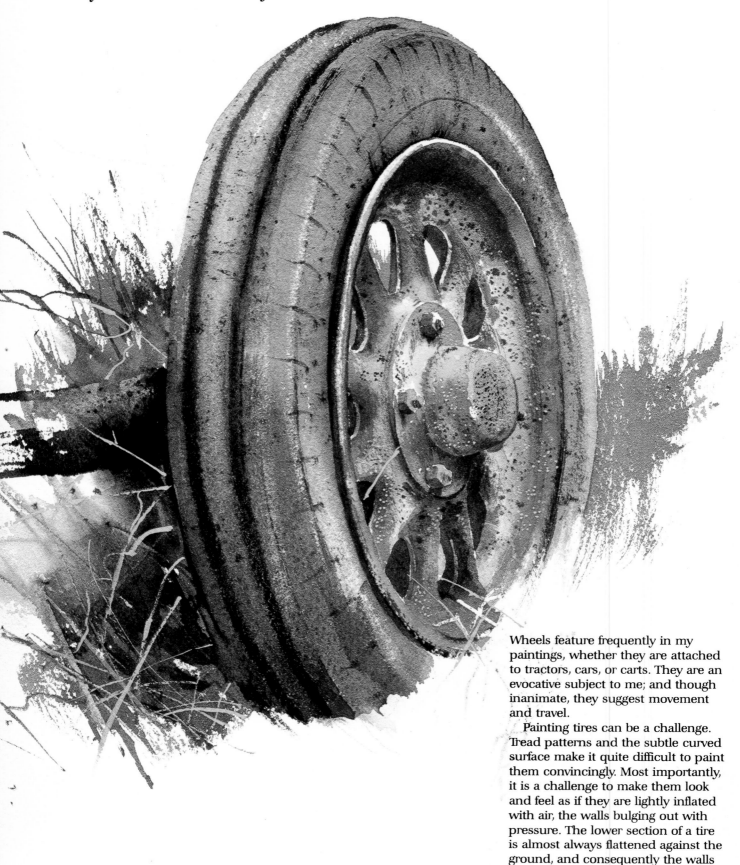

Wheels feature frequently in my paintings, whether they are attached to tractors, cars, or carts. They are an evocative subject to me; and though inanimate, they suggest movement and travel.

Painting tires can be a challenge. Tread patterns and the subtle curved surface make it quite difficult to paint them convincingly. Most importantly, it is a challenge to make them look and feel as if they are lightly inflated with air, the walls bulging out with pressure. The lower section of a tire is almost always flattened against the ground, and consequently the walls of the base bulge out even further.

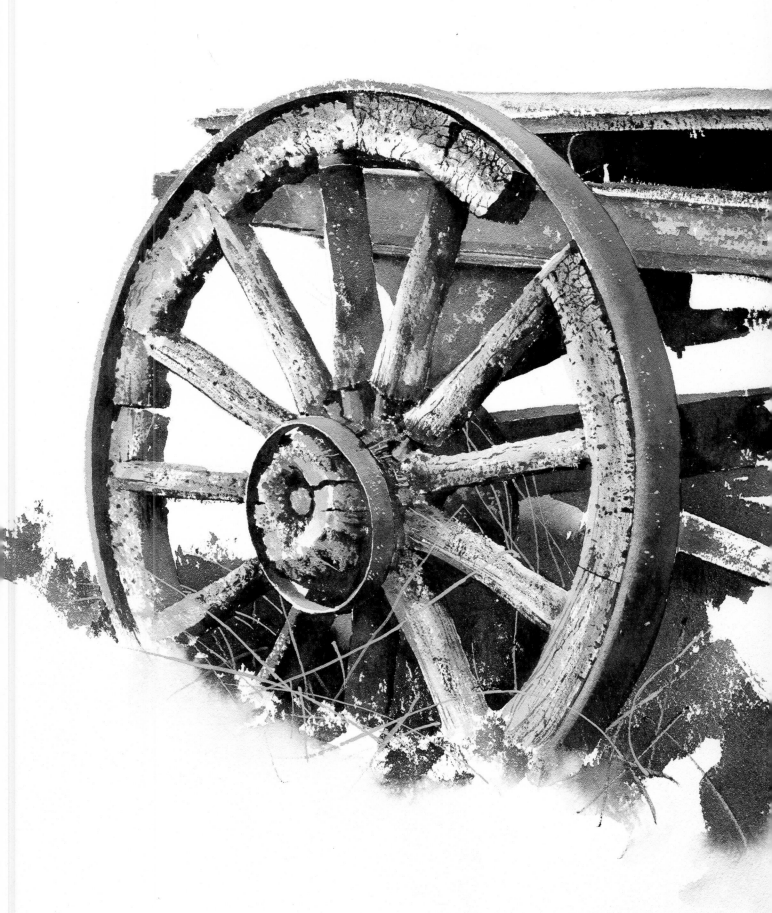

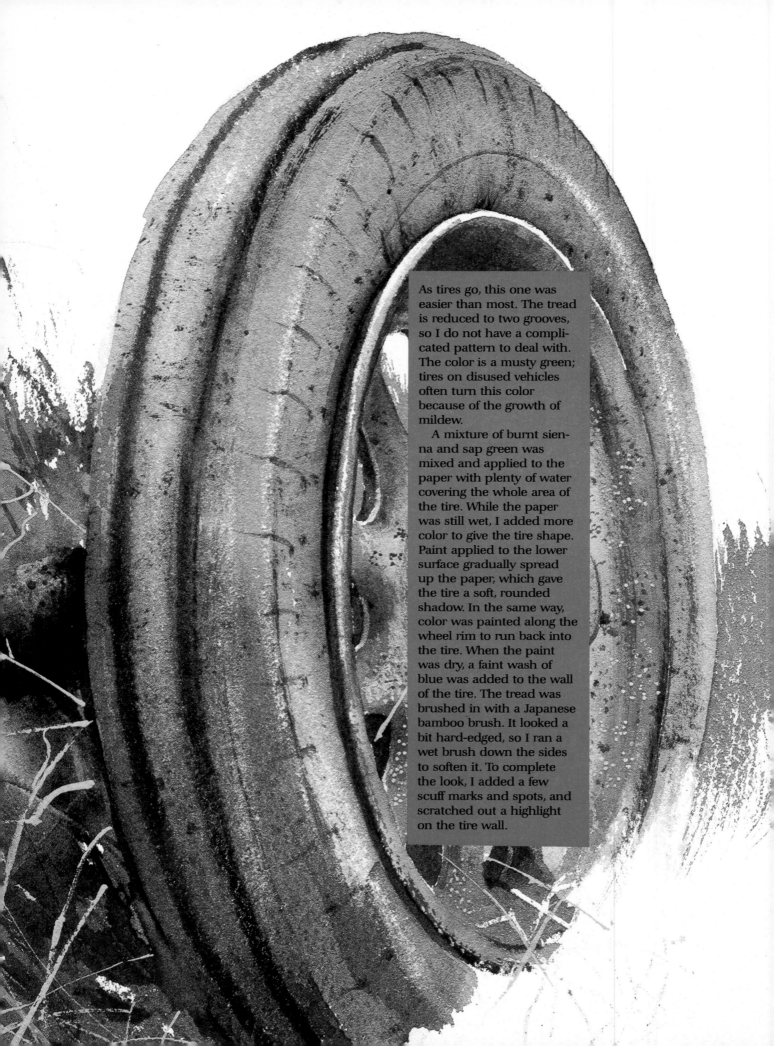

As tires go, this one was easier than most. The tread is reduced to two grooves, so I do not have a complicated pattern to deal with. The color is a musty green; tires on disused vehicles often turn this color because of the growth of mildew.

A mixture of burnt sienna and sap green was mixed and applied to the paper with plenty of water covering the whole area of the tire. While the paper was still wet, I added more color to give the tire shape. Paint applied to the lower surface gradually spread up the paper, which gave the tire a soft, rounded shadow. In the same way, color was painted along the wheel rim to run back into the tire. When the paint was dry, a faint wash of blue was added to the wall of the tire. The tread was brushed in with a Japanese bamboo brush. It looked a bit hard-edged, so I ran a wet brush down the sides to soften it. To complete the look, I added a few scuff marks and spots, and scratched out a highlight on the tire wall.

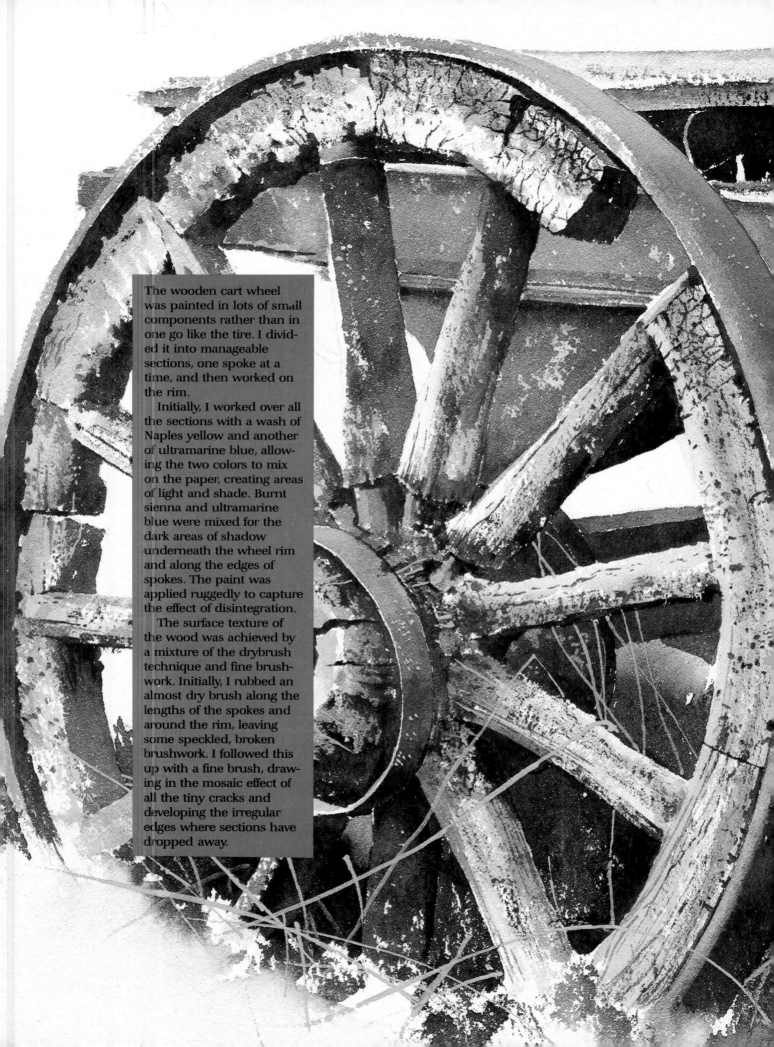

The wooden cart wheel was painted in lots of small components rather than in one go like the tire. I divided it into manageable sections, one spoke at a time, and then worked on the rim.

Initially, I worked over all the sections with a wash of Naples yellow and another of ultramarine blue, allowing the two colors to mix on the paper, creating areas of light and shade. Burnt sienna and ultramarine blue were mixed for the dark areas of shadow underneath the wheel rim and along the edges of spokes. The paint was applied ruggedly to capture the effect of disintegration.

The surface texture of the wood was achieved by a mixture of the drybrush technique and fine brushwork. Initially, I rubbed an almost dry brush along the lengths of the spokes and around the rim, leaving some speckled, broken brushwork. I followed this up with a fine brush, drawing in the mosaic effect of all the tiny cracks and developing the irregular edges where sections have dropped away.

WINDMILL
Selecting a Focus
Lively Brushwork

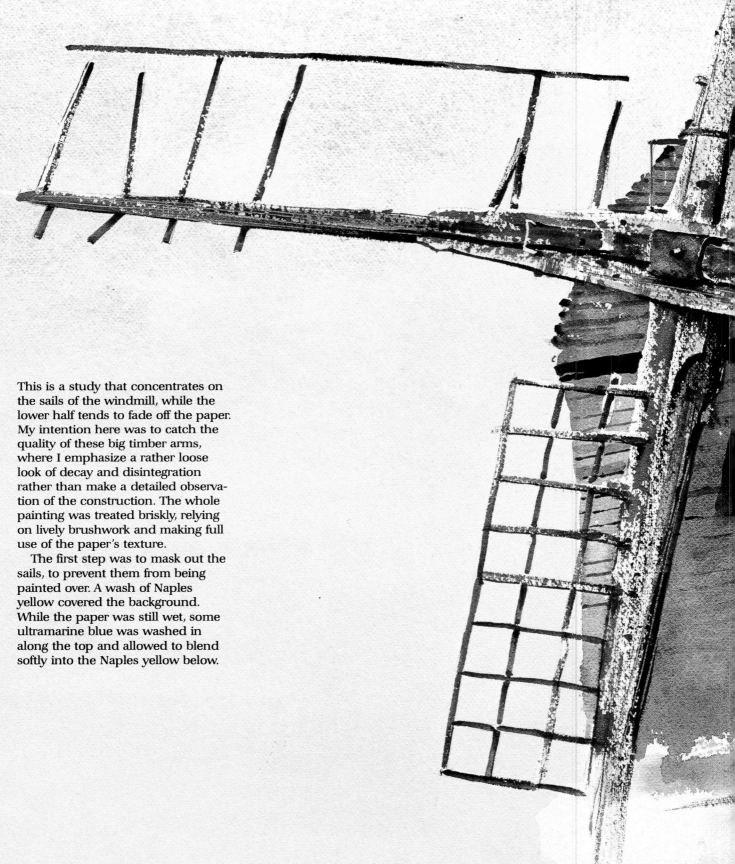

This is a study that concentrates on the sails of the windmill, while the lower half tends to fade off the paper. My intention here was to catch the quality of these big timber arms, where I emphasize a rather loose look of decay and disintegration rather than make a detailed observation of the construction. The whole painting was treated briskly, relying on lively brushwork and making full use of the paper's texture.

The first step was to mask out the sails, to prevent them from being painted over. A wash of Naples yellow covered the background. While the paper was still wet, some ultramarine blue was washed in along the top and allowed to blend softly into the Naples yellow below.

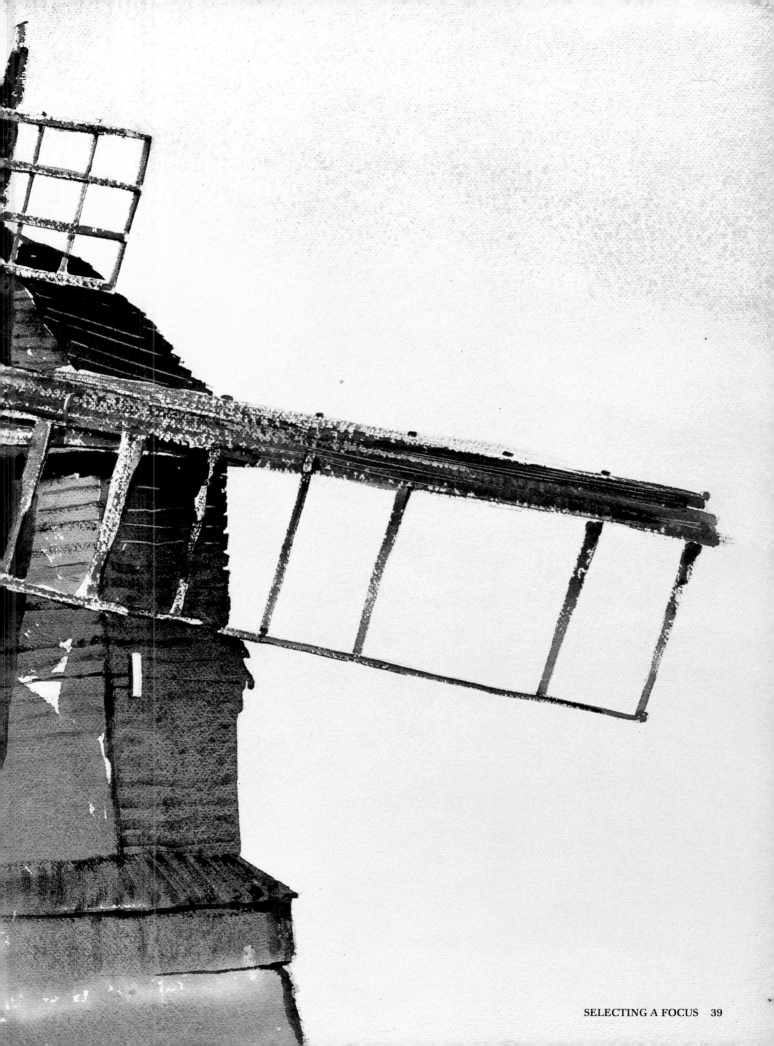

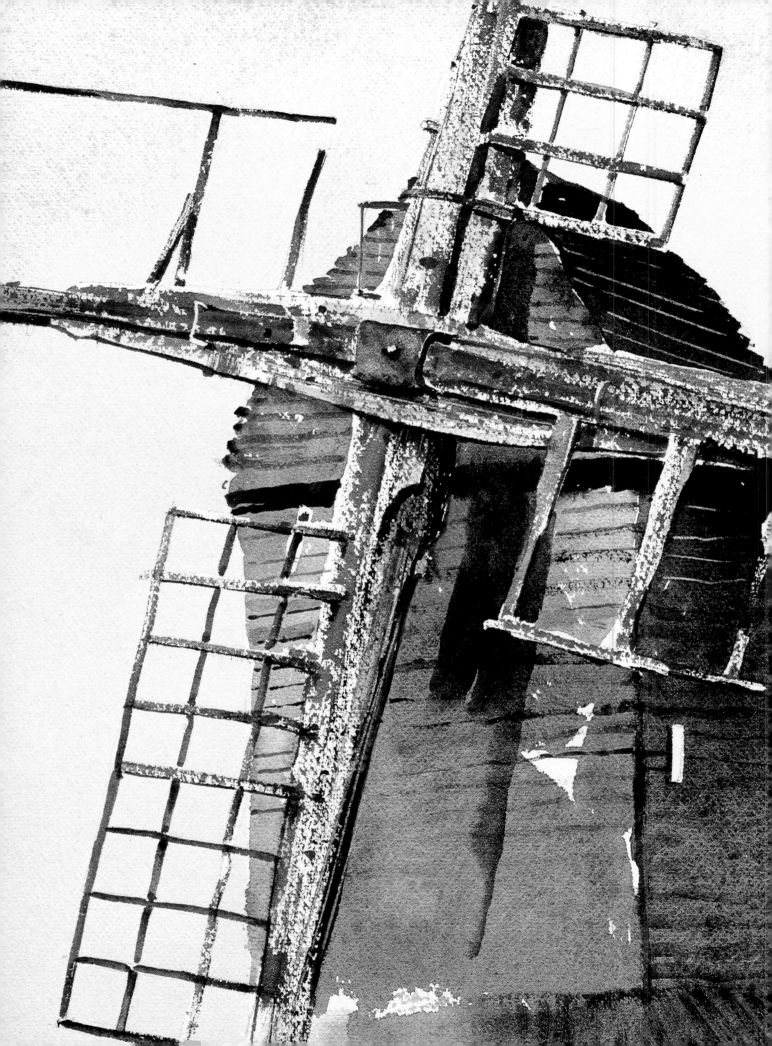

The body of the windmill was painted in using a lot of water, causing the colors to wash together on the paper. Shadows were painted in with a mixture of ultramarine blue and burnt sienna. The wooden construction was suggested by dragging the brush along the lines of the facing planks. Detail was left out altogether so that the effect of the broken-down sails would be more striking.

When the masking fluid was removed, the sharply defined outline of the sails was left to contrast with the body of the windmill. Mixing the colors quite thickly on my brush, I placed it on the paper, holding it right over on its side and dragging it along the length of one of the windmill arms. This technique makes maximum use of the paper's texture, allowing paint to lie on the top of the paper's textured surface only. As can be seen, the paint gives a very speckled, irregular appearance using this technique.

For the main arms, I used a size 6, Japanese bamboo brush; and for the thinner timbers that jut out from the main arms, I used an old size 2 sable brush that had lost its point. Using the same technique, I ran the old brush along the thin timbers. Gentle washes—tints of ultramarine blue and Naples yellow—were then laid over the broken brushwork, but still leaving plenty of white areas.

The finishing touches were made with a fine brush. Painting in fine, dark lines of shadow on the undersides of the wooden sections helped to define the shapes and made the overall form more pronounced.

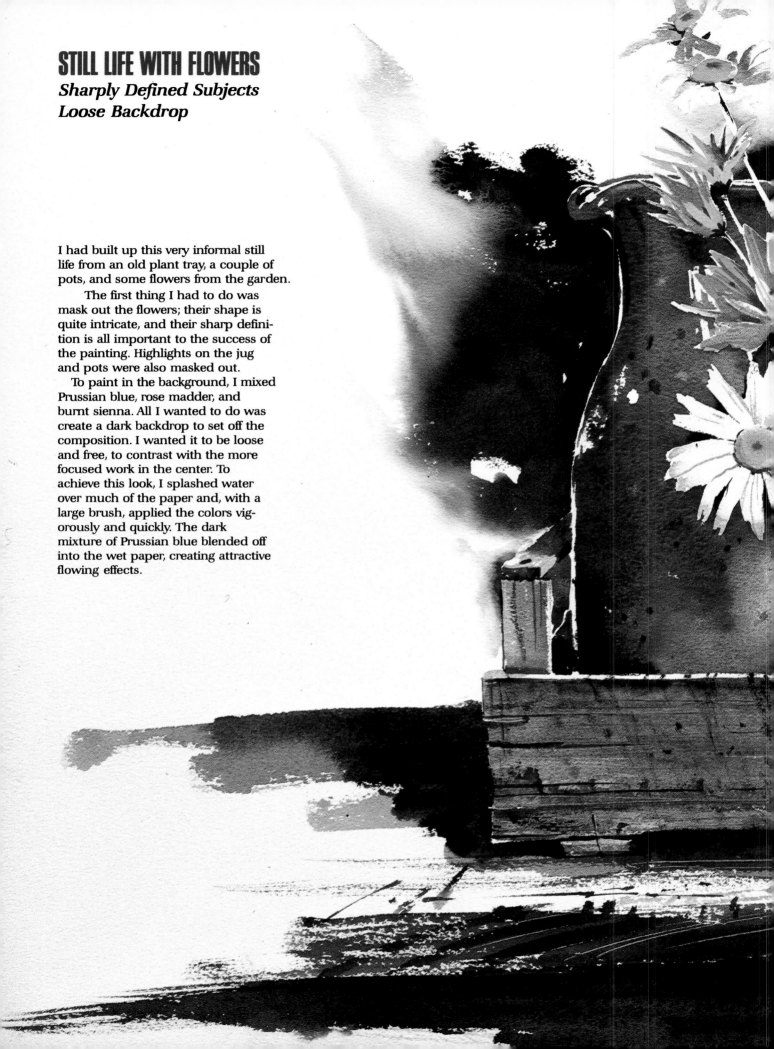

STILL LIFE WITH FLOWERS
Sharply Defined Subjects
Loose Backdrop

I had built up this very informal still life from an old plant tray, a couple of pots, and some flowers from the garden.

The first thing I had to do was mask out the flowers; their shape is quite intricate, and their sharp definition is all important to the success of the painting. Highlights on the jug and pots were also masked out.

To paint in the background, I mixed Prussian blue, rose madder, and burnt sienna. All I wanted to do was create a dark backdrop to set off the composition. I wanted it to be loose and free, to contrast with the more focused work in the center. To achieve this look, I splashed water over much of the paper and, with a large brush, applied the colors vigorously and quickly. The dark mixture of Prussian blue blended off into the wet paper, creating attractive flowing effects.

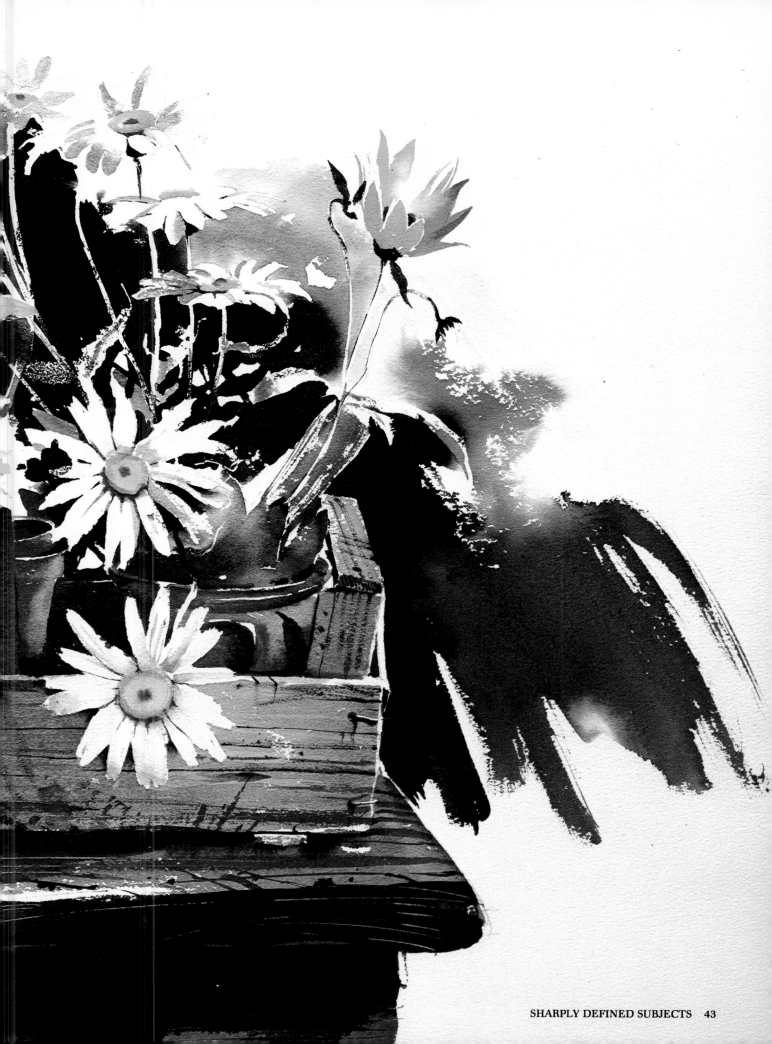

The deep green-brown hue of the pitcher was created from mixing sap green and burnt sienna. I blocked in the color using plenty of water and added ultramarine blue down the left-hand side of the pitcher, giving it a rounded feel. The thin white line running down its side was washed out and prevents the shape of the pitcher from vanishing into the background. The other plant pots were left as little more than dark shapes shaded by the flowers. Finally, I introduced the yellow flowers, softly blending a mixture of cadmium yellow and cadmium orange. The shading was overpainted with ultramarine blue.

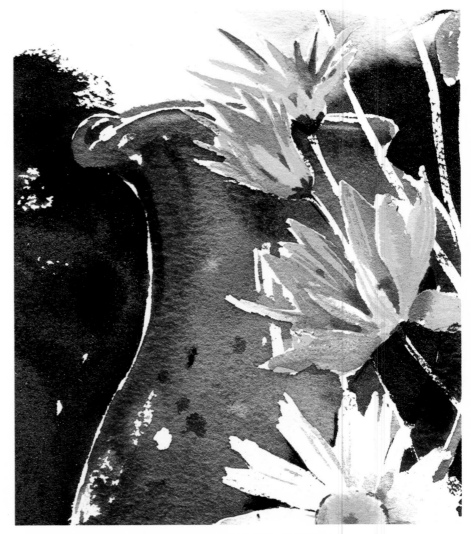

The plant tray was blocked in with ultramarine blue, burnt sienna, and yellow ocher, mixed with plenty of water. The colors were applied and allowed to mix on the paper, giving a variety of tones and shades. When the paint was dry, I used the dry-brush technique to add texture and blemishes to the surface of the wood. Where the grain has split, I have painted it in as thin, dark lines with a fine-pointed brush.

The rustic wooden table was also painted in vigorously with burnt sienna and ultramarine blue; the grain and texture were dabbed in with the side of the brush. Before the paint dried, I also scratched a razor blade through the table a few times for more grain effects. Under the table, I continued the same Prussian blue mixture as in the background; it works well in balancing the painting; without it, the tray and pots would appear to be floating in air.

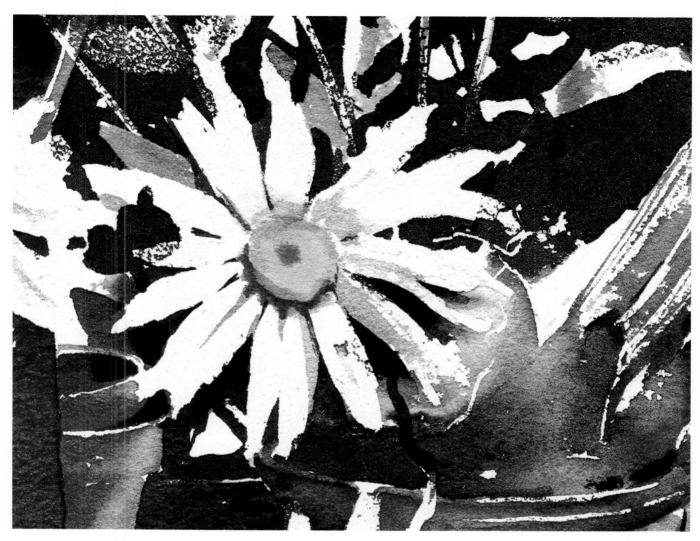

The large marguerite flowers in the foreground were left as white as possible to contrast with the dark background. To heighten this effect, I had carefully painted in darker colors just behind the flower heads, making the contrast even more pronounced. This little bit of color and shade I had used on the flowers comes from mixing ultramarine blue and rose madder.

I dampened the area in the center of the flowers before adding cadmium yellow; this gave the flower heads a softer, more rounded feel. And while the paper was still damp, I dabbed a small dot of burnt sienna and sap green into the centers. The flowers were further defined by picking out the edges of the petals with a fine brush and also the dark underedges of the yellow centers; here, I also softened the edge off with another brush loaded with a little bit of clean water.

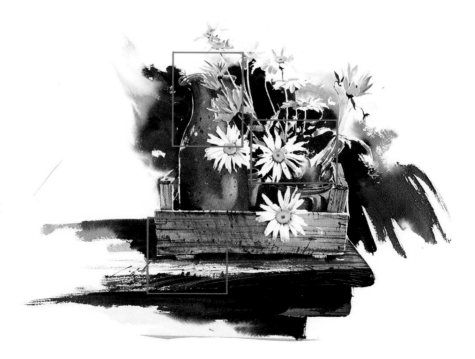

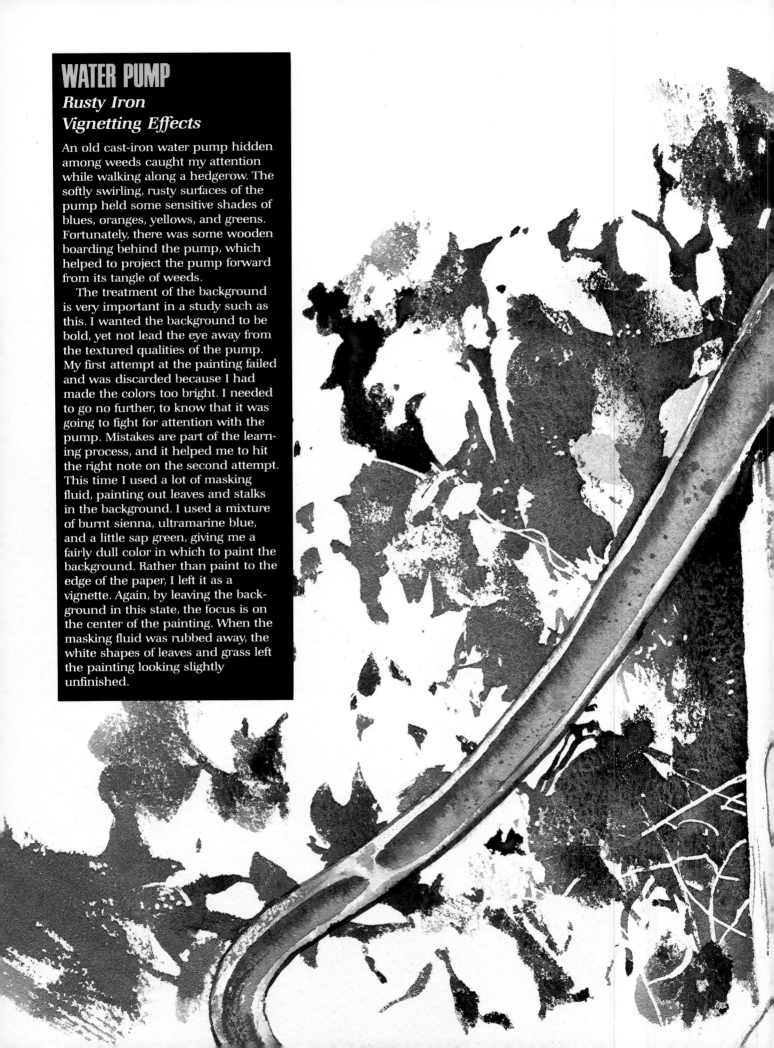

WATER PUMP
Rusty Iron
Vignetting Effects

An old cast-iron water pump hidden among weeds caught my attention while walking along a hedgerow. The softly swirling, rusty surfaces of the pump held some sensitive shades of blues, oranges, yellows, and greens. Fortunately, there was some wooden boarding behind the pump, which helped to project the pump forward from its tangle of weeds.

The treatment of the background is very important in a study such as this. I wanted the background to be bold, yet not lead the eye away from the textured qualities of the pump. My first attempt at the painting failed and was discarded because I had made the colors too bright. I needed to go no further, to know that it was going to fight for attention with the pump. Mistakes are part of the learning process, and it helped me to hit the right note on the second attempt. This time I used a lot of masking fluid, painting out leaves and stalks in the background. I used a mixture of burnt sienna, ultramarine blue, and a little sap green, giving me a fairly dull color in which to paint the background. Rather than paint to the edge of the paper, I left it as a vignette. Again, by leaving the background in this state, the focus is on the center of the painting. When the masking fluid was rubbed away, the white shapes of leaves and grass left the painting looking slightly unfinished.

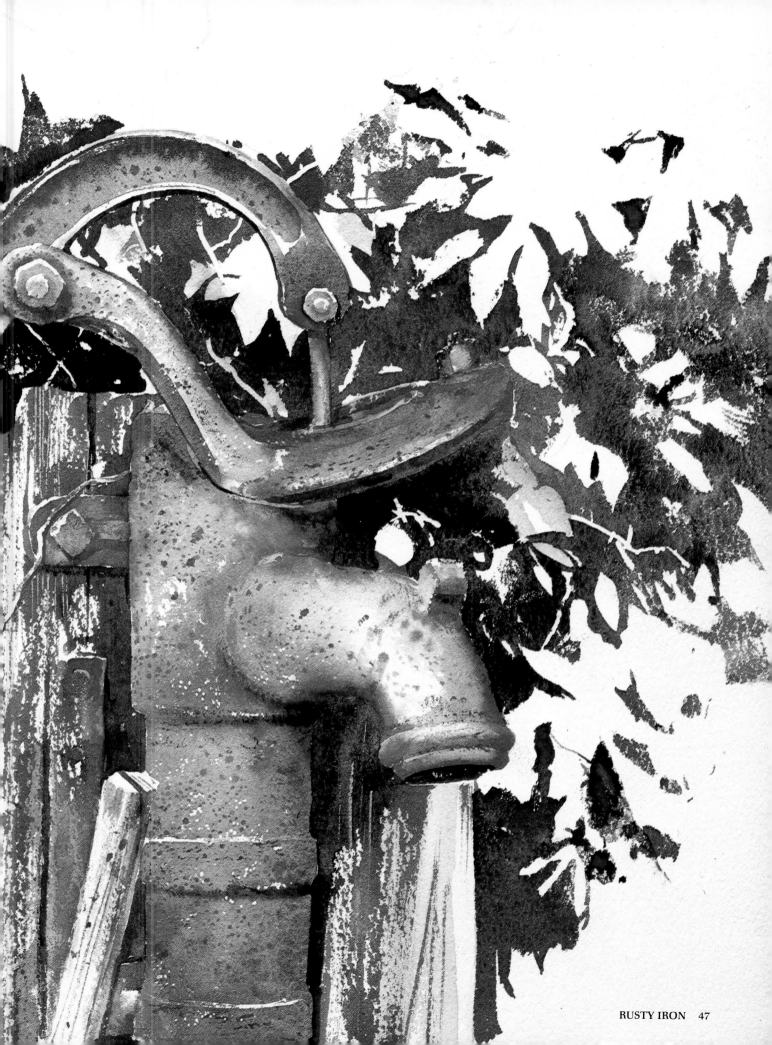

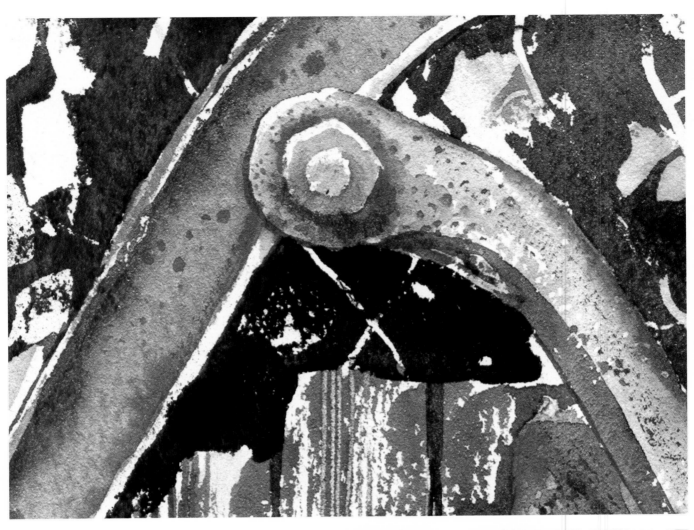

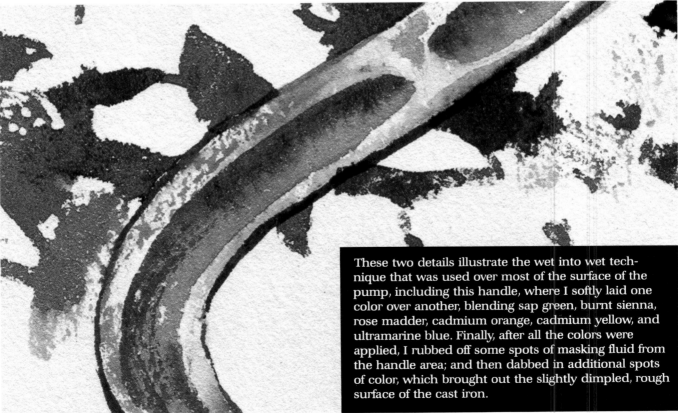

These two details illustrate the wet into wet technique that was used over most of the surface of the pump, including this handle, where I softly laid one color over another, blending sap green, burnt sienna, rose madder, cadmium orange, cadmium yellow, and ultramarine blue. Finally, after all the colors were applied, I rubbed off some spots of masking fluid from the handle area; and then dabbed in additional spots of color, which brought out the slightly dimpled, rough surface of the cast iron.

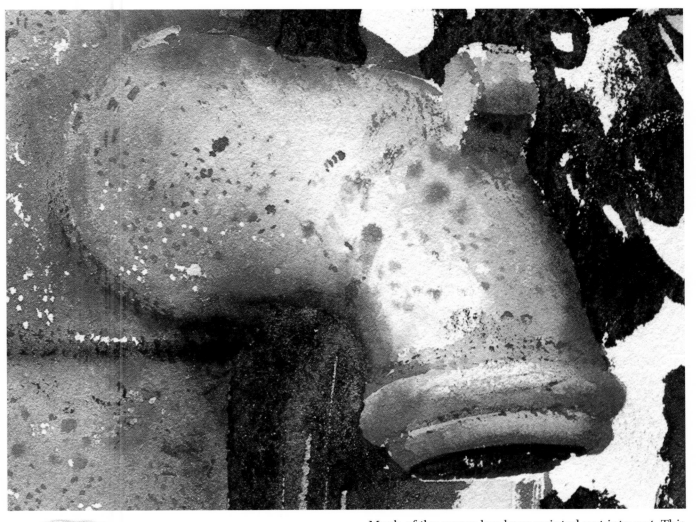

Much of the pump has been painted wet into wet. This section of the paper was wiped over first with a wet brush and the colors were carefully dropped in afterward. To achieve this speckled rusty look, all that was needed was to touch the tip of the brush against the wet paper, and the colors all ran onto the paper and blended softly into the other colors.

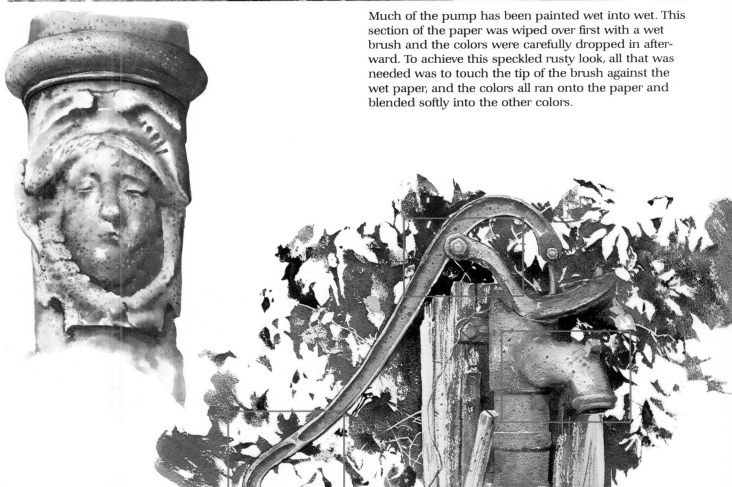

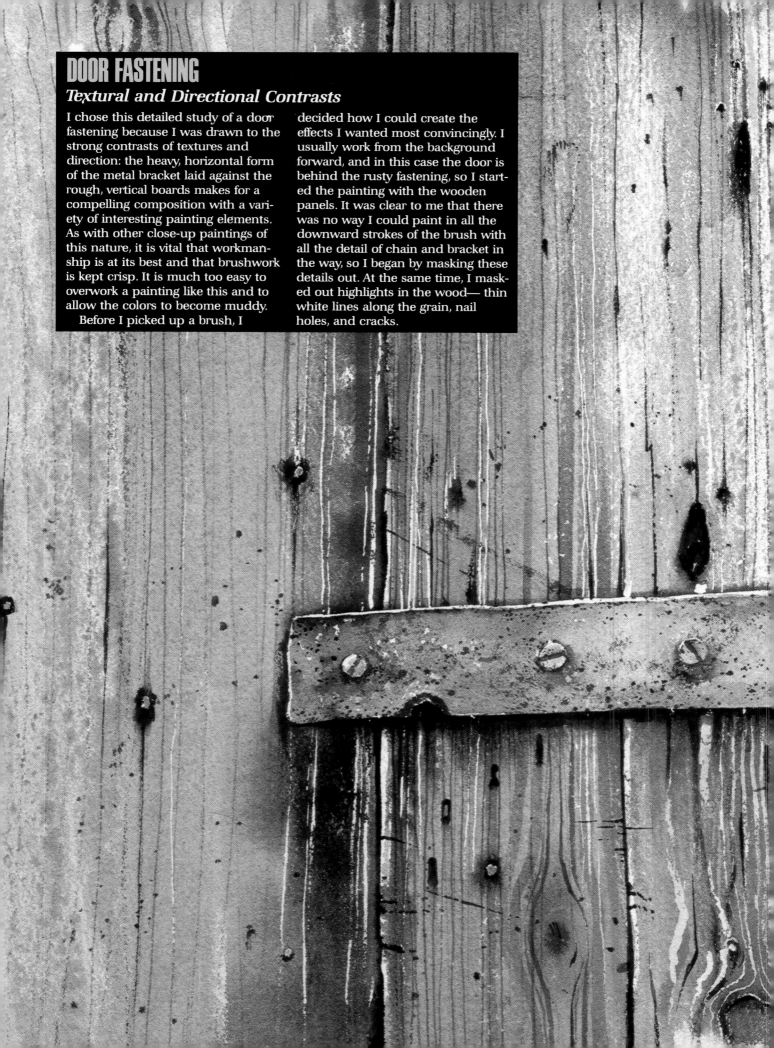

DOOR FASTENING
Textural and Directional Contrasts

I chose this detailed study of a door fastening because I was drawn to the strong contrasts of textures and direction: the heavy, horizontal form of the metal bracket laid against the rough, vertical boards makes for a compelling composition with a variety of interesting painting elements. As with other close-up paintings of this nature, it is vital that workmanship is at its best and that brushwork is kept crisp. It is much too easy to overwork a painting like this and to allow the colors to become muddy.

Before I picked up a brush, I decided how I could create the effects I wanted most convincingly. I usually work from the background forward, and in this case the door is behind the rusty fastening, so I started the painting with the wooden panels. It was clear to me that there was no way I could paint in all the downward strokes of the brush with all the detail of chain and bracket in the way, so I began by masking these details out. At the same time, I masked out highlights in the wood— thin white lines along the grain, nail holes, and cracks.

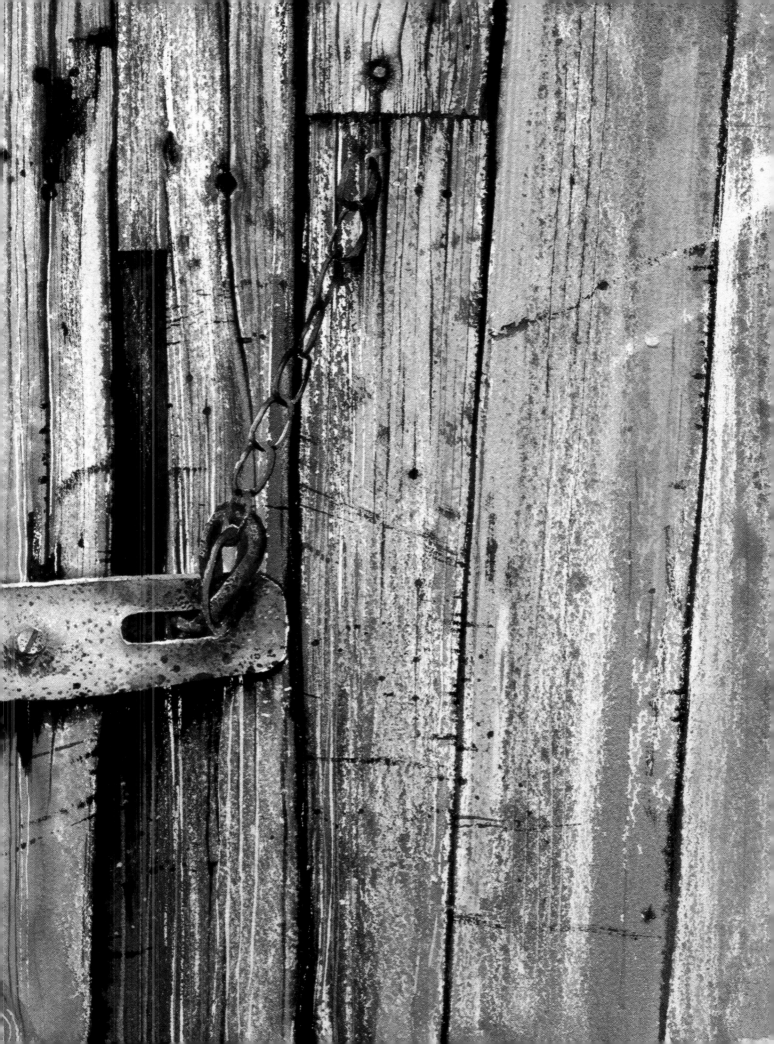

I laid in my first brushstrokes here and developed the vertical wood panels. These are the most important ones in this painting; everything would hang on this first bold statement. So it paid off to think about what I was doing before I dove in with my brushes. There is a subtle range of color across the wood, but I didn't think I could catch it all in one go, so I first laid down brushfuls of Naples yellow and cobalt blue. These colors ran in streaks down the paper, then gently flowed together giving a soft blend of colors. I allowed these colors to dry and then overpainted them in another wash of cadmium orange and a little sap green.

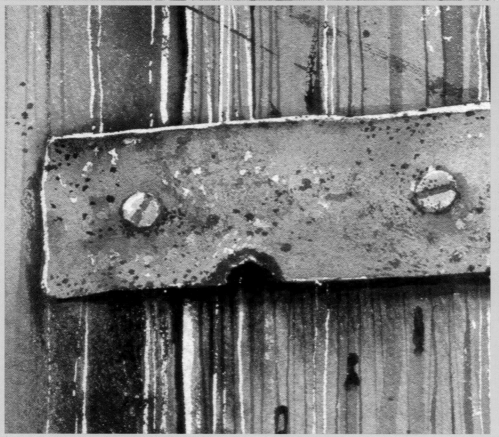

With the washes on the wood areas were completed, I started to build up the textures and finer details. A line of burnt sienna and ultramarine blue was painted around the bracket and then softened with clear water where dirt and rust have stained the wood. The same was done to the nail holes where rust has stained the wood. Large nail holes and cracks were the darkest points in the painting; these were painted out in ultramarine blue and a little burnt sienna. With the same color mix, I picked up a fine-pointed brush, and painted in all the other fine cracks and splits in the wood and the many small holes where nails have rusted away. With another small brush of clear water, I softened the edges where I felt it necessary.

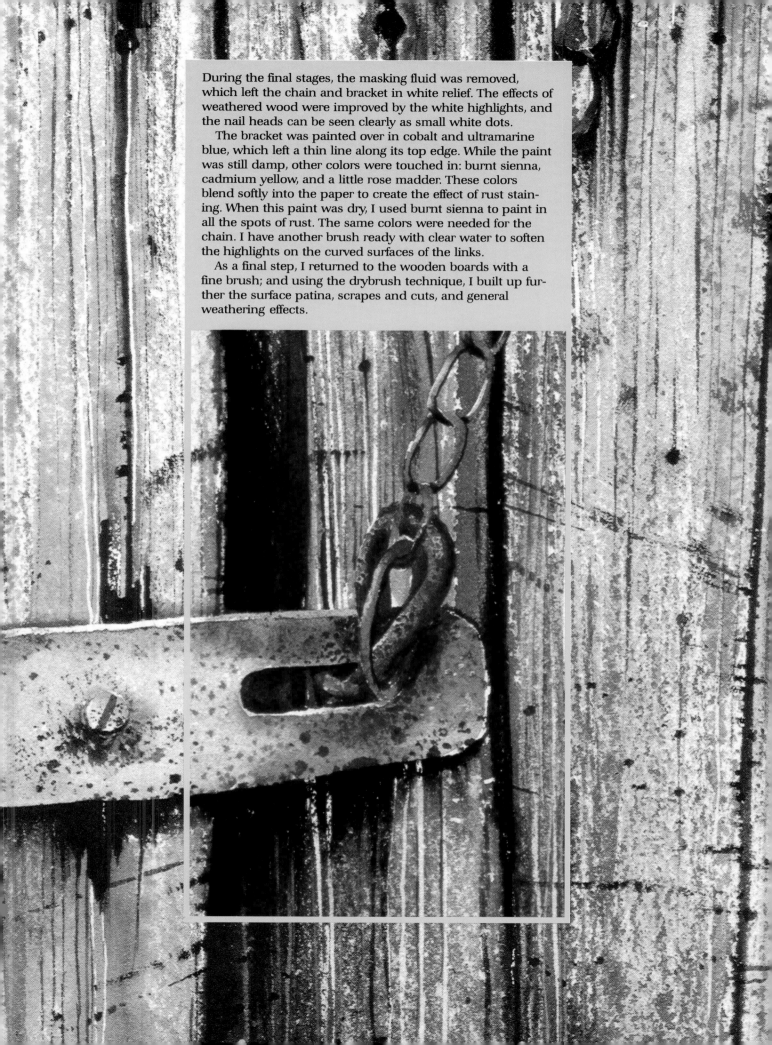

During the final stages, the masking fluid was removed, which left the chain and bracket in white relief. The effects of weathered wood were improved by the white highlights, and the nail heads can be seen clearly as small white dots.

The bracket was painted over in cobalt and ultramarine blue, which left a thin line along its top edge. While the paint was still damp, other colors were touched in: burnt sienna, cadmium yellow, and a little rose madder. These colors blend softly into the paper to create the effect of rust staining. When this paint was dry, I used burnt sienna to paint in all the spots of rust. The same colors were needed for the chain. I have another brush ready with clear water to soften the highlights on the curved surfaces of the links.

As a final step, I returned to the wooden boards with a fine brush; and using the drybrush technique, I built up further the surface patina, scrapes and cuts, and general weathering effects.

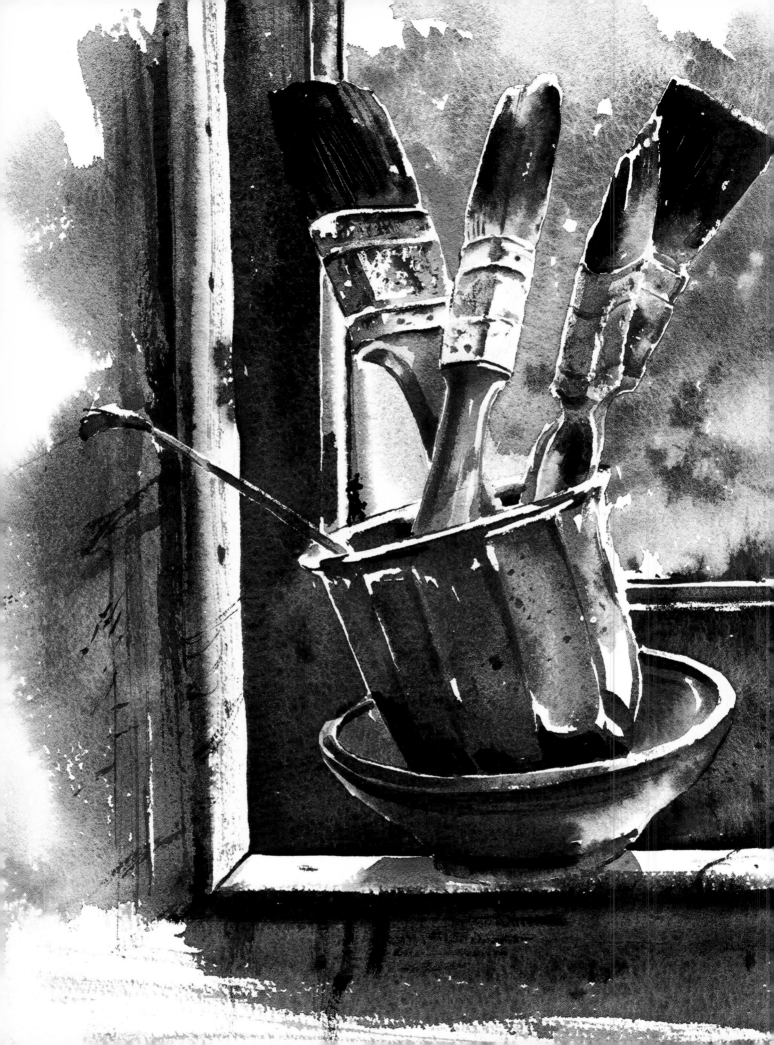

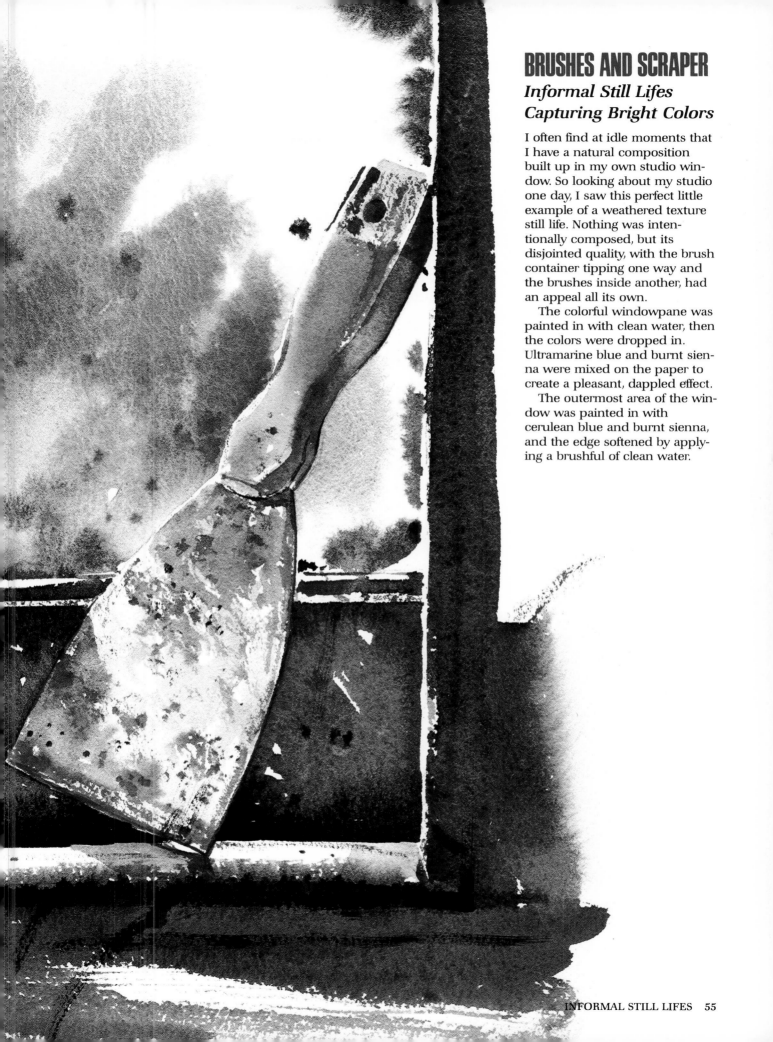

BRUSHES AND SCRAPER
Informal Still Lifes Capturing Bright Colors

I often find at idle moments that I have a natural composition built up in my own studio window. So looking about my studio one day, I saw this perfect little example of a weathered texture still life. Nothing was intentionally composed, but its disjointed quality, with the brush container tipping one way and the brushes inside another, had an appeal all its own.

The colorful windowpane was painted in with clean water, then the colors were dropped in. Ultramarine blue and burnt sienna were mixed on the paper to create a pleasant, dappled effect.

The outermost area of the window was painted in with cerulean blue and burnt sienna, and the edge softened by applying a brushful of clean water.

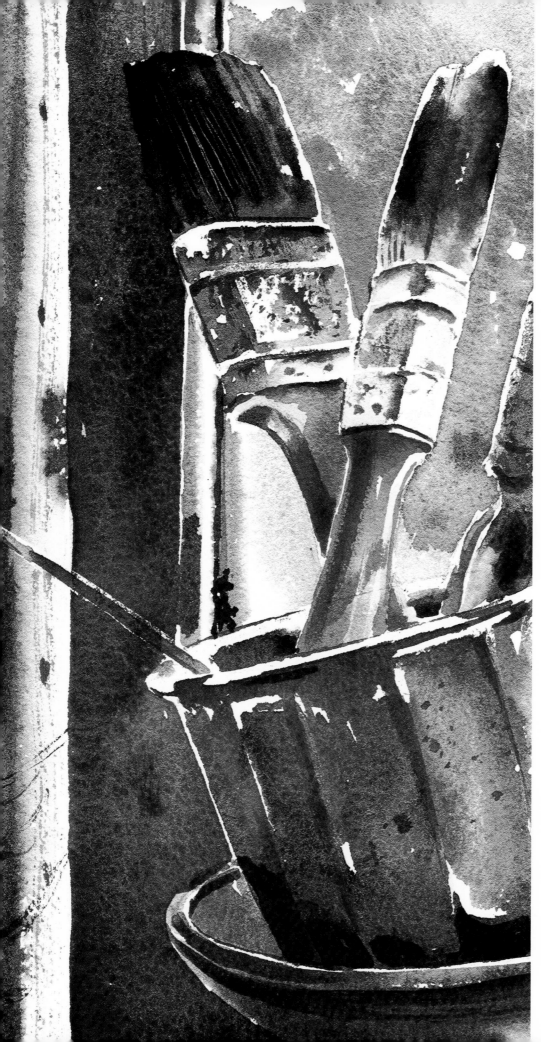

In this detail, my first step was to mask out some highlights on the brush container, the small brush leaning away from the window, and the rim of the small brown bowl set under the brushholder. I tried to use as little masking fluid as possible here and to rely on brush control wherever possible. It is easy to get carried away with aids to painting, but at the end of the day the best paintings are made with brushes and paints.

The brush container is a dark, glazed color but it is also reflecting colors from all around. To me, this is really the most important part of the painting—to capture these often bright colors and sharp highlights in a vibrant way. I tried to achieve this by using the paint fresh from the tube, so that the colors were bright, and then letting them melt together on the paper. Also, if the colors are too bright, it is easy to tone them down—the reverse is not possible.

The various angles and shapes of the brushes make interesting forms against the window, which are heightened by a thin white highlight outlining them against the windowpane. Although each brush is different, the bristles were all painted from ultramarine blue and burnt sienna, with one having a rich streak of burnt sienna in its bristles while another is more blue. Before I let the paint dry, I scratched out the individual hairs of the brushes using the corner of a razor blade. Finally, I took a small brush and touched in blemishes and lines in the window frame and the brush ferrules.

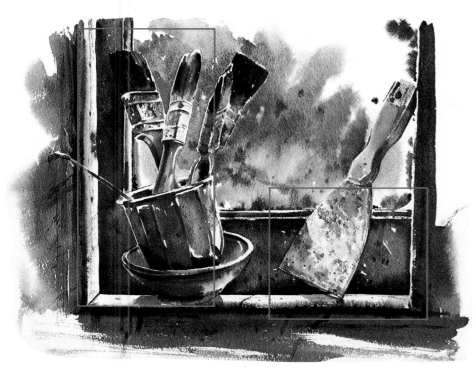

The scraper's blade is covered in Spackle and rust, so it has a wonderful textured surface. To impart the same texture in the painting, I leaned my Japanese bamboo brush over on its side, and using a wiping motion left a broken, textured effect. The bottom edge of the scraper was then dampened, and cadmium yellow and burnt sienna were allowed to stain the area where the rust is showing through.

The surrounding framework of the window is the darkest section of the painting, consisting of cadmium orange, ultramarine blue, and burnt sienna. The colors were applied quite richly and allowed to mix on the paper. Well-mixed colors on the palette surface are likely to turn to shades of mud; but if colors are applied to the paper "almost" separately and allowed to mix and blend there, they will retain their individual character. I am also careful to work the colors on the paper as little as possible, as this too will have the same dulling effect.

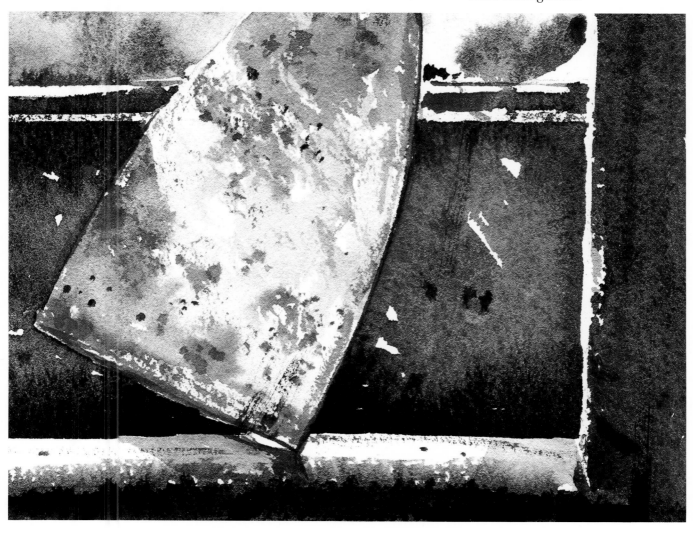

WINTER WILLOW
Emphasizing Form Over Detail

Willows are a common feature in my part of the country. Their twisted, gnarled shapes have been a long-standing favorite of many artists.

When evaluating this particular scene, I decided that it would be best to avoid the tangle of detail and to set out first to catch the twist and curl of the tree's shape. Using two of my bamboo brushes, one with clean water and the other charged with a mixture of sap green, burnt sienna, and ultramarine blue, I began to describe the essential shape of the tree, sweeping my brush in a curve down the trunk. Where I wanted to soften an edge, I used the brush with clean water to wash the hard edge away. (I also allowed for plenty of white paper to remain for highlights on the trunk.)

After the initial paint used to establish the lines of the tree were laid in, I began to bring in the detail of the bark, dragging a fine, long-haired brush up and down the trunk, building up the texture and patterns. Bark typically has a very random pattern and varies greatly among different species of tree. It is best to avoid trying to copy every curve and furrow exactly in the hope that the pattern will be there at the end.

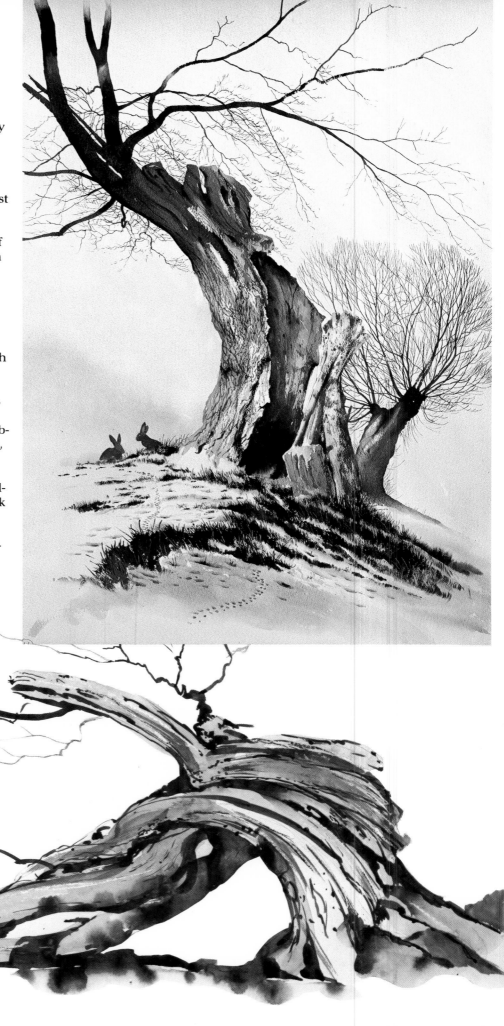

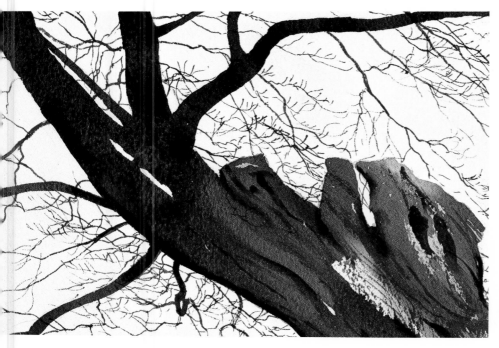

The darker colors of the large branches run down into the main body of the tree. This blended effect was achieved by sweeping the brush down from the branches into the trunk with a mixture of burnt sienna, sap green, and ultramarine blue. When the bulk of the tree was completed, I was able to work further on detail and light washes, introducing tints of color: a little cobalt blue in the bark, some Naples yellow where the bark has peeled away, and some more burnt sienna in the hollow interior of the tree. With burnt sienna and ultramarine blue, I added shape to the top of the trunk where branches have been cut away, dragging the brush down following the grain, creating dark pits and creases. Where the shape is rounded, I used a brush of clear water to soften the edge of the wet paint.

The darker interior was loosely washed in with burnt sienna, yellow ocher, Naples yellow, and ultramarine blue. The lighter colors of Naples yellow and yellow ocher were laid in first and then the darker colors were allowed to run into it from the left-hand side and from the base where the darkest shadows are.

The tree in the background was given the look of distance by painting it in ghostly coloring. To achieve this, I used Windsor and Newton Gray No. 2 and let it merge into the darker colors of ultramarine blue and burnt sienna. The branches were filled in with my fine, size O, long-haired sable brush.

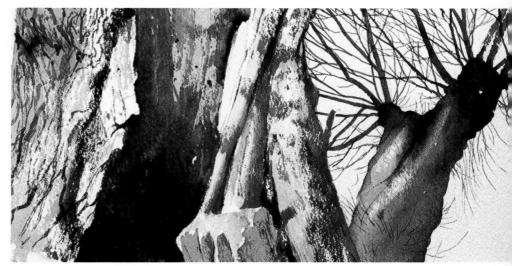

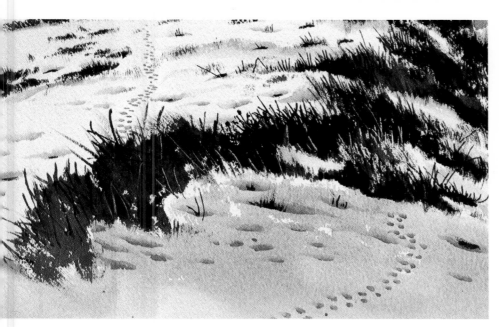

Turning my attention to the snow in the foreground, I repeated the colors of the sky with ultramarine blue, cerulean blue, and a little Naples yellow. The grass pushing through the snow provides a useful "lead in" for the eye and balances the painting well with the large branches leaning off to the left. To give the effect of dried tufts of grass, I mixed sap green and burnt sienna together, using the drybrush technique to scrub the colors onto the paper and flicking the brush upward to feather the edge of the brushstroke. Most important here was to keep the paint as dry as possible and to painstakingly rub the paint in. While the paint was still damp, I used the corner of a razor blade to scratch in some of the grass stems.

THE ROW CROP
Using White Space

I found this old tractor in the corner of a barn. Its interwoven machine parts made such a complex, almost tapestrylike design on the paper that I decided to leave out the dark background of the barn altogether, using the white of the paper to throw out the image.

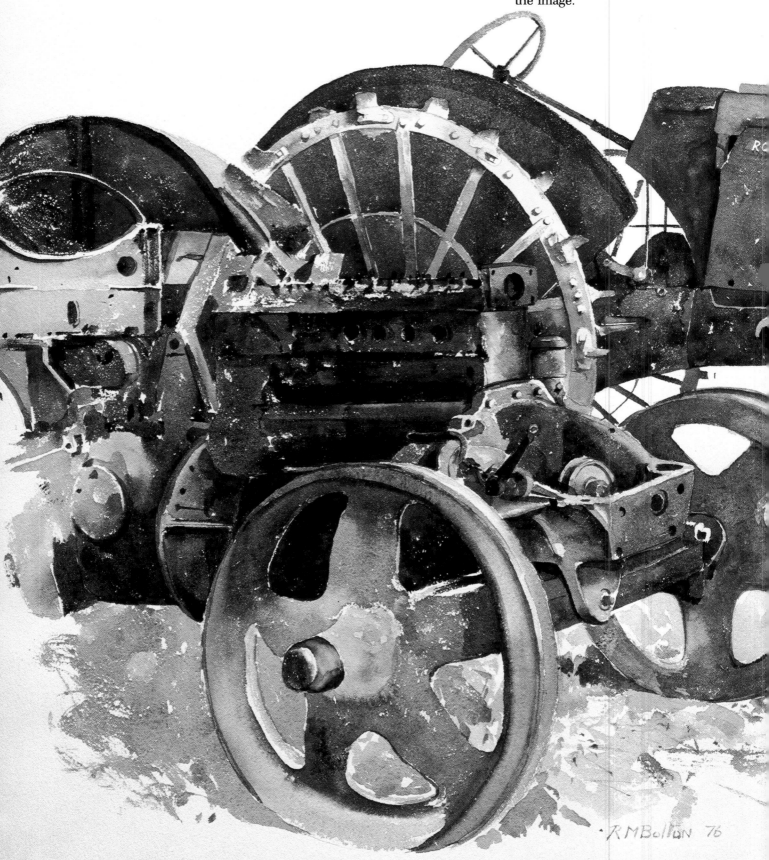

R M Bolton 76

This is the oldest painting of mine in this book; and it is interesting to see the completely different range of colors I was using then. I still use Indian red, although now I lean far more heavily on burnt sienna. My preference for burnt sienna came about because it is brighter, more orange than Indian red, and as I have said elsewhere, it is easier to tone down a bright color than a dull one.

Cobalt blue is still a favorite of mine, although I stopped using it because it became very expensive and scarce at one point. Now I lean most heavily on ultramarine blue and find it gives a richer color than cobalt blue.

I don't have lemon yellow in my palette at all these days; instead, I use cadmium orange, although on reflection I might reintroduce lemon yellow, as I like the soft tones it produced on the tractor engine.

Masking fluid was not used in this painting; instead, I painted carefully around all the details, such as the rear wheels and the various components in the engine.

To begin, I started painting some of the large rust areas between the spokes of the rear wheel and the panel with "Row Crop" written on it. Indian red and cobalt blue were mixed and painted onto the paper with a lot of water. As I worked around the rust sections, I kept to the wet into wet technique, brushing some clear water onto the paper, then adding color: a little lemon yellow along the top of the bonnet, and then down around the radiator with cobalt blue and little touches of Indian red. Prussian blue and Indian red gave the engine section a darker color with the nuts and bolts outlined.

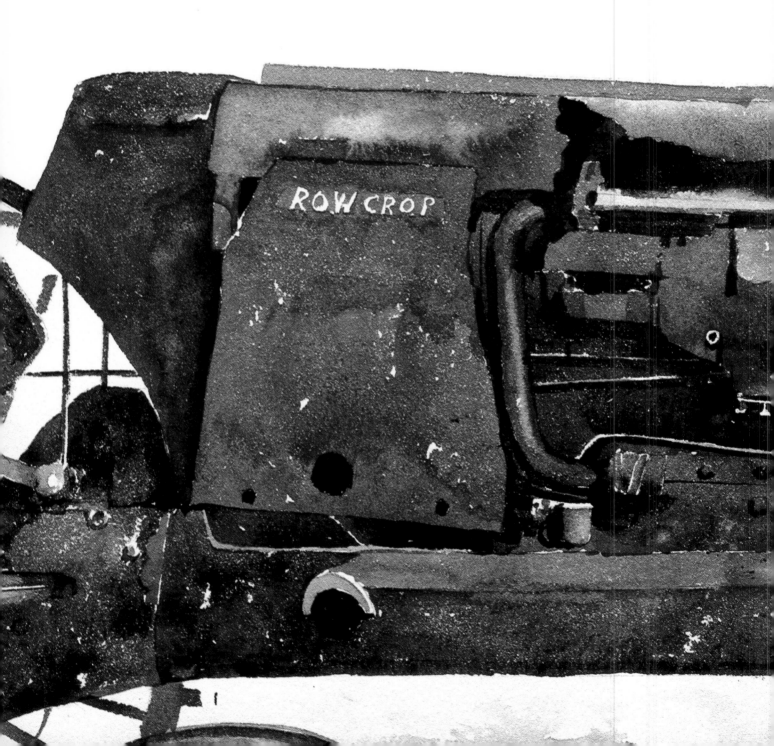

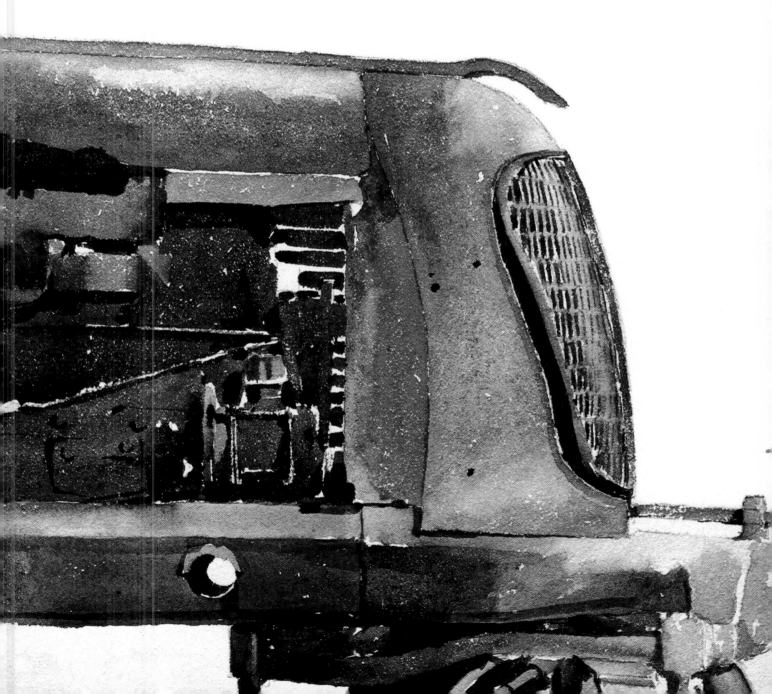

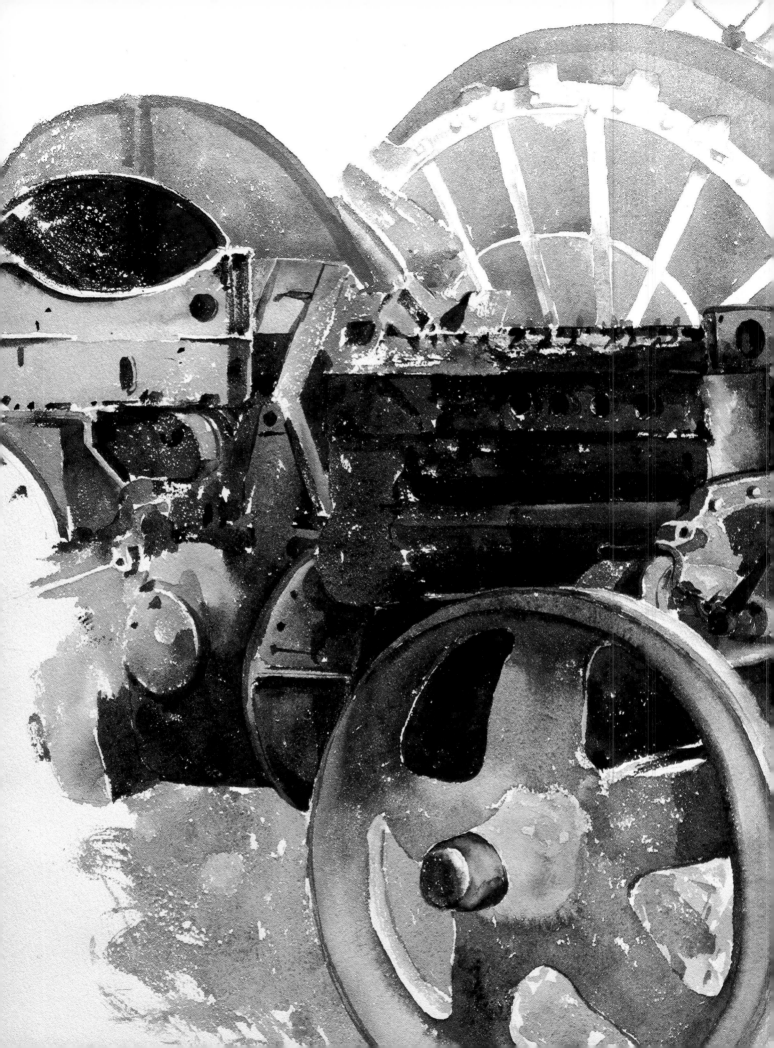

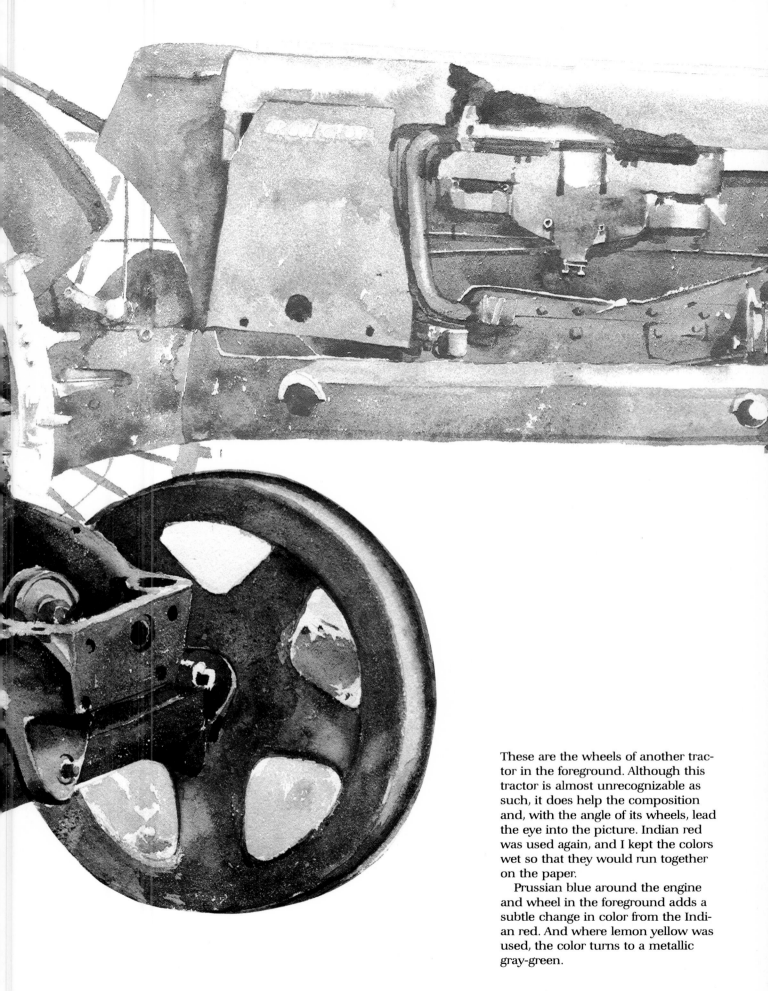

These are the wheels of another tractor in the foreground. Although this tractor is almost unrecognizable as such, it does help the composition and, with the angle of its wheels, lead the eye into the picture. Indian red was used again, and I kept the colors wet so that they would run together on the paper.

Prussian blue around the engine and wheel in the foreground adds a subtle change in color from the Indian red. And where lemon yellow was used, the color turns to a metallic gray-green.

WHEELBARROW
Soft Colors and Sharp-Edged Forms

In my last book, I incorporated two drawings of my old wheelbarrow; this time I have painted it. Its rustic quaintness makes it a natural target for my paintbrush. To give the picture as much impact as possible, I have omitted the background; this heightens interest in the outline of the wheelbarrow shape.

I started off with masking fluid, painting out the fork, spade, and some flower stalks in the wheelbarrow. It is important to mask out the fork and spade because it would be difficult to keep their outlines clear and sharp against all the background brushwork.

Selecting size 2 and size 4 sable brushes, I began painting the wheel. This is a good place to start, because I find that if I can get a small part of the painting to progress well, it sets a standard for the rest of the painting that follows.

Much of the time when I am painting I hold two brushes in my hand—one for applying paint, the other charged with clear water and used for softening hard edges. The size 2 sable was charged with a mixture of burnt sienna and ultramarine blue; I then filled in the area of the tire. With the size 4 sable, I washed away a highlight on the side of the tire. The wheel hub interests me here because of the pattern of rust breaking through the paint and dirt. Naples yellow toned down with ultramarine blue provided the main coloring. The rust color was then dabbed on finely with the size 2 sable. Mixing burnt sienna and a little ultramarine blue, I kept the paint as dry on the brush as possible so that it was carried to the paper in a broken, haphazard style.

The wooden structure of the wheelbarrow is comprised of five colors: sap green, ultramarine blue, burnt sienna, Naples yellow, and rose madder. Soft colors were made first by dropping paint into wet paper; in this case, I have used sap green, Naples yellow, and ultramarine blue. When the paint is dry, the feel of wood was created by dragging the brush along the direction of wood grain, keeping the paint as dry as possible on the brush. Finer grain effects were picked out with a fine brush, like all those little woodworm holes and the fine cracks between grains; other grain effects were scratched out with the corner of a razor blade while the paint was still damp on the paper.

Underneath the wheelbarrow, I painted the area out in clear water and dropped in a strong dark mix of ultramarine blue and burnt sienna. The effect of the water was to soften the colors, which contrast well with

the angular, sharp-edged form of the wheelbarrow.

With work completed on the wheelbarrow and underneath it, I turned my attention to the fork and spade. First, I removed the masking fluid, leaving clean, white paper behind. The metal part of the spade was painted in cadmium yellow, burnt sienna, and Naples yellow. The colors were all allowed to flow into one another, creating an attractive blend while still damp. Pinpricks of blue were touched onto the spade head and allowed to spread out. The wooden handle was treated in the same way as the rest of the wooden sections, although without sap green; and the gentle effects of grain were painted in with burnt sienna and ultramarine blue.

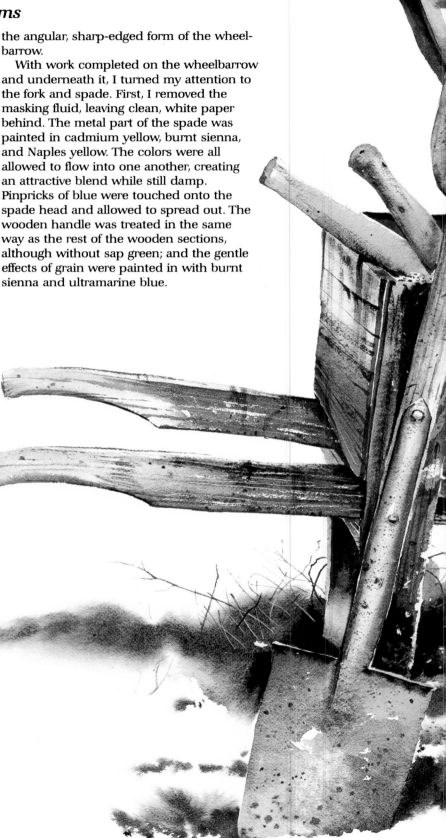

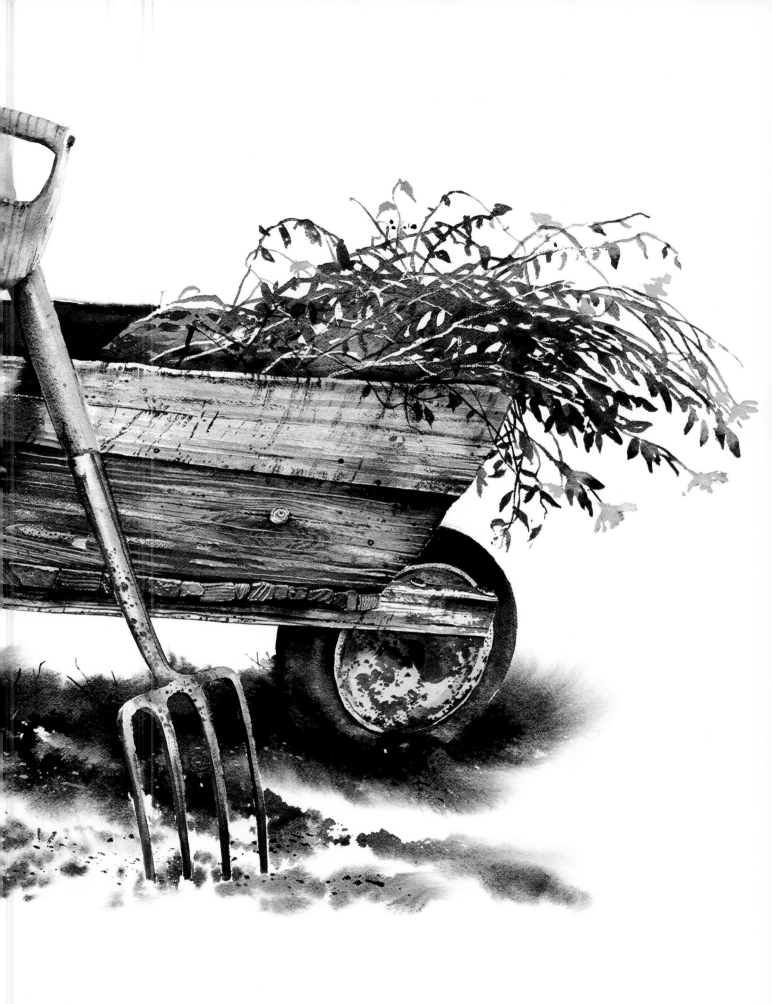

TIN BATHS

Rusty Relics
Silhouetted Weeds

I find a lot of my material for painting around old sheds, along hedgerows, and in quiet places where things have stood still—where the hand of man has been at work and then suddenly left, leaving rusty derelict symbols of past labors. I find something very precious in these vanishing relics; like an archaeological dig, these objects should be recorded and not moved.

I can remember being scrubbed down in a tin bath when I was small. The bath was set in the middle of the kitchen, and hot water was poured in from the kettle. Of course, tin baths are now a thing of the past; these two have been left to rust away on the side of a shed.

There are marked similarities between this painting and the *Water Pump* (see pages 46–49). This painting followed directly after the painting of the pump, and the lessons learned there were carried over into this one—in particular, the treatment of the silhouetted weeds.

In the first stage, I used masking fluid, masking out the two tin baths and the weeds growing up beneath them. Areas of wood were first rubbed with a small wax candle along the directions of grain, and wax was also rubbed along the lengths of corrugated tin on the shed's roof.

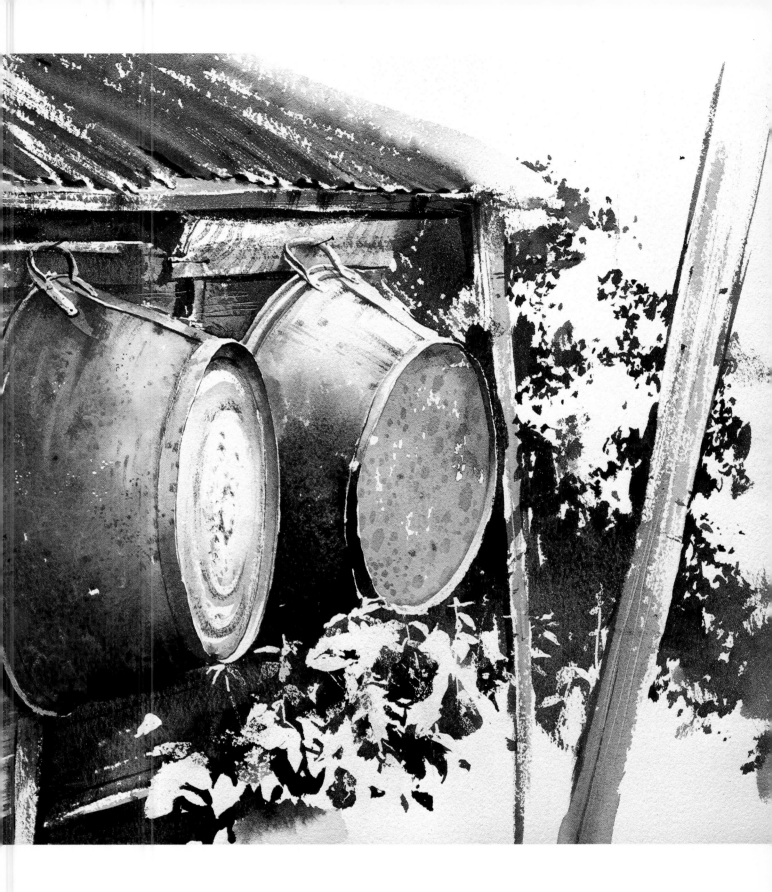

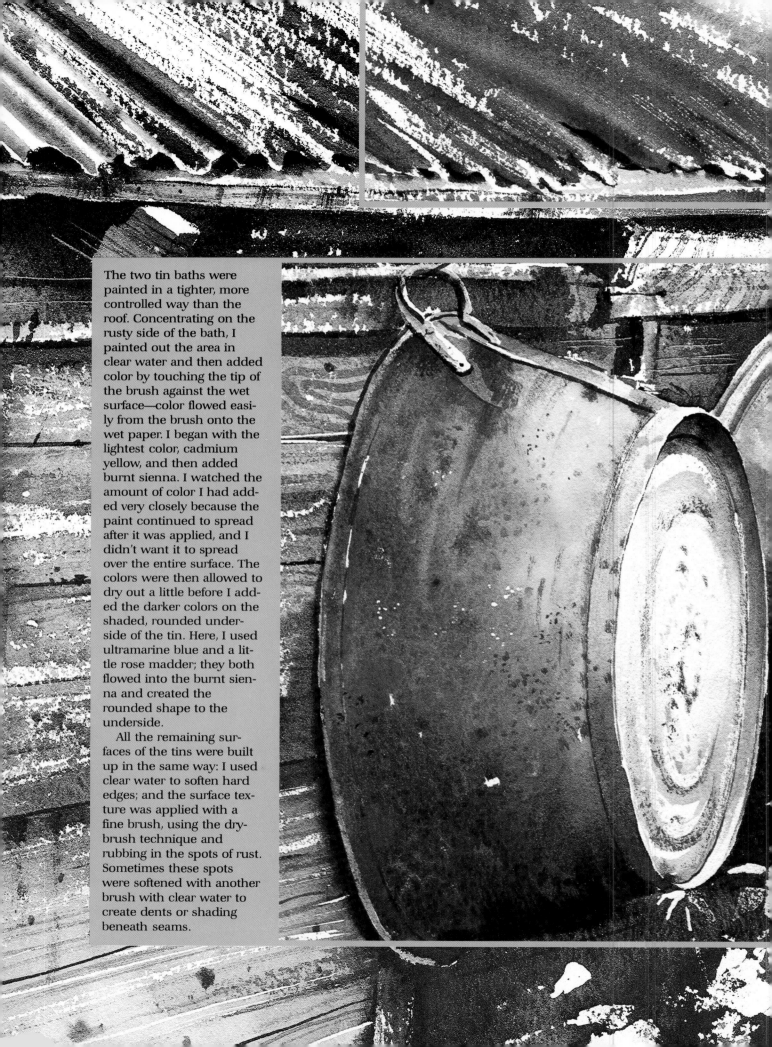

The two tin baths were painted in a tighter, more controlled way than the roof. Concentrating on the rusty side of the bath, I painted out the area in clear water and then added color by touching the tip of the brush against the wet surface—color flowed easily from the brush onto the wet paper. I began with the lightest color, cadmium yellow, and then added burnt sienna. I watched the amount of color I had added very closely because the paint continued to spread after it was applied, and I didn't want it to spread over the entire surface. The colors were then allowed to dry out a little before I added the darker colors on the shaded, rounded underside of the tin. Here, I used ultramarine blue and a little rose madder; they both flowed into the burnt sienna and created the rounded shape to the underside.

All the remaining surfaces of the tins were built up in the same way: I used clear water to soften hard edges; and the surface texture was applied with a fine brush, using the dry-brush technique and rubbing in the spots of rust. Sometimes these spots were softened with another brush with clear water to create dents or shading beneath seams.

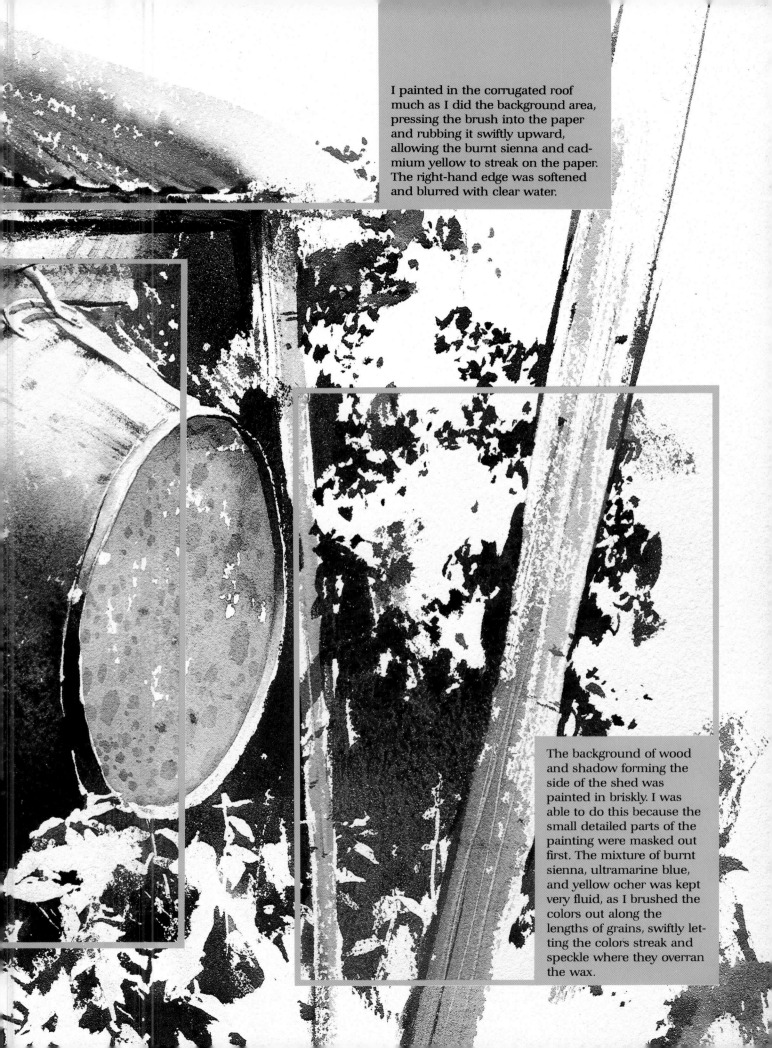

I painted in the corrugated roof much as I did the background area, pressing the brush into the paper and rubbing it swiftly upward, allowing the burnt sienna and cadmium yellow to streak on the paper. The right-hand edge was softened and blurred with clear water.

The background of wood and shadow forming the side of the shed was painted in briskly. I was able to do this because the small detailed parts of the painting were masked out first. The mixture of burnt sienna, ultramarine blue, and yellow ocher was kept very fluid, as I brushed the colors out along the lengths of grains, swiftly letting the colors streak and speckle where they overran the wax.

CARPENTRY TOOLS

Balancing Lights and Darks

Windows can be an ideal situation for a still life. I find the way that sunlight filters through dusty windows produces exciting effects. The window itself serves as an ideal frame for a still life, and the old tools make fascinating shapes silhouetted against hazy light.

The balance of light and dark is all important in this painting. The old saws and tools in the window were painted in with very dark colors, but not so dark that they end up as simple silhouettes. The effects of light need to be observed closely. Light and color tend to reflect from one surface to another, so that surfaces, like the face of the saw blade, though rusted and pitted, still acts like a mirror, reflecting light back from the interior of the room and, at the same time, casting its own shadows and colors. A thin rim of light outlines the tools, helping to show them clearly against the background.

Only a little masking fluid was used in this painting. With a fine brush, I masked out the thin white lines surrounding the tool and also touched in the highlights such as those on the wooden handles.

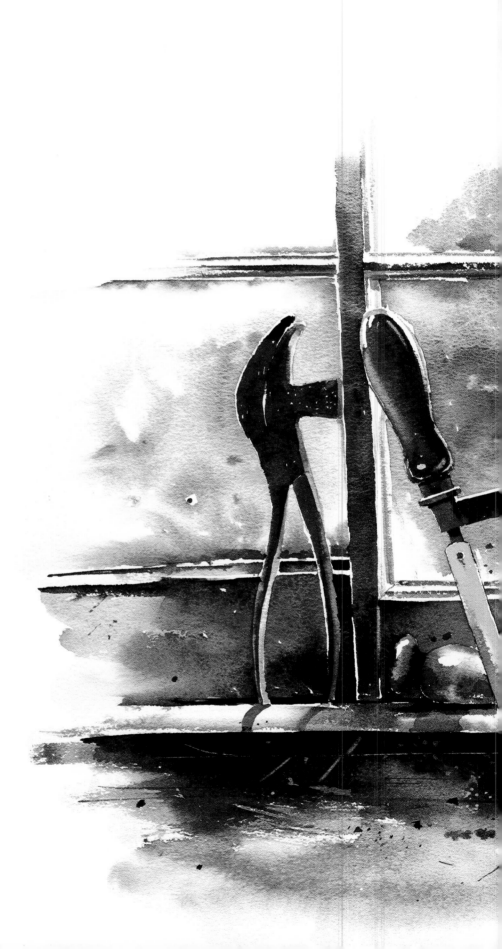

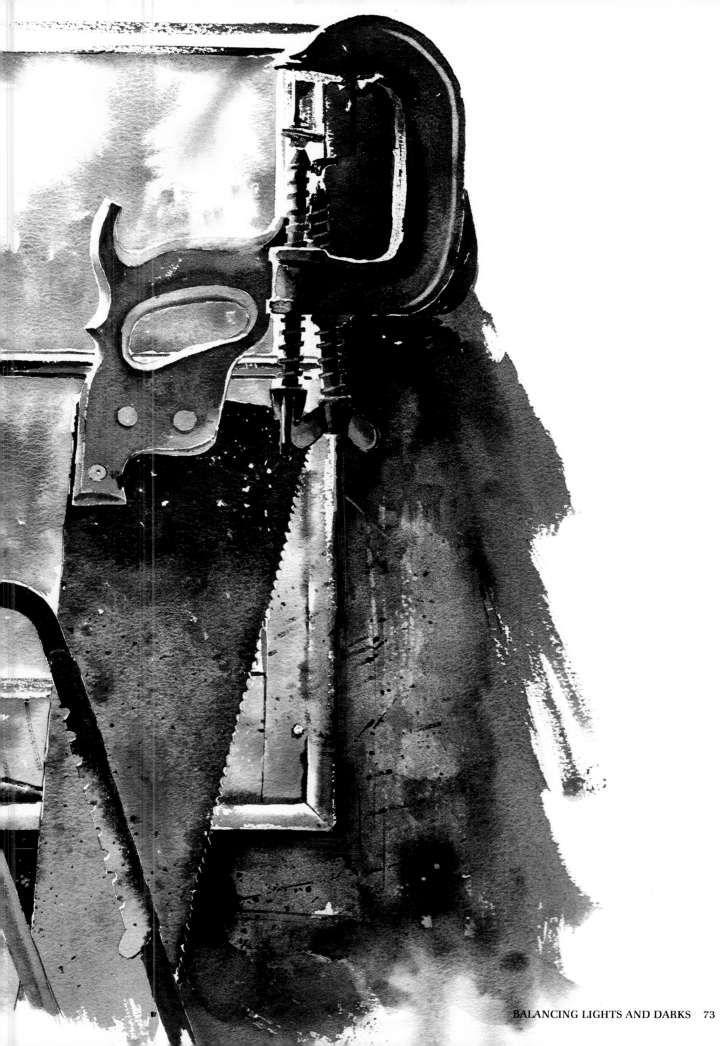

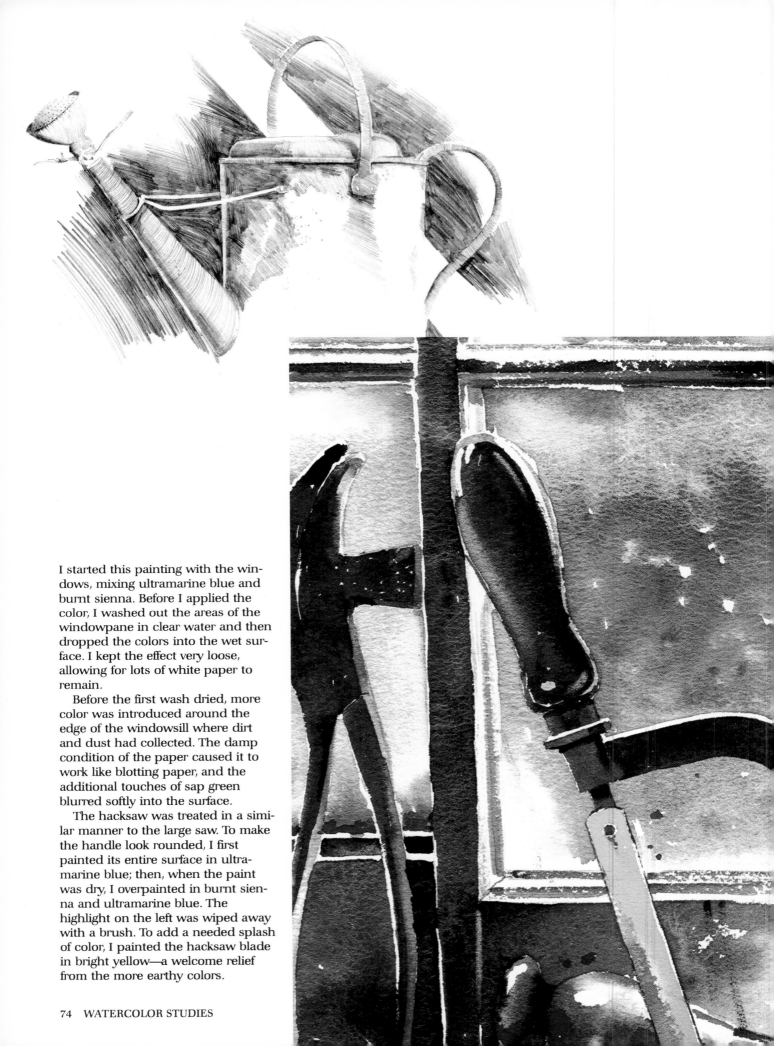

I started this painting with the windows, mixing ultramarine blue and burnt sienna. Before I applied the color, I washed out the areas of the windowpane in clear water and then dropped the colors into the wet surface. I kept the effect very loose, allowing for lots of white paper to remain.

Before the first wash dried, more color was introduced around the edge of the windowsill where dirt and dust had collected. The damp condition of the paper caused it to work like blotting paper, and the additional touches of sap green blurred softly into the surface.

The hacksaw was treated in a similar manner to the large saw. To make the handle look rounded, I first painted its entire surface in ultramarine blue; then, when the paint was dry, I overpainted in burnt sienna and ultramarine blue. The highlight on the left was wiped away with a brush. To add a needed splash of color, I painted the hacksaw blade in bright yellow—a welcome relief from the more earthy colors.

This saw is the most important feature in the composition because of the sculptural quality of the handle and the large shape of the blade. The saw handle was painted with cadmium orange, yellow ocher, burnt sienna, cerulean blue, and ultramarine blue, in an attempt to capture the subtle shades and shadows therein. The blade was made up of a dark mixture of ultramarine blue and burnt sienna. I carefully left a lot of white specks behind to add more texture and variety to the painting. The bottom half of the blade was painted lighter, where I mixed cadmium orange in with the burnt sienna and ultramarine blue, to give it a slightly pink quality.

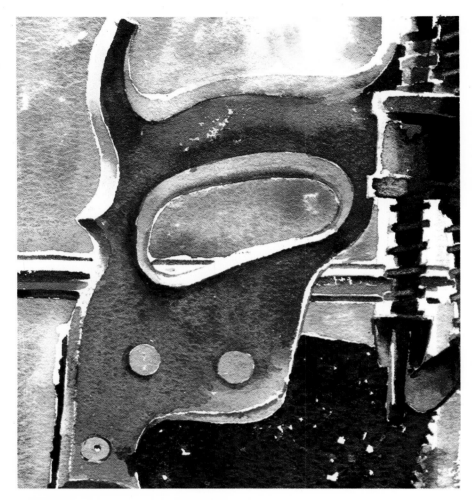

The background color of the windowsill and wall is predominantly cerulean blue, but other colors have drifted in, which reflect the colors and hues coming from the interior of the studio as well as the other tools. Some of the color was lifted away from the wall with a sponge; by doing this, I created some texture and shape to the wall. The whole outline area of the painting was left very ragged rather than painting up to the borders of the paper; this helped the composition, giving it a more vibrant and uncontrolled look.

As a final step, I worked in some texture on the wall and windowsill. To create highlights, I wiped away at an area with the tip of a brush and dabbed a paper towel against the spot to lift out even more color. The dark dots and dashes in the wood were made by laying the side of the brush against the paper or dabbing the tip gently against the paper to leave a spot.

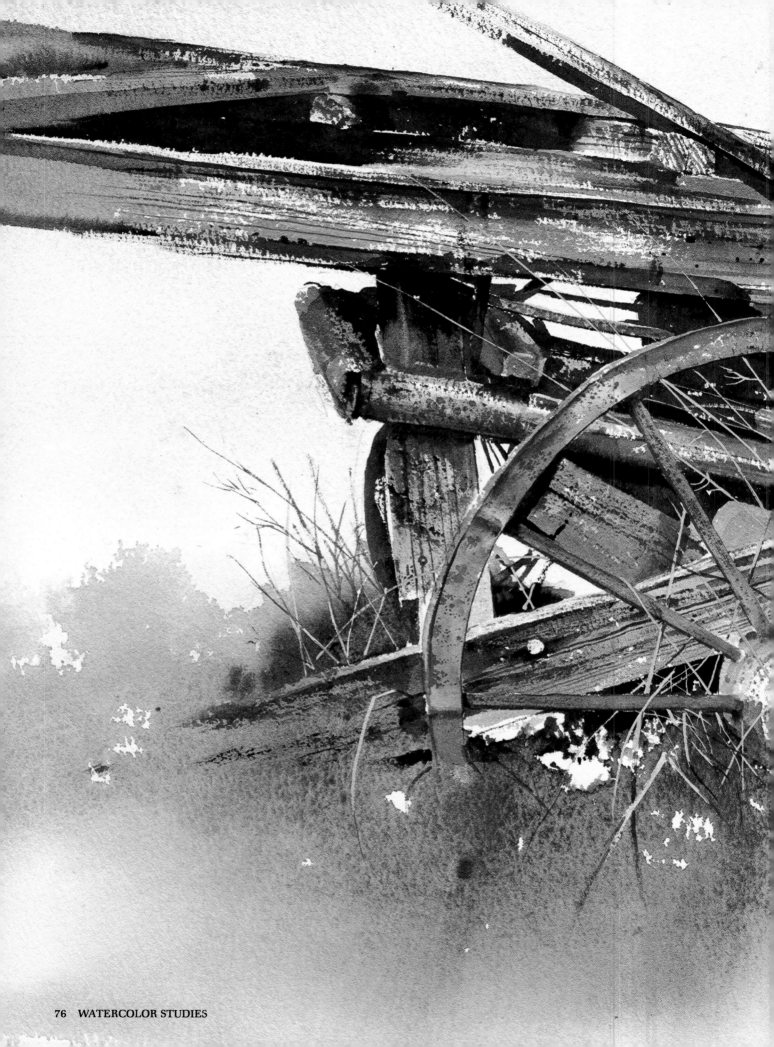

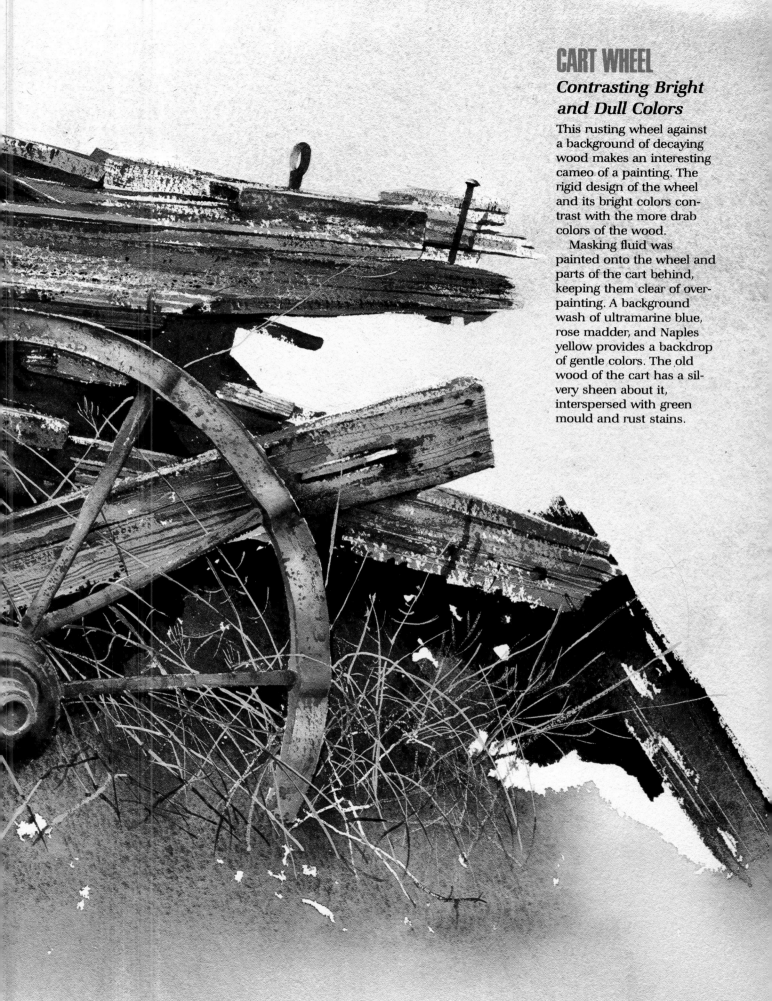

CART WHEEL

Contrasting Bright and Dull Colors

This rusting wheel against a background of decaying wood makes an interesting cameo of a painting. The rigid design of the wheel and its bright colors contrast with the more drab colors of the wood.

Masking fluid was painted onto the wheel and parts of the cart behind, keeping them clear of overpainting. A background wash of ultramarine blue, rose madder, and Naples yellow provides a backdrop of gentle colors. The old wood of the cart has a silvery sheen about it, interspersed with green mould and rust stains.

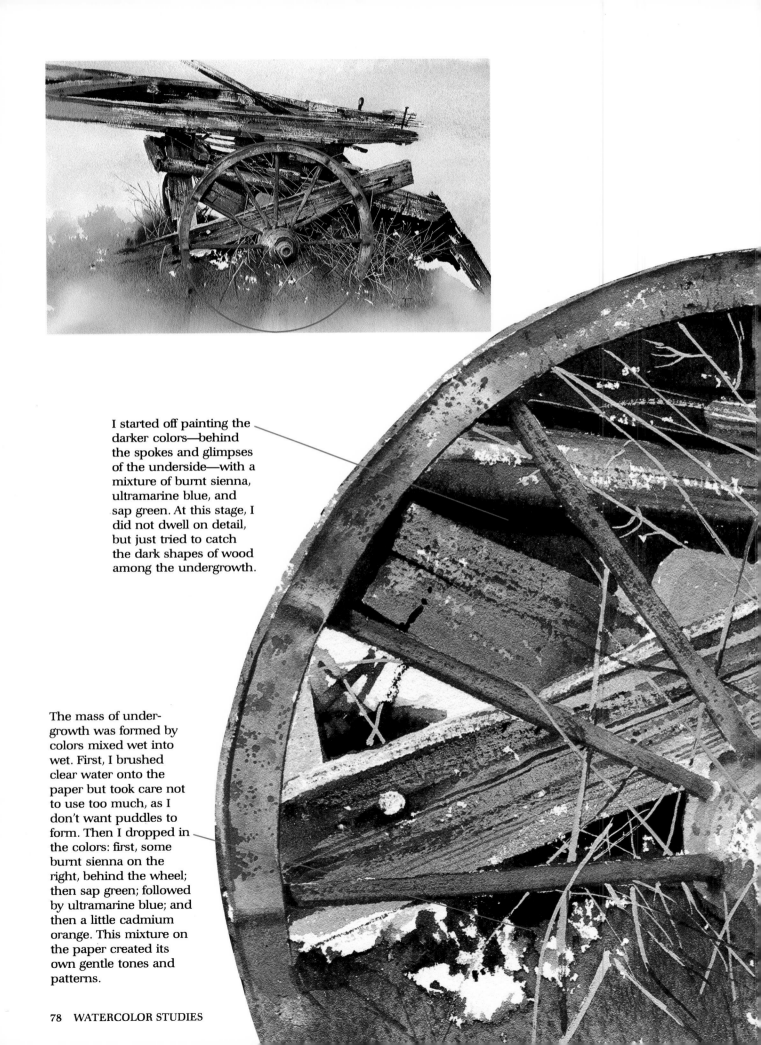

I started off painting the darker colors—behind the spokes and glimpses of the underside—with a mixture of burnt sienna, ultramarine blue, and sap green. At this stage, I did not dwell on detail, but just tried to catch the dark shapes of wood among the undergrowth.

The mass of undergrowth was formed by colors mixed wet into wet. First, I brushed clear water onto the paper but took care not to use too much, as I don't want puddles to form. Then I dropped in the colors: first, some burnt sienna on the right, behind the wheel; then sap green; followed by ultramarine blue; and then a little cadmium orange. This mixture on the paper created its own gentle tones and patterns.

The long beams of wood behind the wheel were first brushed in with ultramarine blue and rose madder, where I ran the brush swiftly along the grain, causing the paint to speckle. Other pieces of wood were then treated in the same way. When the paint was dry, the same technique was repeated—this time with sap green and a little burnt sienna. While this layer was drying, I dragged the corner of a razor blade down the length of grain and scratched out some grain highlights.

The wheel was also painted with wet into wet technique. Working my way round the rim, I added touches of paint into the wet surface to achieve the mottled effect of rust. Here, I have used cadmium yellow, Naples yellow, burnt sienna, and sap green. Once the colors had dried, I added texture using the drybrush technique. The spokes were made slightly more subdued with the addition of rose madder and ultramarine blue, turning them mauve in places.

To add a final delicate touch, I drew in some fine lines of grass with a mixture of Naples yellow and permanent white applied with a fine, long-haired, size 0 sable brush.

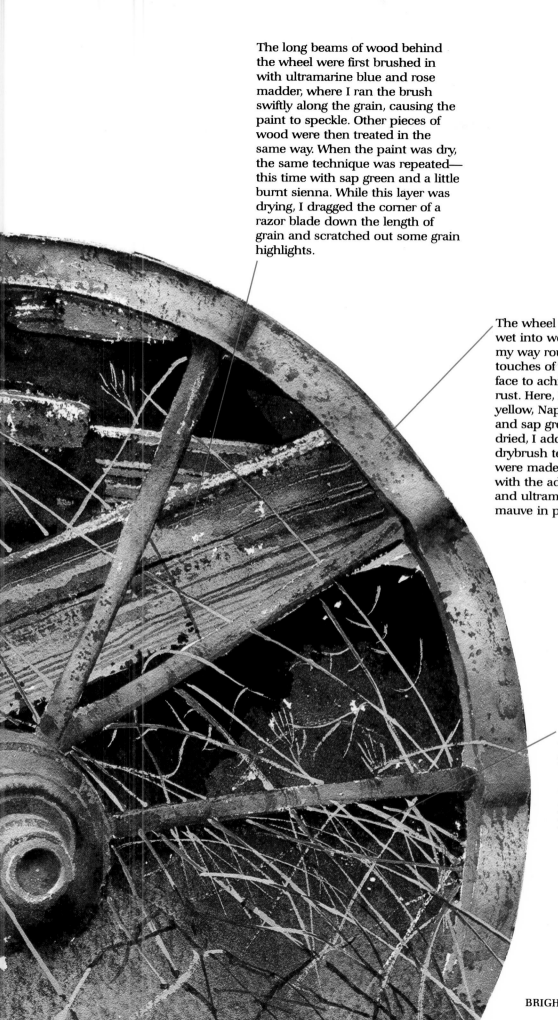

PART TWO
Finished Paintings

STUBBLE FIELD
Creating Strong Atmosphere

This landscape has similarities to *Mud Tracks* (see pages 98–101) and was painted around the same time with similar sky and earth colorings. It is a little unusual for me not to have anything in the foreground; I usually like to focus my attention on something close in. But here, the stubble field was what caught my attention along with the great trees interspersed among the farm buildings and hedgerows, casting long shadows across the field and creating a strong atmosphere.

In many respects, painting is all about using and manipulating light to create the right effects. Finding the right view is only part of the battle—the time of day; the weather; creating atmosphere, shadows, and light are equally important. In this painting, I have carefully focused my attention on a band that crosses through the center of the painting. I did this by using a bank of dark clouds halfway down the sky and by drawing a veil of shadows across the foreground, leaving a light-filled area in the middle ground.

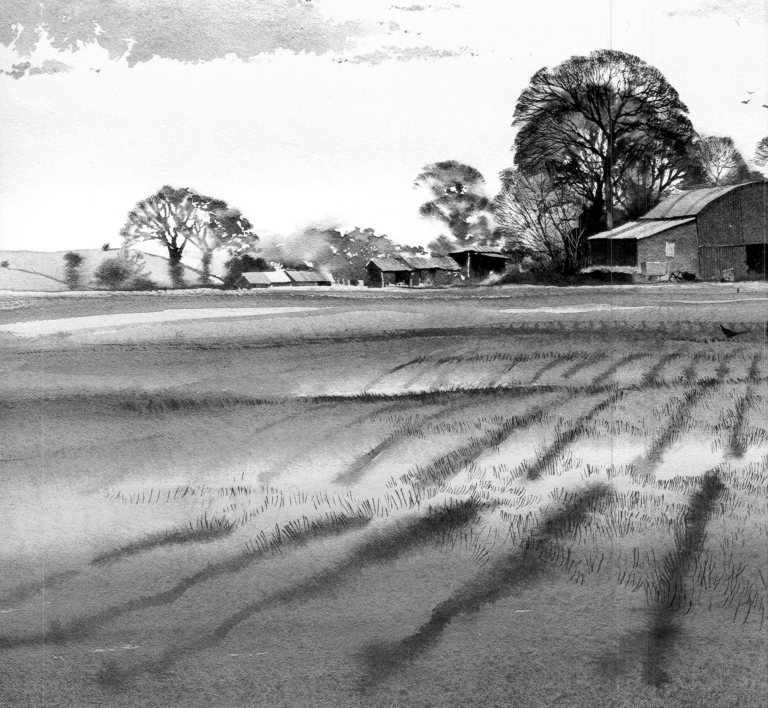

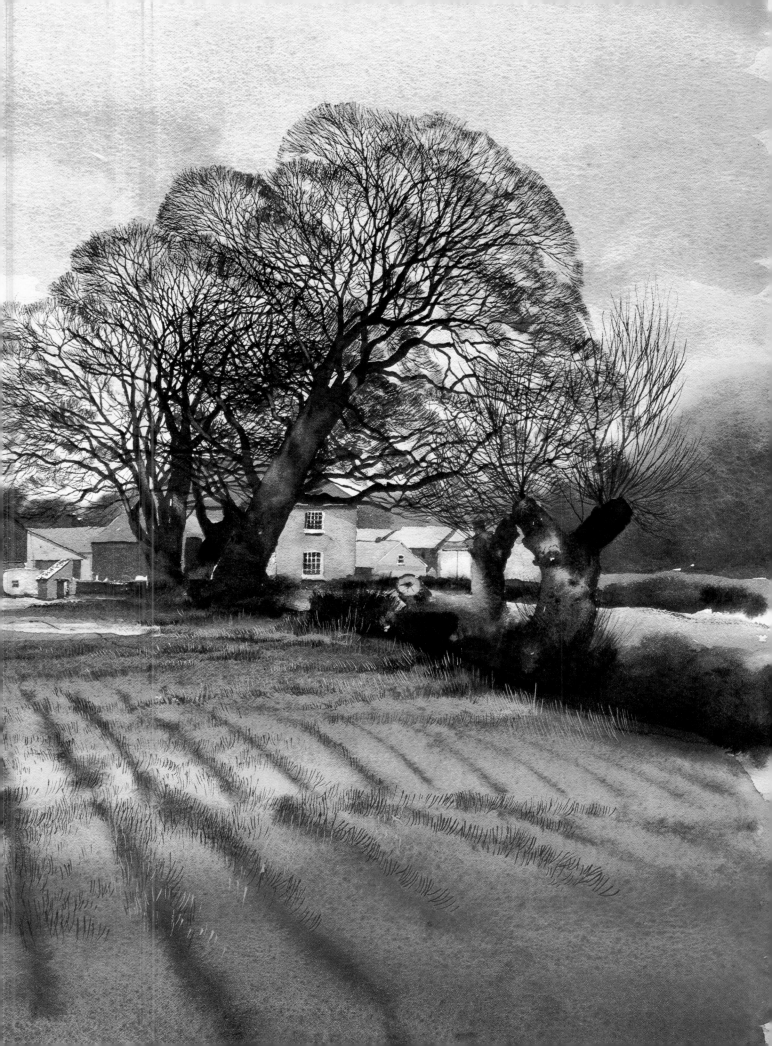

The light background of the sky consists of a wash of Naples yellow combined with a touch of cadmium yellow. While this paint was still wet, a brush of ultramarine blue and rose madder was drawn across the horizon, and the board was tipped up to enable it to run upward into the rest of the wash. When the wash was dry, a mix of ultramarine blue and a little rose madder was used to form the clouds, where I dabbed my Japanese bamboo brush around the edges to produce the irregular cloud edges.

The field in the foreground took quite a long time to capture on paper. At first, a wash of Naples yellow was laid in and then streaks of ultramarine blue and cadmium orange were drawn across to softly blend into the Naples yellow. When these colors were dry, another was applied, which deepened the colors and made them darker in the foreground; at the same time, I was careful not to blanket the color over the highlights. Ridges of stubble were drawn on the paper with burnt sienna, cadmium orange, and ultramarine blue, and blended softly at the edges into the wet colors beneath. The stubble was further defined with a fine brush, when I drew in the individual stalks of stubble. Many of these were drawn in the same dark color-mix as the ridges were, and others were painted in gray and Naples yellow.

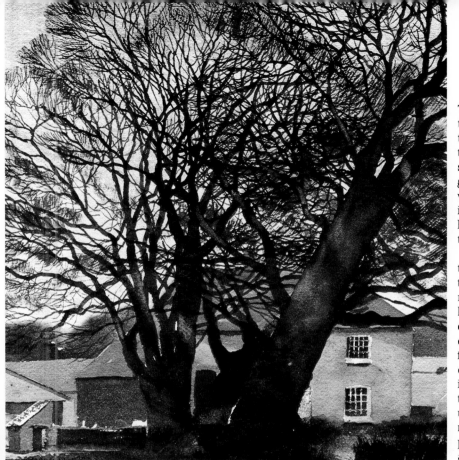

Trees take on more definition as they get closer; those farthest away eventually become blurred shapes. In the middle ground, much attention was paid to detail: the myriad twigs and the subtle lighting that falls on the trunks between branches.

The most common way to paint the outer limits of trees is to treat them in much the same way as I have the edges of the clouds, using a brush to create a broken edge. I prefer to work in as much detail as possible, painting in nearly all the twigs and then continuing to build up the edges in drybrush, rubbing the paint onto the paper to develop contours and shapes.

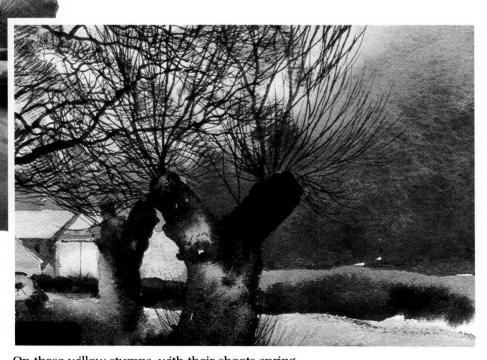

On these willow stumps, with their shoots springing up from their bowls, I used Naples yellow and ran into it burnt sienna and ultramarine blue to get the mottled color effects of light on the trunk. The background of trees to the right was suggested very simply with blocks of color blurred at the edges to form hazy shapes.

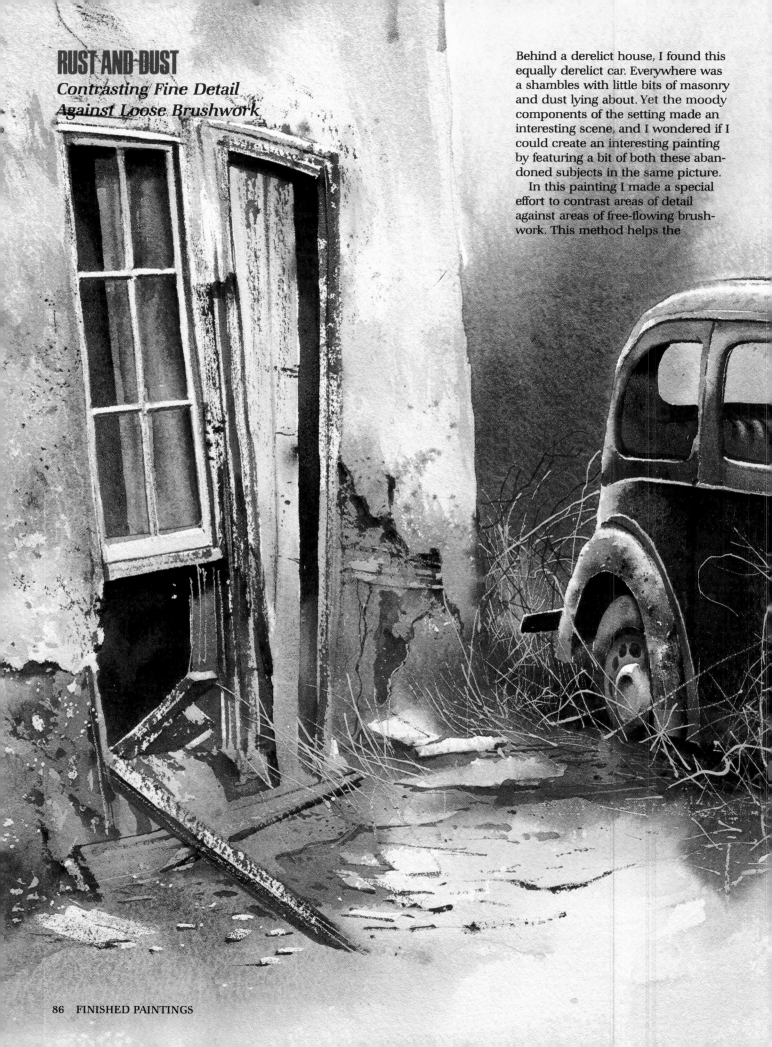

RUST AND DUST
Contrasting Fine Detail Against Loose Brushwork

Behind a derelict house, I found this equally derelict car. Everywhere was a shambles with little bits of masonry and dust lying about. Yet the moody components of the setting made an interesting scene, and I wondered if I could create an interesting painting by featuring a bit of both these abandoned subjects in the same picture.

In this painting I made a special effort to contrast areas of detail against areas of free-flowing brushwork. This method helps the

painting to retain a feeling of freedom and sparkle, and keeps too many elements from fighting for attention. I picked out the features most important to me, in particular the car and shed door, and allowed the rest of the scene to slip away as suggested detail or areas of wash.

The car was masked out in masking fluid. A wash of Naples yellow was brushed over the whole surface of the paper, up to the edge of the building. While the wash was still wet, cerulean blue was added to the background area between the car windows. A mixture of burnt sienna and sap green was brushed on either side of the car and allowed to run into the wet colors of the sky. Colors were controlled by tilting the painting board back to prevent the sap green and burnt sienna from flowing too far into the sky. Some color flowed into the foreground, so I encouraged it to fill in under the car where I need an area of soft color.

When everything was completely dry, I removed the mask. It's best not to be too impatient with masking fluid; always wait for it and the paint to dry completely because the colors are likely to smudge if you don't. The body of the car makes a colorful study. The effects of age and weathering have induced an array of rusts, greens, and blues. The best way to approach this is to deal with one section at a time. I started at the front with the radiator grill.

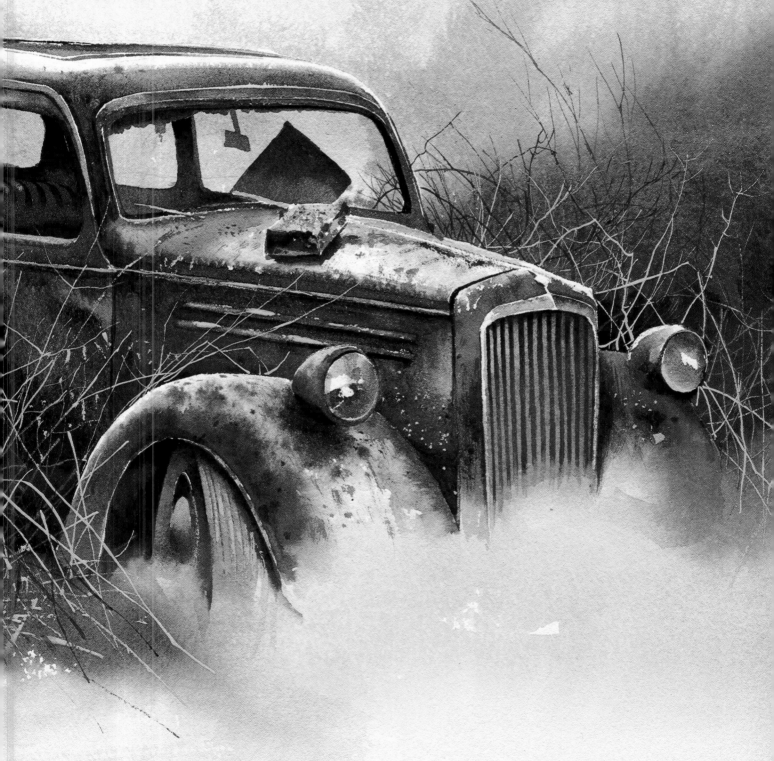

The doorway and wall were lightly brushed over in ultramarine blue and cerulean blue, just to tint the whiteness of the paper and to give shape and character to the wall. The window panes were painted in cerulean blue and burnt sienna, which gives the basic colors seen through the glass. After these colors were laid in, the shapes and shadows were then defined inside the shed. Old timber work in the door frames and the debris in the foreground were brushed in swiftly, with the brush pressed against the paper to make the paint speckle.

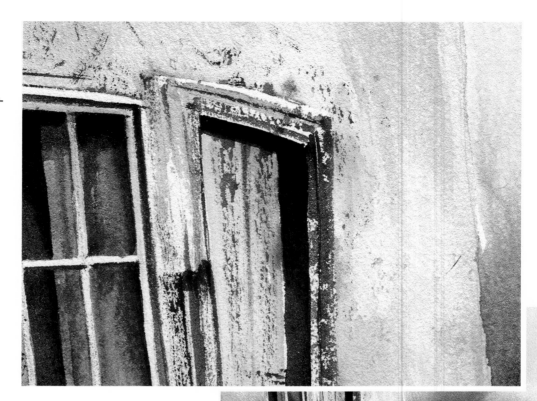

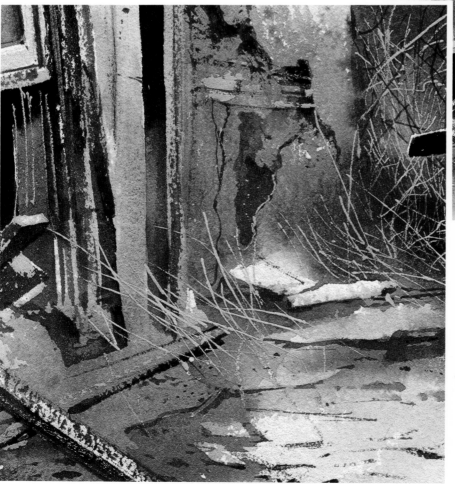

The lower section of the wall that has crumbled away was brushed in with burnt sienna, ultramarine blue, and Naples yellow; and the sharp edges painted in later when the paper had dried. The foreground was left purposely vacant to give a "fading off" effect to the painting, rather like a camera that is letting in light. This effect helps to draw attention to the more detailed sections.

Finally, definition was given to the dry tangle of grass smothering up round the car with long sweeps from my size 0, long-haired sable.

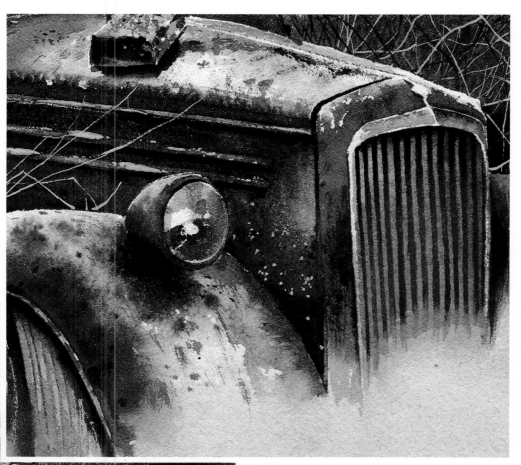

The metal surrounding the grill was painted wet into wet. At the corner it is cadmium orange and sap green with other color added to build up the mottled effect. The fender in the foreground was brushed over with clear water, and then ultramarine blue and cerulean blue were dropped in. With the tip of the brush, I dabbed in spots of burnt sienna onto the damp surface, the spots dispensing softly into the paper. The side of the hood, next to the fender, was painted over in ultramarine blue and rose madder; then sap green, cadmium orange, and burnt sienna were left floating in pools.

When all sections had dried, I worked on top of the colors in drybrush, adding a little rough texture and broken color on top of the smooth, rounded colors.

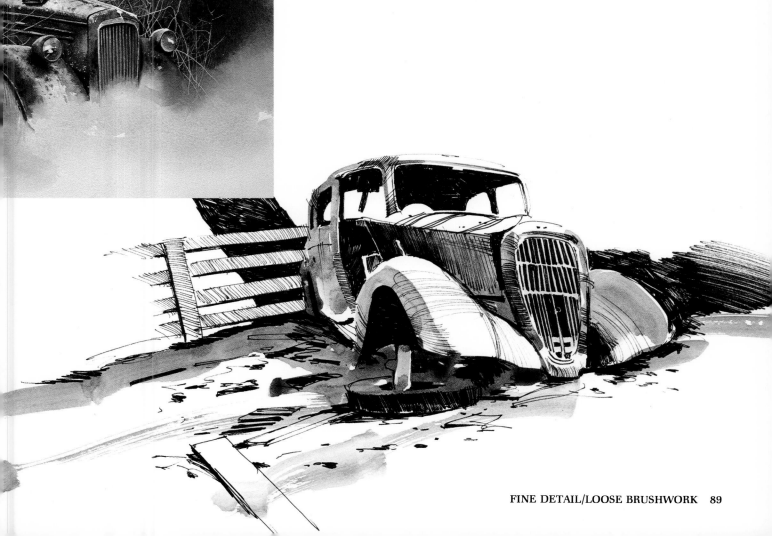

WILLINGHAM WINDMILL
Dramatic Skies

This is a rather romantic painting of Willingham Windmill. The surrounding landscape is really very drab but by manipulating color and design, I have given it a charm.

Because of the height of the windmill, much of the background in this painting is sky, so I purposely made it an interesting feature in the landscape. In the first wash, I mixed Naples yellow with a little cadmium yellow; and on another palette, a weak wash of ultramarine blue with a touch of rose madder. Working from the bottom of the picture, I started to lay down the first mix of Naples yellow and cadmium yellow, but halfway up the paper, I changed to a second mix of ultramarine blue and rose madder. The colors mixed softly at the center of the painting, and consequently there is no sudden jump from one color to the next. It is important here that the colors were mixed before I began to paint, because there is no time to mix colors while working on the wash. The change from one color to another must be made without a pause, otherwise they tend to settle and are likely to leave a line. The sails and top of the windmill were masked out so that the brush can overrun these areas without any danger of losing these small areas of white.

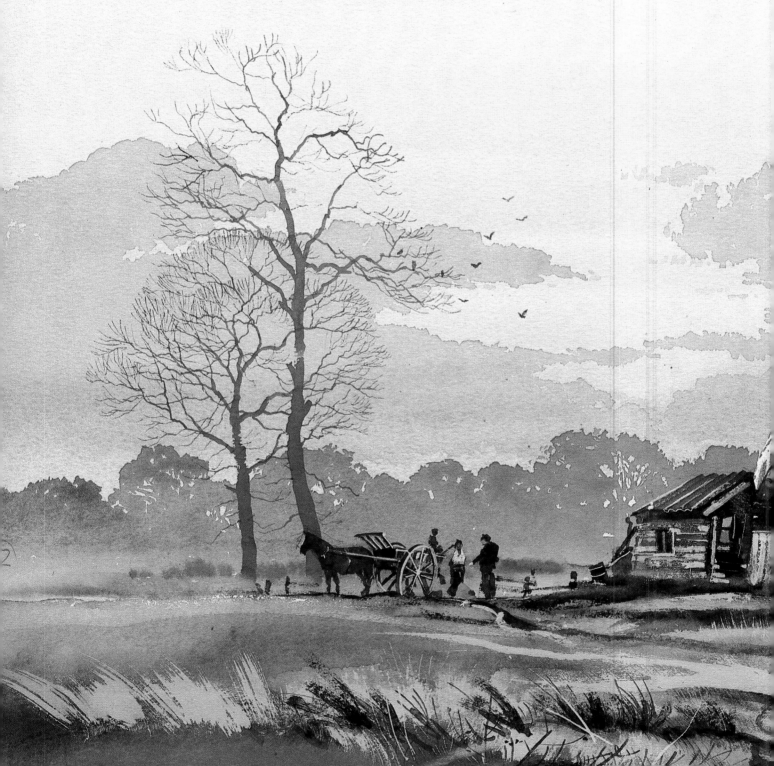

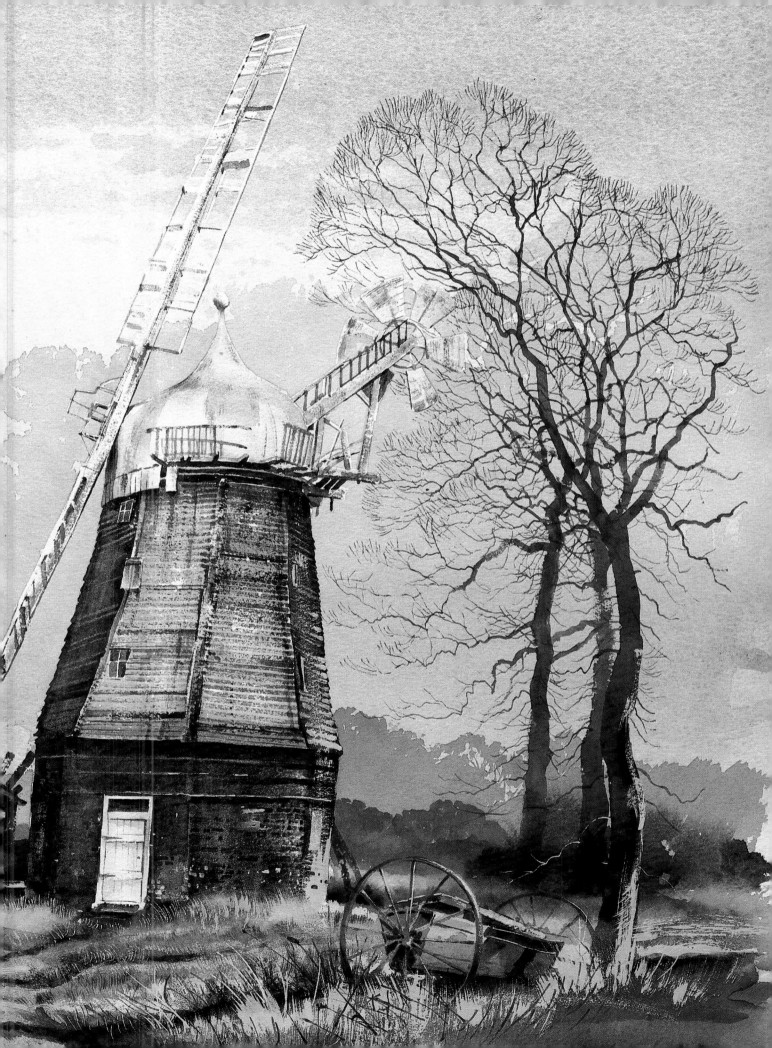

When the wash colors were dry, another wash was laid over the first one. This produced the cloud effect. Windsor and Newton's Gray No. 2 was mixed with ultramarine blue and rose madder. I picked a No. 6 Japanese bamboo brush with a worn tip and applied the color by dabbing the brush up and down to create the ragged edges of the clouds. At the same time, I painted outwards keeping all the edges wet. Above the windmill, a softer cloud effect was achieved by painting the clouds in the same way as before, but then sponging the color away when the paint was dry. I allowed the colors to dry first, because otherwise they would have lifted unevenly and probably left hard-edged outlines to the clouds.

Here, the horizon line is a line of trees. They were treated in much the same way as the clouds above—with the same brush, same colors, but a stronger mixture of color. Underneath the tree area, I wiped a wet brush along the edge of the wet paint to prevent a hard edge from forming. Note that certain areas of this detail—the rim of the wheel, the man's shirt—do not make use of the white of the paper, but instead were overpainted with permanent white.

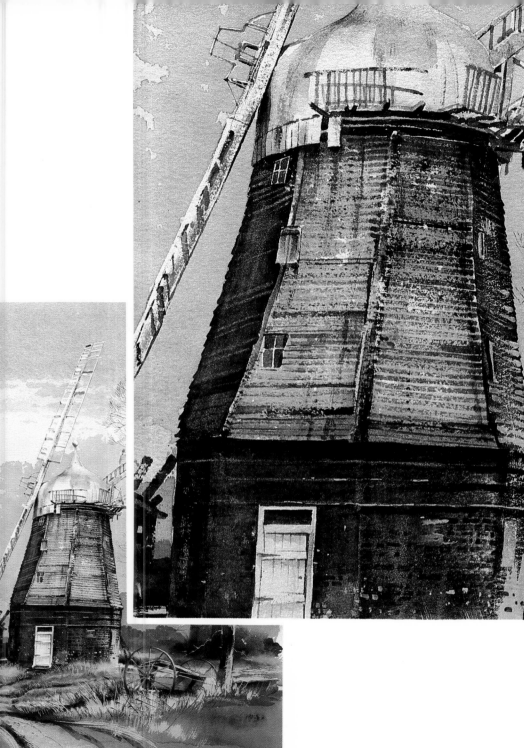

The windmill is constructed from wood and brick. The brick at the base is painted black and the wooden boarding of the top half covered with creosote or black paint. The timber boards form rugged lines across the flat planes of the windmill and are best characterized by using the drybrush technique. Colors were then washed over the top: some ultramarine blue toward the top of the boards and pale hints of other colors below. The darker, lower section was washed in one dark mix of ultramarine blue, allowed to dry, and then small areas were sponged off to give it the slab-sided, bricklike effect.

The foreground was composed of Naples yellow, with a dark mixture of burnt sienna and ultramarine blue brushed in underneath. The two colors were allowed to run together, which gave an effect of light running across the grass. However, when I returned to the foreground area after painting in the rest of the picture, I found it a bit flat and uninteresting, so I turned to some tubes of gouache (opaque body color) to build up some contours there. At this point, I was moving away from the purist's attitude about watercolor technique by building up paint layers of opaque colors. Naples yellow, Windsor and Newton's Gray No. 1 and zinc white were applied with the drybrush technique to create the texture and feeling of grass and brush. The pathway leading to the windmill door was wiped out with a sponge and then dark contour lines drawn in to describe the undulations of the path. My fine, long-haired, size 0 sable brush was used to flick in grass stems; the long hairs enable the brush to hold a lot of paint and still make fine lines.

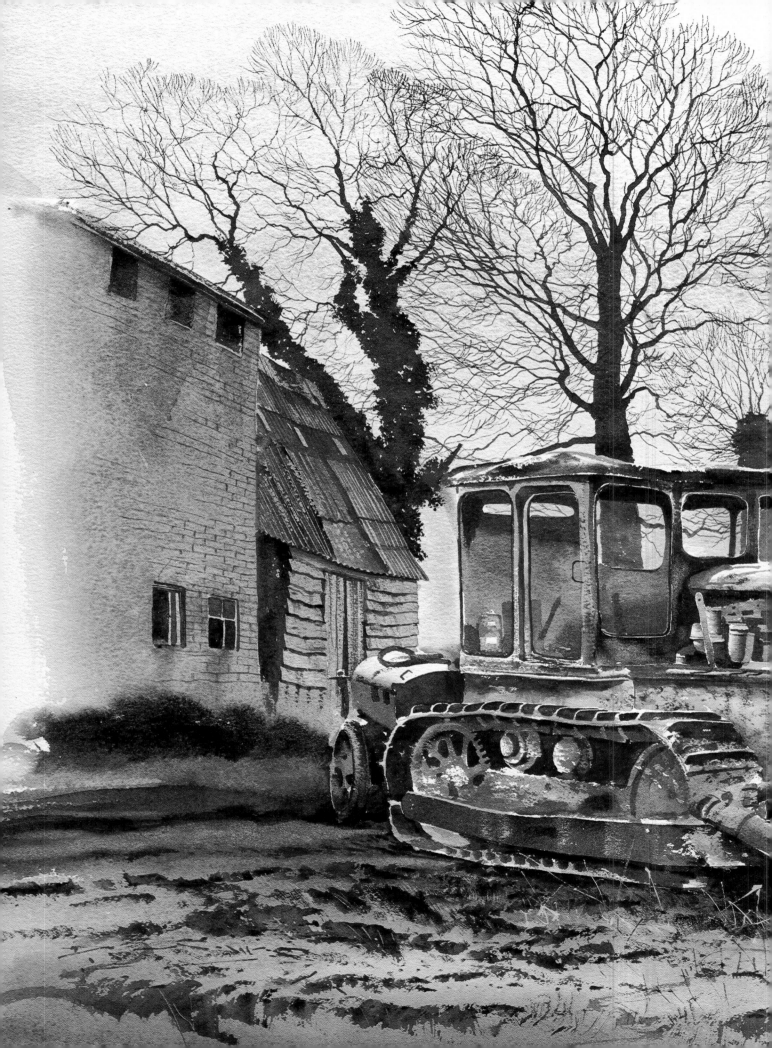

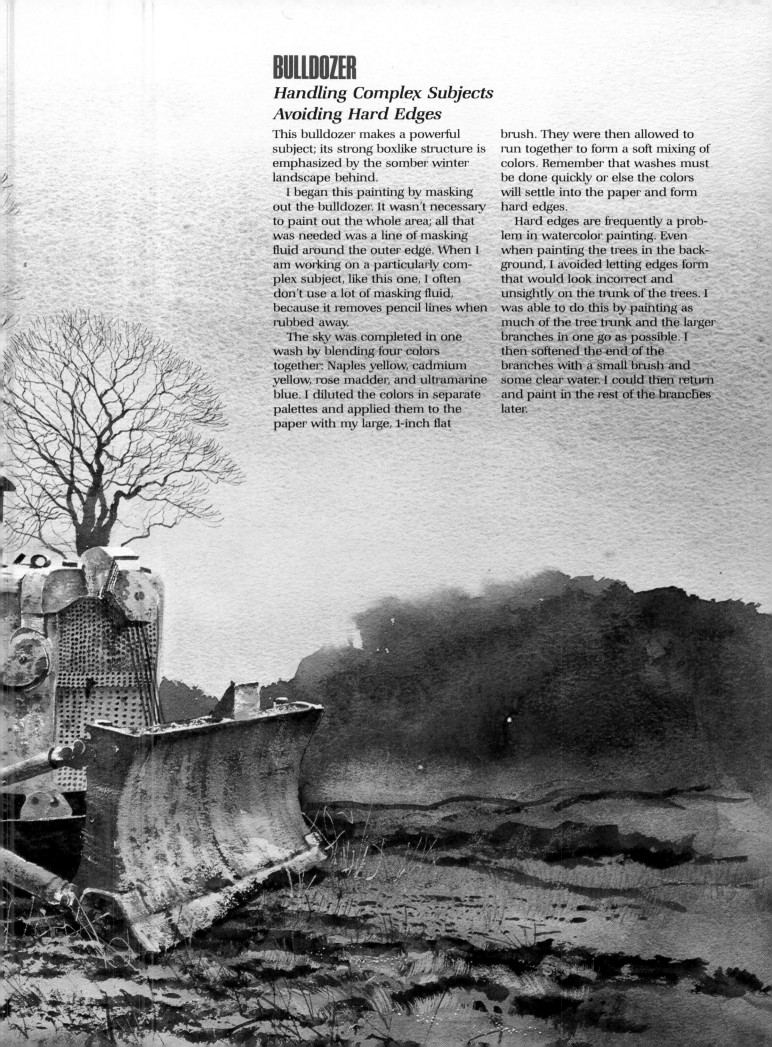

BULLDOZER

Handling Complex Subjects
Avoiding Hard Edges

This bulldozer makes a powerful subject; its strong boxlike structure is emphasized by the somber winter landscape behind.

I began this painting by masking out the bulldozer. It wasn't necessary to paint out the whole area; all that was needed was a line of masking fluid around the outer edge. When I am working on a particularly complex subject, like this one, I often don't use a lot of masking fluid, because it removes pencil lines when rubbed away.

The sky was completed in one wash by blending four colors together: Naples yellow, cadmium yellow, rose madder, and ultramarine blue. I diluted the colors in separate palettes and applied them to the paper with my large, 1-inch flat brush. They were then allowed to run together to form a soft mixing of colors. Remember that washes must be done quickly or else the colors will settle into the paper and form hard edges.

Hard edges are frequently a problem in watercolor painting. Even when painting the trees in the background, I avoided letting edges form that would look incorrect and unsightly on the trunk of the trees. I was able to do this by painting as much of the tree trunk and the larger branches in one go as possible. I then softened the end of the branches with a small brush and some clear water. I could then return and paint in the rest of the branches later.

I began painting the bulldozer by painting in some of the darkest points—the engine and the front of the cab. For these darker areas, I mostly use ultramarine blue and burnt sienna; the burnt sienna gave some warmth to the overall blue tone. I progressively added the colors as I tried to create as much variation as possible to capture the worn, over-worked appearance of the machine. Because I had already painted out some of the darkest areas, I used those areas as a yardstick to judge other tonal values by. I find that if I am not extra careful, I let the colors get too dark, so this is a simple way of keeping in check.

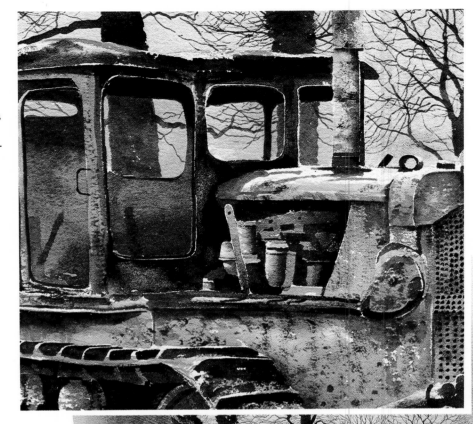

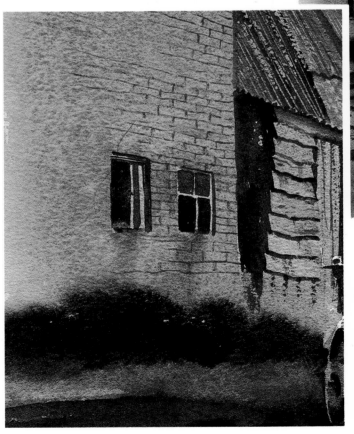

The weeds in front of the brick building as well as the background trees were painted in burnt sienna and sap green, giving a rich warm feel to the painting. The farm buildings on the left are in shade so I have painted them out completely in ultramarine blue. When this wash was dry, I was able to paint on top of the color the details of wooden planks, brickwork, and the tin roof. Here, the blue shows through where otherwise there would be white paper.

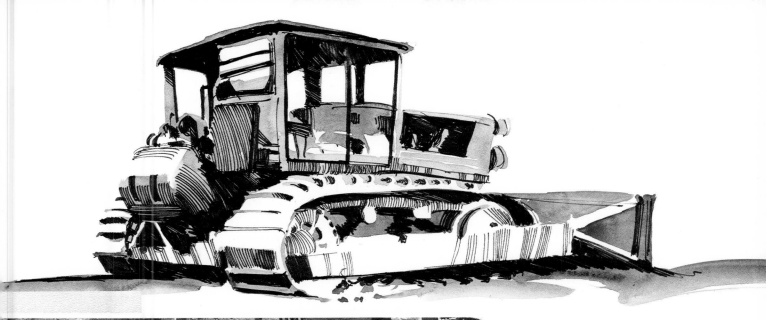

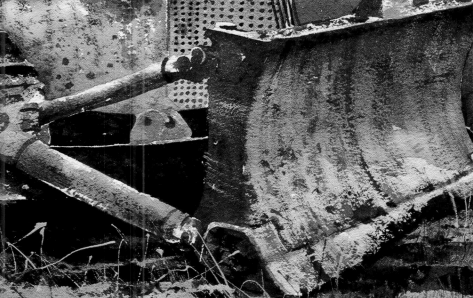

The yellow paintwork of the machine was created mostly from cadmium yellow and some occasional touches of cadmium orange. This color was then worked over using the drybrush technique, rubbing in the effects of dirt and rust. The same technique was used with the earth scraper or plow at the front. Here, I used washes of blue and cadmium orange, followed by a lot of textural effects using the drybrush technique again. To help create this effect, I used a worn-out, size 1 brush with a tip that was worn down to a chisel.

The roughened-up look of the foreground was created in the same way as the metal and tree surfaces; but for this area, I used a bigger brush— a size 6, Japanese bamboo brush. The size 6 is my most useful brush; I use it for almost everything, except sky washes and the finest detail work. Prior to applying the textural effects in the foreground, washes were put down—burnt sienna, ultramarine blue, and sap green. Then highlights were made by washing away some areas, which was done by scrubbing the surface of the paint with a brush and then lifting the color off with a paper tissue. For me, scrubbing is best achieved with a bristle brush but for softer effects my bamboo brush works well. As a final touch, grass stalks were drawn around the bulldozer with a fine, long-haired brush.

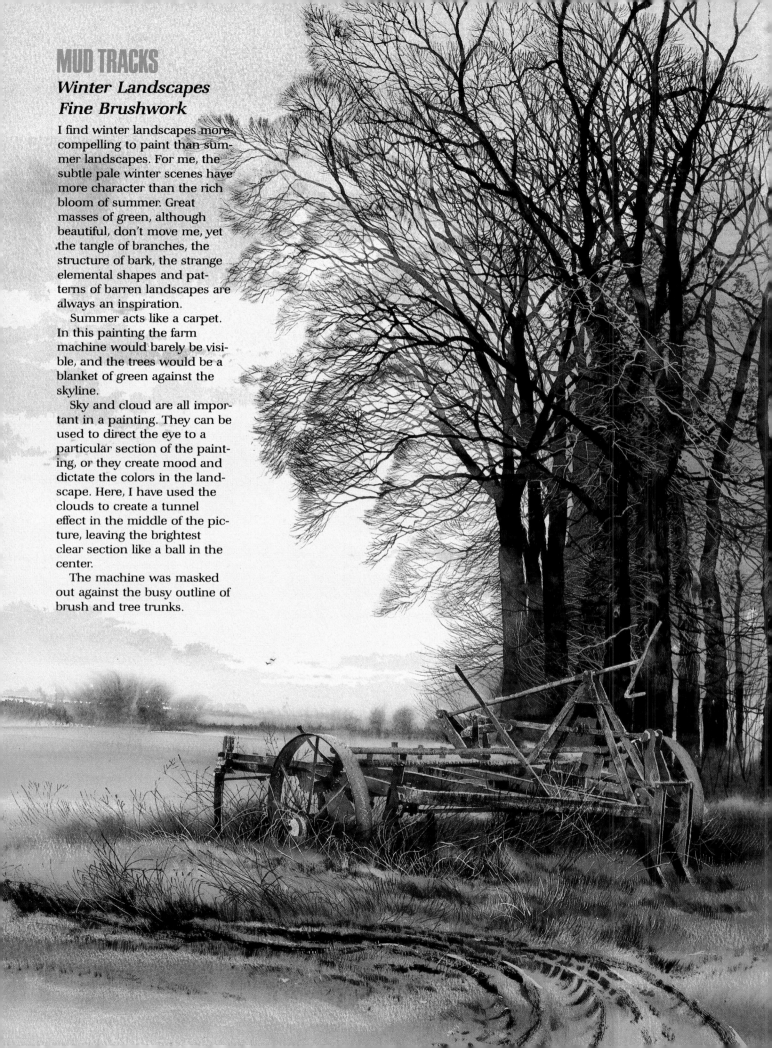

MUD TRACKS
Winter Landscapes
Fine Brushwork

I find winter landscapes more compelling to paint than summer landscapes. For me, the subtle pale winter scenes have more character than the rich bloom of summer. Great masses of green, although beautiful, don't move me, yet the tangle of branches, the structure of bark, the strange elemental shapes and patterns of barren landscapes are always an inspiration.

Summer acts like a carpet. In this painting the farm machine would barely be visible, and the trees would be a blanket of green against the skyline.

Sky and cloud are all important in a painting. They can be used to direct the eye to a particular section of the painting, or they create mood and dictate the colors in the landscape. Here, I have used the clouds to create a tunnel effect in the middle of the picture, leaving the brightest clear section like a ball in the center.

The machine was masked out against the busy outline of brush and tree trunks.

The sky was formed in two washes, the first a flat covering of Naples yellow, cadmium yellow, and rose madder—a very thin mix, just tinting the paper. The clouds were then built from a weak mix of ultramarine blue and a touch of rose madder. As described elsewhere in this book, the broken edges of the clouds were created with a worn Japanese bamboo brush, dabbing it up and down. The brush was kept fairly dry around the edges; otherwise, it will leave large blots instead.

The landscape background was kept very simple: burnt sienna was brushed across and allowed to dry; then the hedgerow was painted in. Finally, a wet brush was drawn along the top, which caused the colors to run together to form the hazy look of the hedgerow.

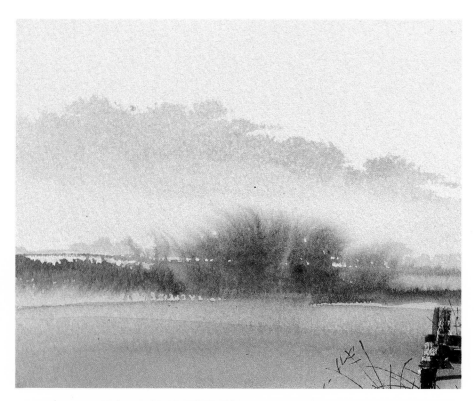

The trees to the right are little more than silhouettes against the sky. Their shapes were painted in with a Japanese bamboo brush. The brush's long, slender point allowed me to paint the thickest part of the trunks, and out along the branches; I only needed to change brushes for the very fine twigs at the outer edge. Burnt sienna and ultramarine blue made up the bulk of the color, with indigo added to the closest trees to make them darker still. Twigs and young shoots growing from the trunks were painted in Naples yellow and then toned down by washing over them with ultramarine blue.

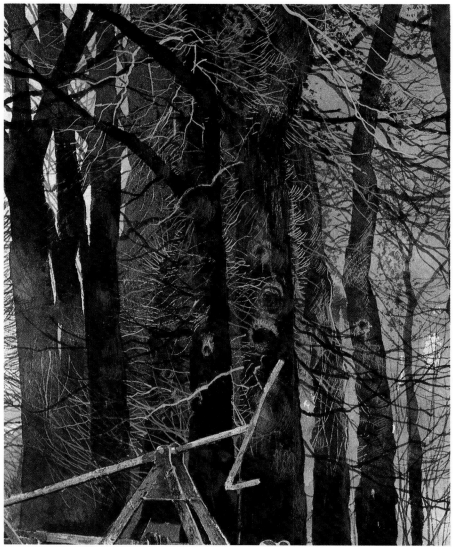

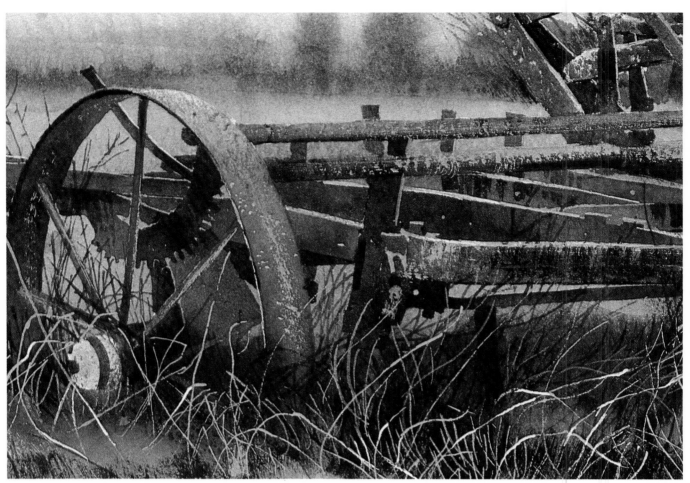

The machine's original color had been a light blue, so I used cerulean blue over most of the metalwork. Much of this was then overpainted in rust colors, where the rust had replaced the original color. The wheels formed the only curved surfaces and were the only really recognizable pieces among the complex structure of bars. A lot of fine detail work was required in this intricate part of the painting, where I spotted in the areas of rust and painted in shadows around components such as nuts, bolts, and levers.

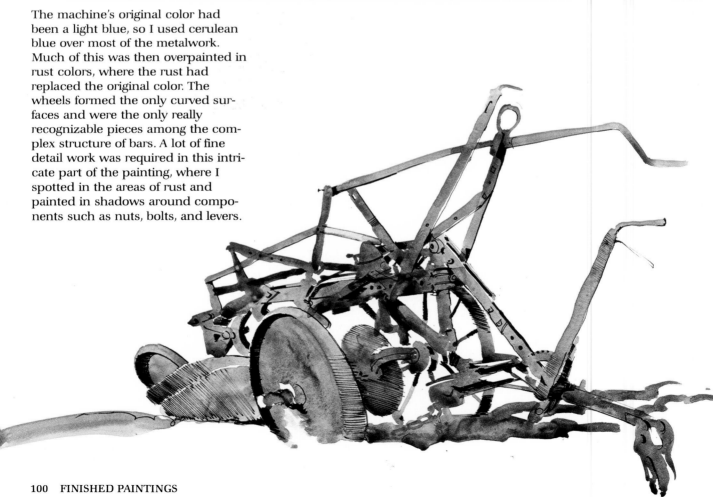

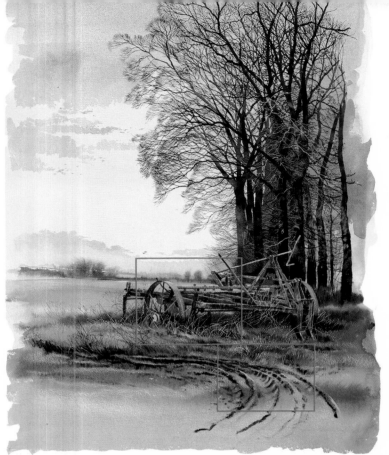

The foreground was built up by applying a strong wash of Naples yellow and then adding brushfuls of other colors into the wet paint. Around and to the sides of the machine, I have added burnt sienna and ultramarine blue. Below that, in the bottom foreground area, another dark streak of the same mix of burnt sienna and ultramarine blue was added as a band across the paper, followed by some cadmium orange. These colors all ran softly together, creating highlights and shades.

Once these clouds of color were dry, the stalks of field grass and the thick ridges of cracked mud tracks can be rubbed in with the drybrush technique.

A lot of detail work was done with my fine, size 0, long-haired sable: the build-up of twigs hanging out into the sky; the delicate grass stems in the foreground. These were initially painted in with burnt sienna and a little ultramarine blue, then some other grass stems were picked out in Naples yellow and permanent white.

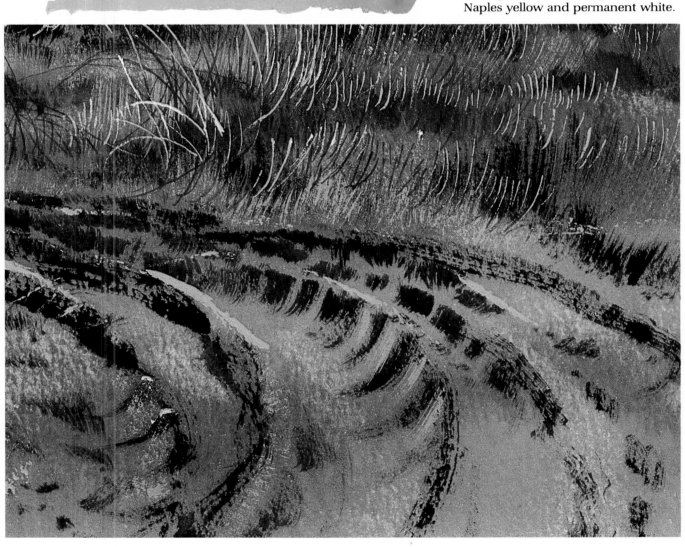

FARM SHED IN SNOW

Snow Scenes
Using Opaque Color

Snow scenes typically add another dimension to landscapes, where the stark shapes of the countryside stand out against the whiteness of the snow. Such is the case of this dilapidated shed, with its dark interior and geometric form, contrasting against the barren backdrop of snow and brush.

Even though the shed is predominantly dark, I masked out its timbers, in case some areas of whiteness were required later.

The background was painted in with a single wash of Naples yellow and cadium orange and a touch of rose madder. These colors were then reflected on the snow in the distance.

The band of trees on the horizon line were painted in with a mix of cadmium orange and ultramarine blue. Here, I carefully worked the brush along this line to give it the broken pattern of spindly treetops and light shining through between tree trunks.

To paint the wooden shed, I first removed the masking fluid and then started filling in some of the darkest areas. For a dark, warm color, I mixed ultramarine blue, burnt sienna, and rose madder. I then carefully painted round the boarding at the front, so that the planks maintained a sharp-edged quality. The dark colors were continued into the recess of the shed to where the sunlight strikes the back wall. The light that does penetrate to this area wall is a rich, warm color, so here I chose a mixture of yellow ocher, Naples yellow, and ultramarine blue to achieve the right color.

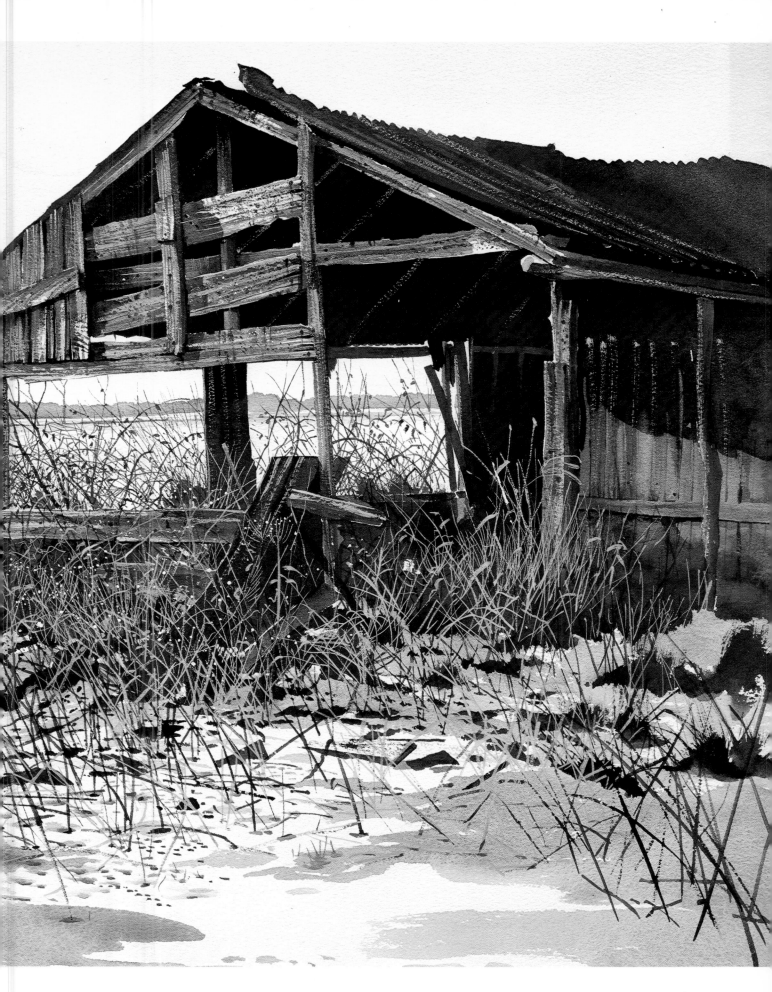

For the weathered planks at the front of the shed, I painted in the shaded areas first. The gentle shading was created with a touch of burnt sienna. When that paint was dry, more colors were washed in—Naples yellow, sap green, and burnt sienna. Before this layer dried, however, I scratched in a few grain effects with the corner of a razor blade. When these colors were completely dry, I could begin to work on the character and grain of the wood—rubbing the paint on with the drybrush technique using one of my old brushes that had seen better days. (Remember this technique is very hard on brushes.) Gradually, the surface effects were built up—the nail holes, weathered grain effects, the rust and water stains.

Rich mixtures of burnt sienna, ultramarine blue, and rose madder were brought together to create the deep rust color of dead brush surrounding the shed. Here, I used a size 6, Japanese bamboo brush and vigorously applied this color, pressing the brush into the paper and sweeping it upward to create the feathered, fine edge of grass tips. Outcrops of grass and soil were also dabbed in, as were the many dots and lines that form some of the debris lying around on the snow. I used some gouache in this painting to "build up" on top of the transparent watercolor. In particular, I used it to create the fusing quality of the foreground—stalks of dead grass and seed pods. I applied the paint straight from the tube with a little water to make it workable.

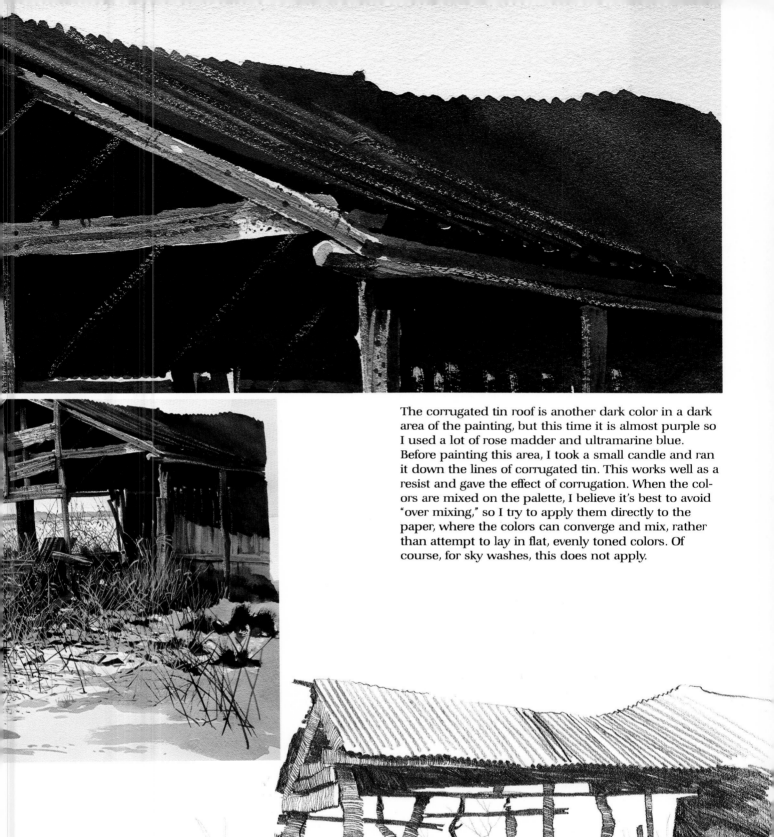

The corrugated tin roof is another dark color in a dark area of the painting, but this time it is almost purple so I used a lot of rose madder and ultramarine blue. Before painting this area, I took a small candle and ran it down the lines of corrugated tin. This works well as a resist and gave the effect of corrugation. When the colors are mixed on the palette, I believe it's best to avoid "over mixing," so I try to apply them directly to the paper, where the colors can converge and mix, rather than attempt to lay in flat, evenly toned colors. Of course, for sky washes, this does not apply.

TRACTION ENGINES
Building Up Detail and Strong Color

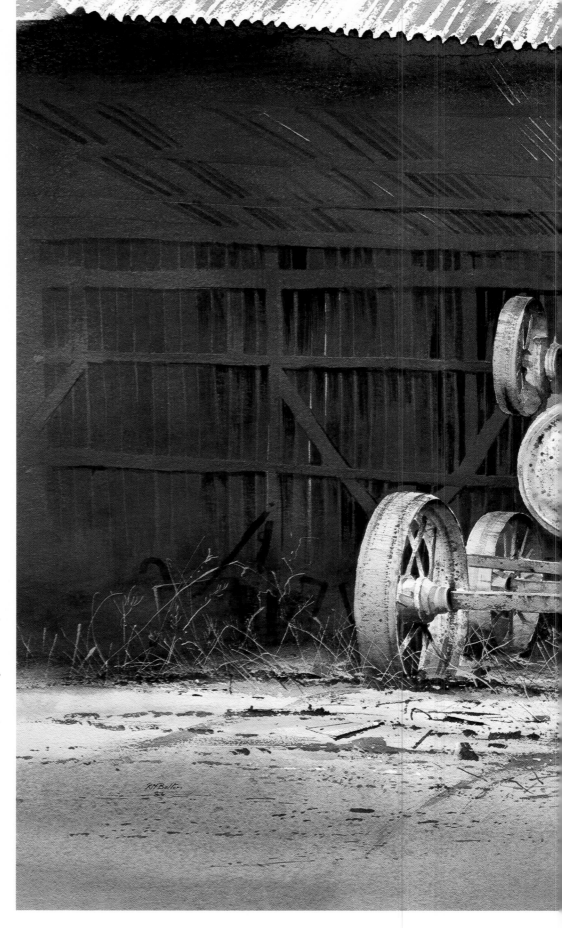

Although watercolor paintings can be loose impressions that rely very much on a look of energy and free brushwork, they can also be treated in very different ways. They can even be built up strongly with layers of paint; it is even possible to varnish watercolors and make them look like oil paintings.

This painting is very heavily worked and relies on a very dark background for effect. The style of painting was dictated by the background. I could have laid down a dark wash and left it at that, but I was interested in the half-hidden shades, the little chinks of light, and the subtle variations in tone and color. These elements set the pattern for the rest of the composition; I couldn't very well work detail into the background and then leave the traction engines as hazy images in the foreground.

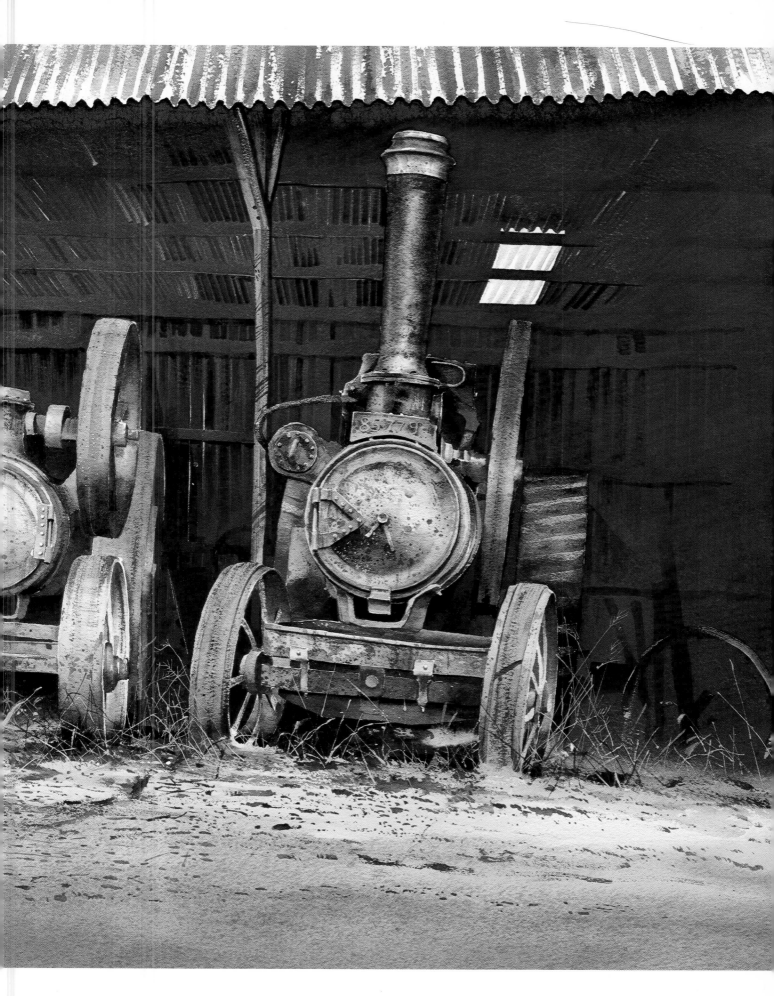

The dark interior of the shed was created in three washes. First, burnt sienna and ultramarine blue were mixed as a thick, dark wash and painted on from right to left, working carefully round the contours of the engines and the rippling edge of the roof. The second wash was of ultramarine blue. Most of the wash area was brushed over with clear water, and then ultramarine blue was brushed in along the underside of the roof and down behind the engines where the darkest shadows are. My third wash added some sap green and cadmium yellow to vary the color a little more in the background.

The two engines made an interesting contrast. This one seemed to be predominantly blue while the other is more Naples yellow and burnt sienna. I started on the one on the left, and washed in Naples yellow gently round the wheels, using wet into wet to create the subtle rounded shapes. In like manner, burnt sienna was introduced to give rich areas of shadow under the wheel arches and under the rounded front of the engine. Colder areas of shadow were formed with ultramarine blue and the odd touch of rose madder. Much work was then done with a fine brush in the drybrush technique, touching in all the effects of rust breaking out in little patches all over the surface. Detail has also been introduced along edges of spokes, rivets, and bolt holes. Other colors have gently been introduced: sap green around the chimney stack; cadmium yellow to make the oranges stronger; rose madder and ultramarine blue building up the complexity of the colors, shapes, and textures.

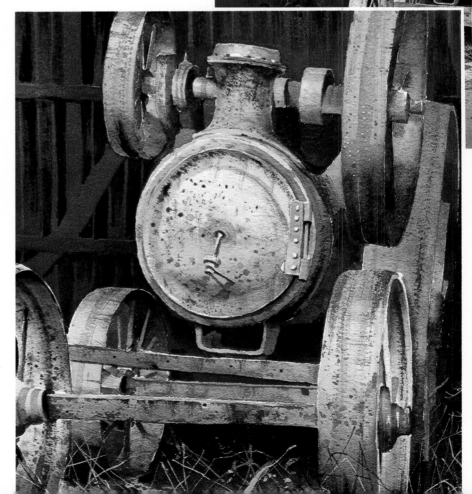

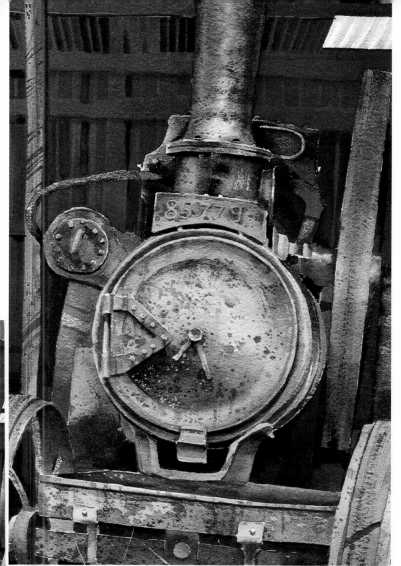

This engine captures the same colors as its mate but also has a rich blue in the metal, probably because it has not rusted to the same extent. The tall chimney was painted in clear water first, and then the ultramarine blue and cadmium orange were mixed and painted down each side. The colors blend softly round the chimney, leaving a white highlight down the center. One of the great strengths of watercolor is its ability to form rounded and curved edges so naturally. In any other medium, one could tease the colors around for ages and never get the same soft effect. Dry brushwork was used again to create the surface pattern of rust, dirt, and flaking paint. On the wheel the brush was dragged round the rim to leave a rough speckle of paint. Patches of rust were dragged downward with the brush, smearing the paint down, imitating the staining effects left by rainwater.

A shaft of light runs across the foreground lighting up the engines above it, so I was careful not to overrun that area with too dark a color. Cadmium orange, burnt sienna, and ultramarine blue were washed onto the paper here; the board was then tipped up from the top to prevent color from spreading up too far. When these colors were dry, some Naples yellow was washed across the area that was still white. At that stage, I thought the colors were too bright, so I added another wash of ultramarine blue along the lower section of foreground, which tones it down a little more. With a fine brush, all the debris in the foreground was added. More shape was also given to the foreground by dragging the brush across the paper. Inside the shed, the ground becomes darker with shadows being cast by the wheels. These dark shadows were overpainted in Naples yellow gouache with many stems of grass caught in the sunlight's rays. I find a size 0, long-haired sable is best for this. The brush can be bent right over on its side and dragged along, giving long, thin lines of paint.

TRACTOR IN WINTER LANDSCAPE

Winter Skies, Dramatic Effects

With the fall of snow, the landscape takes on a new look. Trees produce a pattern of latticework against the sky-line, and dramatic effects are created between the snow and the land-scape.

This snow-covered path features a tree that I had painted during the summer. In winter, it looked witchlike or reminded me of something sinis-ter. Its branches seem to reach out like menacing arms. To dramatize this idea, I decided to add the two black crows using a spindly branch as a perch.

The focal point of this picture is the path leading into the middle dis-tance; and the tractor and trees on either side work well in balancing the composition. The tractor facing along the path also helps to point the eye in the same direction, leading the viewer into the painting.

I rarely paint a landscape without something solid in the foreground to look at. I like to think that my paint-ings are more than just impressions, but that they also give something of interesting detail that can be looked at over and again. In this case I show a rundown tractor braving the winter without protection, except for its brightly colored blue tin can set on top of the exhaust to prevent water from running down into the engine.

The sky was created from a gentle wash of Naples yellow and a small touch of cadmium yellow, which blends softly into a wash of ultra-marine blue mixed with rose madder. To do this, I first laid in the wash of Naples yellow and cadmium yellow, filling the whole top half of the paper. Then, while the paper was still wet, I added the rose madder and ultra-marine blue, dividing the wash area in half. I could then tilt the board both ways to get the colors to blend together so that the Naples yellow gradually fades into the blue mixture.

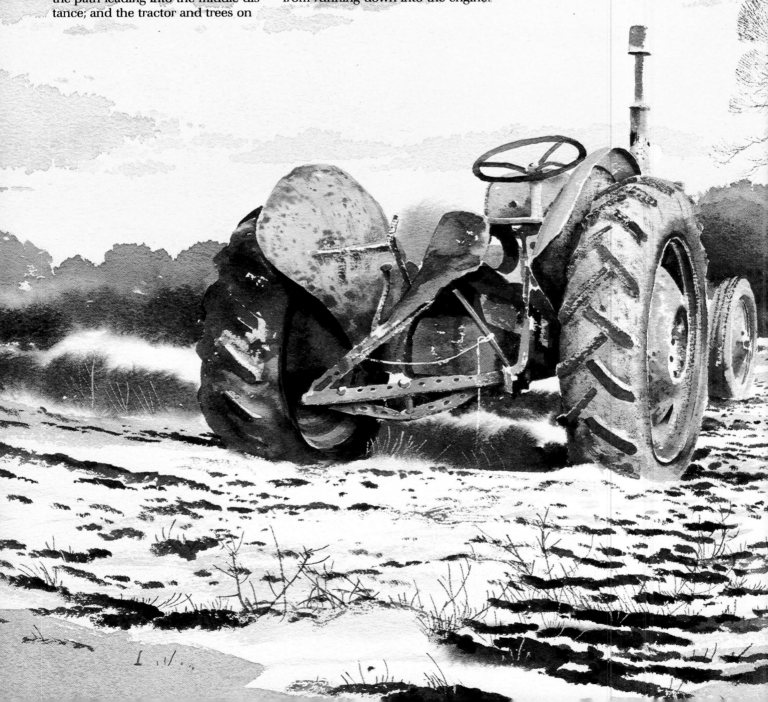

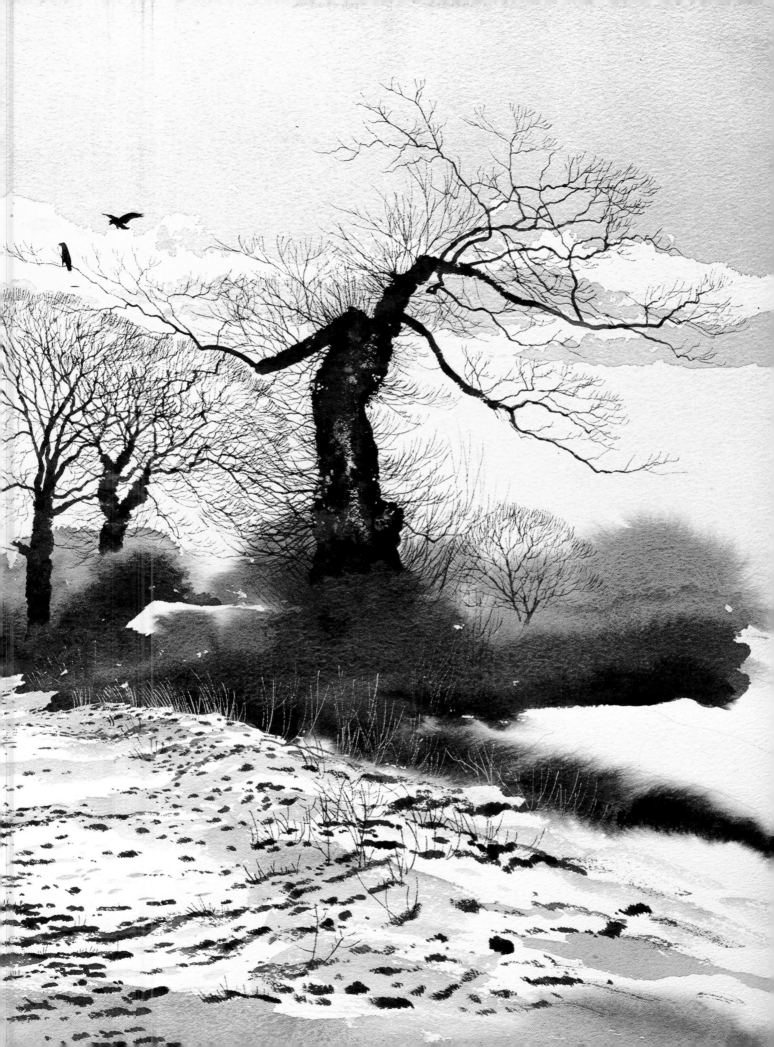

Before adding the clouds, I let the initial sky colors dry completely. For this I used Windsor and Newton's Gray No. 2, mixing the color well so that it will go onto the paper completely flat. It's a weak mix of color, about the same consistency as the wash beneath it, and I applied it with an old Japanese bamboo brush that has no point. By jabbing the brush up and down vertically and teasing the wash out, I created the feathered edge of the clouds, but at all times I must make sure that the edges were kept wet. This is an intensive part of the painting, and it must be worked quickly. Otherwise, unsightly blemishes will form on the paper.

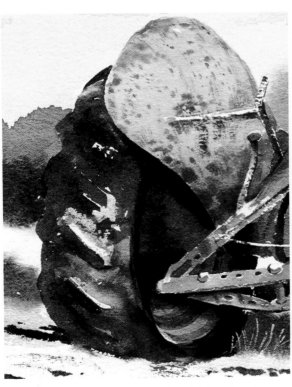

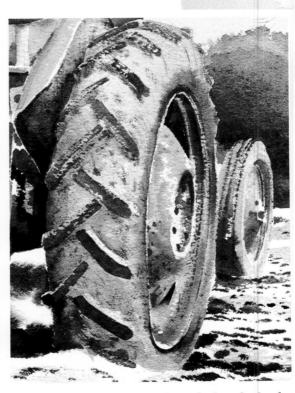

The wheel on the left is cast in shadows, so I painted it much darker than the other wheel using burnt sienna and ultramarine blue. Detail was then picked up around the wheel hub with a darker mix of burnt sienna and ultramarine blue.

The original color of the bodywork has been lost to rust and fading. I have created the same colors by mixing yellow ocher, Naples yellow, and cadmium yellow. The rust was rubbed on with a small brush afterward, where I used as little water as possible to give the application of paint a toothy texture.

I began this painting with the right-hand wheel, masking out highlights on the tread. A light wash of cerulean blue and burnt sienna was washed over the tire, giving it a rounded shape by deepening the color at its base. The pattern of tread was brushed in using the drybrush technique; the irregular, broken brushwork helps to give the feel of a worn wheel.

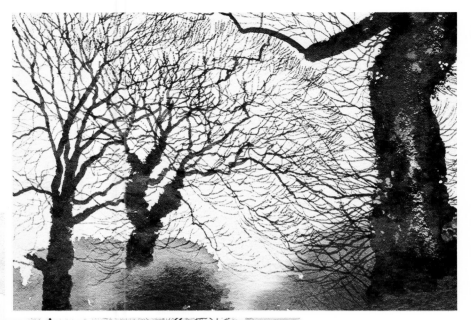

I used the same color in the background as I did for the clouds, although a stronger mixture was used for the band of trees on the horizon. With a small brush, I used the same technique as I used with the clouds to tease out the ragged edge along the tops of the trees.

The two trees in the background were painted in with gray, burnt sienna, and ultramarine blue; the gray color helps to push the trees into the background. For the witchlike tree in the foreground, I rubbed a small wax candle down the center. This will add a speckle of white dots when painted over because the wax works as a resist. This effect could also be used for the texture of bark or for the look of snow caught in the crook of a tree.

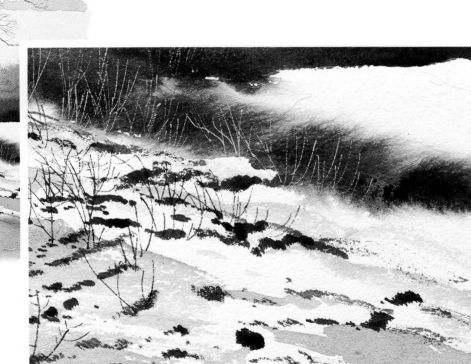

Because I wanted to create a soft, rounded effect of the thick underbrush and grass growing in rows along the path, I first dampened the paper with a large brush and then added a mix of burnt sienna, yellow ocher, and ultramarine blue. These colors then softly blur into the paper.

Ground and stubble break through the snow on the path, making a crazyquilt paving of dark spots. Each spot was painted in with a size 2 brush with a worn tip. By carefully dabbing away with tip of the brush and keeping the paint as dry as possible, I was able to give the clods of soil a "toothy edge" rather than becoming just a rounded spot, which is what they would have been if a more dilute mixture had been used on the brush.

For the final touches, I used a long-haired, size 0 brush to flick in all the whitish grass stems that are highlighted against the dark background of brush and dead grass. Here, I mixed permanent white and Naples yellow keeping the colors as strong as possible.

FARM CART

Retaining Spontaneity Keeping Edges Wet

The danger with a frail, complicated structure like this old farm cart is that the artist can become so submerged in its detail and structure that all spontaneity is lost. Also, this picture was completed without masking fluid, proving that it is not essential, though it does save time and makes the job a lot easier.

To begin, I covered the paper with a wash of Naples yellow, adding some cadmium orange below the cart. Normally the cart would have been masked out to allow me free movement of the brush across the paper; since this was not the case, I was forced to work laboriously around the cart, painting between the spokes and around jagged outlines. The trick here is to keep the working edge wet, so I was continuously working in different areas in order to keep the edges wet. It's rather like the circus act where a

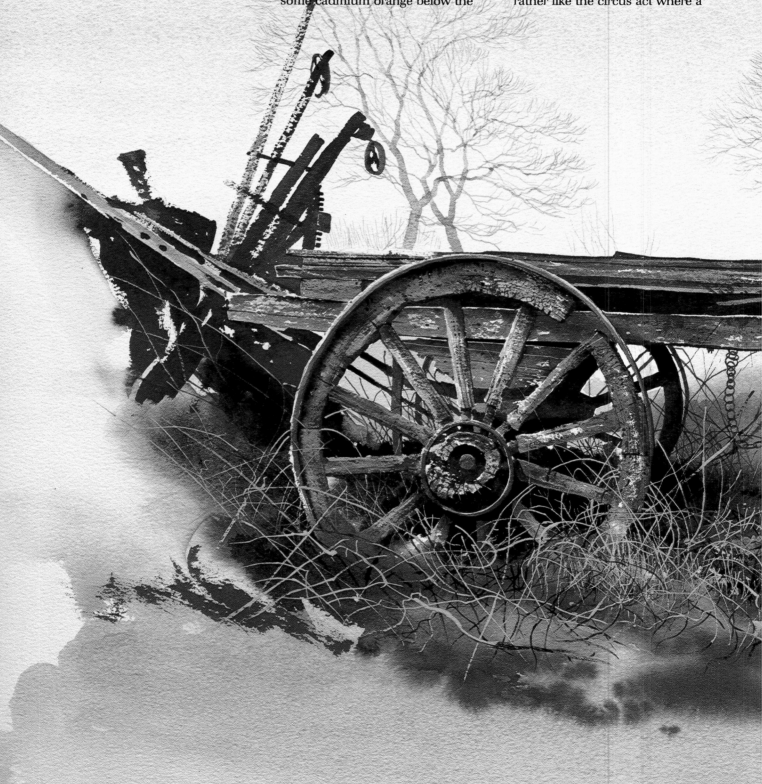

man spins plates on the top of a whipping stick, and then has to rush back and forth giving them a twirl to prevent their falling to the ground.

I went through the same problem again with a second wash on the lower half of the painting. More Naples yellow was used along with cadmium orange and a little ultramarine blue. This time an evenness of coverage was not so important, and the colors were blended softly to form a background. Sap green, burnt sienna, and ultramarine blue were mixed quite strongly to form the foreground of undergrowth. Care was taken here to avoid it becoming a dark mass, and the color was added with care and built up until I thought it had the right feel.

After the background and foreground had been roughly worked out, I started to build up the paint on the cart. I decided to work on the darkest areas first, such as the wheels at the back where they converge into the undergrowth. I did this because there was a real danger of painting the cart too darkly, so by starting off with the darkest areas, I was able to assess just how dark the color could be in this painting. This is an important point because if your colors get too dark, details will often become muddied and the painting looks overworked.

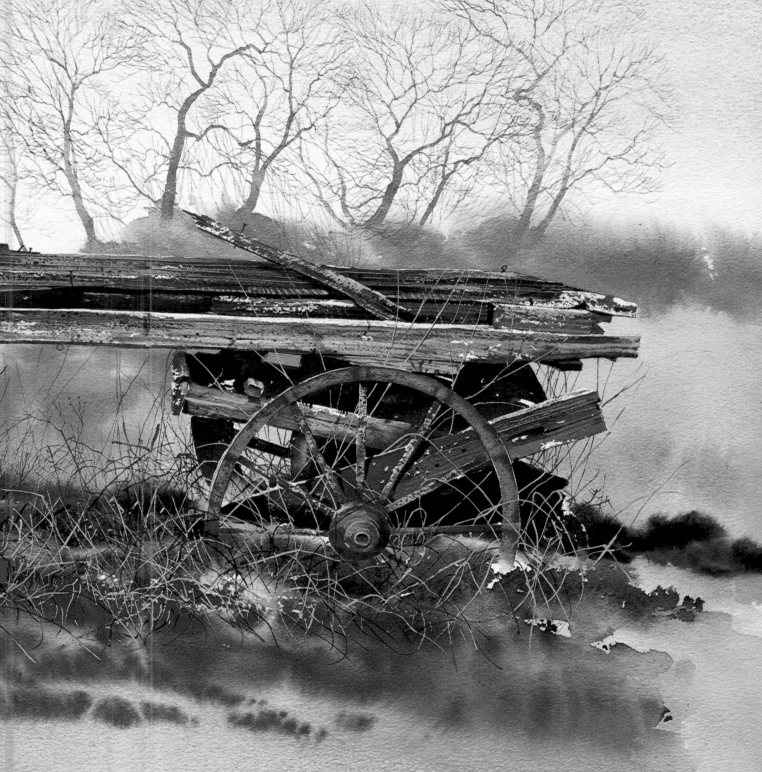

The main body of the cart—the horizontal timbers that form its length—were painted in very quickly by running my size 6 bamboo brush along the length with a mixture of ultramarine blue and rose madder; this was followed in the same way by burnt sienna, sap green, and Naples yellow. Here, I took care to make as little use of the brush as possible and thus to avoid muddying the colors. Some grain effects were introduced by sweeping the corner of a razor blade along the length of the grain, knifeing out hairline, white lines through the paint.

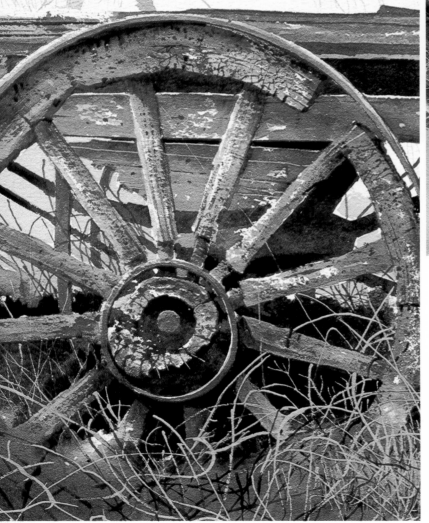

The wheels are the most important part in this painting. They have to be very convincing, or else the whole painting fails. The wooden wheel was painted one spoke at a time, and I made sure that some white paper was left to enhance the effects of texture. I paid particular attention to the many cracks in the woodwork and tried to catch the mosaic quality of the decaying wood. The technique remains the same as for the other wood effects: a light wash, followed by dry brushwork, followed by detailed work with a fine brush.

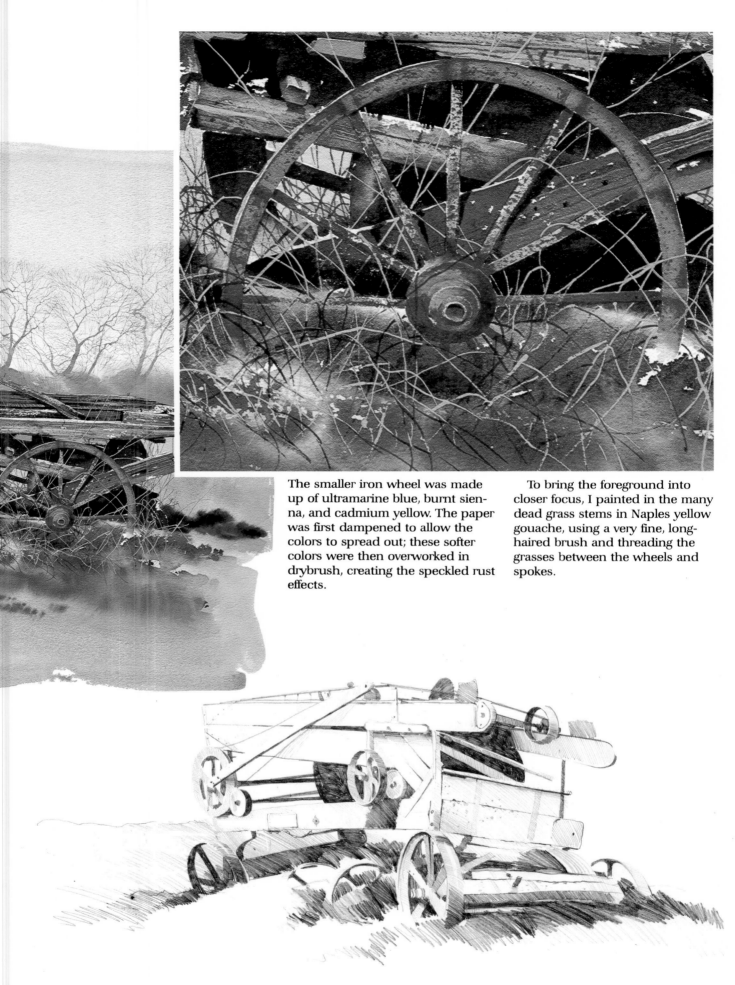

The smaller iron wheel was made up of ultramarine blue, burnt sienna, and cadmium yellow. The paper was first dampened to allow the colors to spread out; these softer colors were then overworked in drybrush, creating the speckled rust effects.

To bring the foreground into closer focus, I painted in the many dead grass stems in Naples yellow gouache, using a very fine, long-haired brush and threading the grasses between the wheels and spokes.

WILLOW AND UNDERGROWTH
Small Paintings
Delicate Brushwork

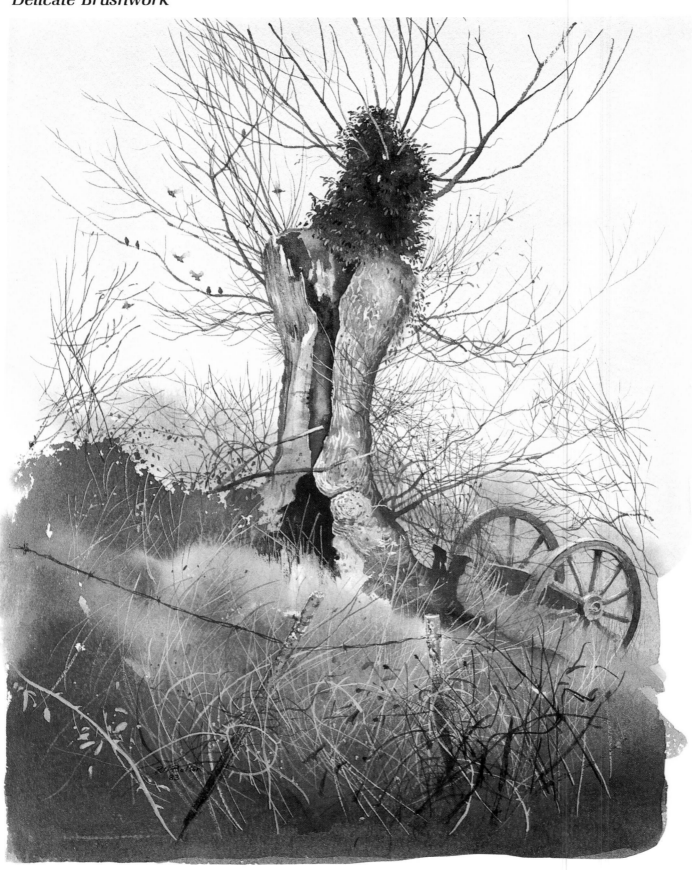

This is a painting measuring only 7" x 9" (18 x 23 cm), which is the smallest size I work in. Generally, I find that watercolor painting lends itself to small sizes. The scale makes the painting more controllable, the danger of hard edges forming is reduced, and applying washes becomes much easier. It is hard to say what dictates the size of a painting. Often, I look at the subject and think it would simply be better painted small and, in this case, I didn't think it would improve the painting to be any bigger.

Initially, the whole painting was washed over with Naples yellow and yellow ocher; masking fluid was not used on this occasion. To form the haze of winter shrubbery, the lower half of the painting was washed over with a mixture of Naples yellow, burnt sienna, and a little cadmium orange and ultramarine blue. I brushed these colors in carefully round the base of the tree, taking care not to allow the colors to bleed too far up and obliterate the trunk.

I painted the tree trunk in starting with the ivy clinging to the top. Burnt sienna, sap green, and ultramarine blue were mixed and applied with a small brush. The color was then teased out to form leaves and stems. Normally, I wouldn't paint in the detail so finely, but because of the scale, detail becomes more important. Leaves were painted over the green surface: Naples yellow and a little sap green for the light colors, and ultramarine blue for the dark ones.

Carefully painting around the contours of bark, I gradually built up the trunk of the tree with a fine brush. I kept another brush on hand loaded with clear water to soften edges and wash in highlights. The thin, raised highlights are really the background wash showing through. Burnt sienna and ultramarine blue formed the colors; but some areas of bark are pure ultramarine blue. To give almost a black color to the dark interior of the hollow trunk, indigo was mixed with burnt sienna and ultramarine blue. There is also a small amount of green showing round the base of the tree. This was painted with sap green and burnt sienna; the lower edge was wiped away with a brush of clear water in order to soften it as it falls behind the curtain of dead grass.

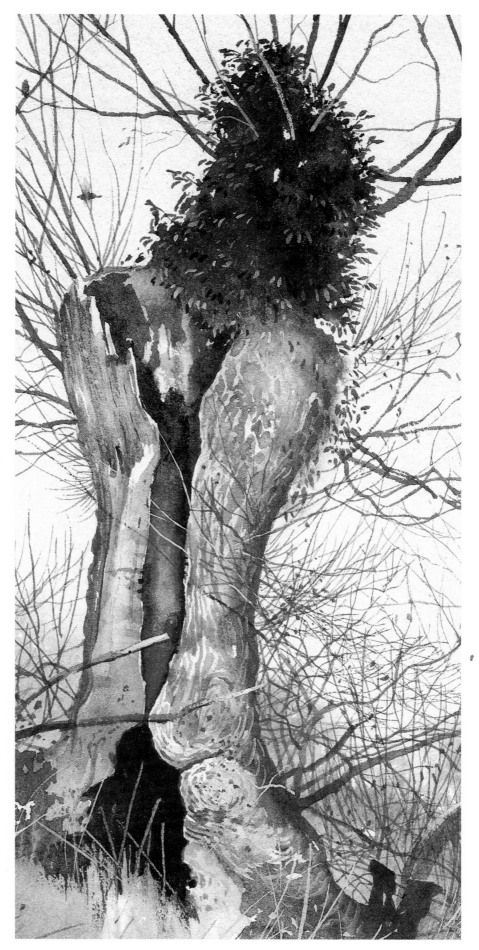

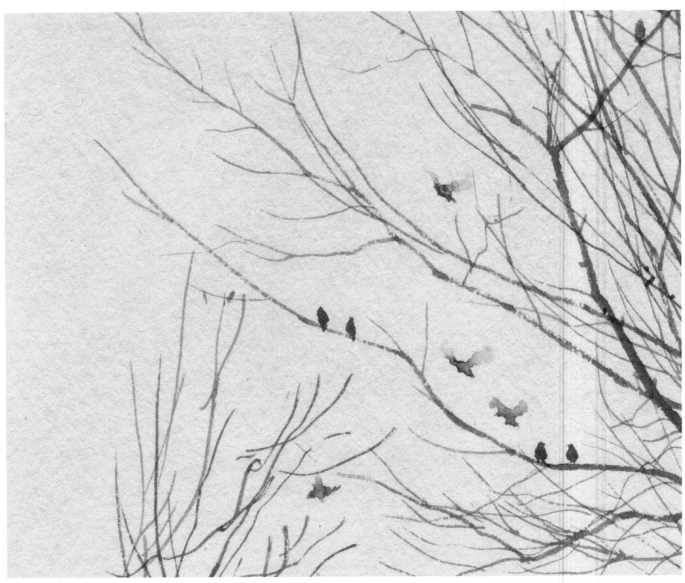

These willow branches curve gently upward, creating delicate lines that lend themselves to the curve of a brushstroke. As a final touch, a few sparrows were scattered among the branches. I often put birds in my paintings, as they add a little touch of light.

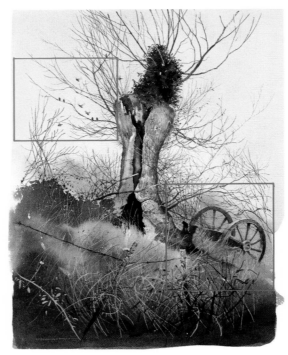

The remains of an old cart rest to the right of the tree and were painted on top of the background. The highlight around the rim and hub were scrubbed away with water and a paper towel pressed against the paper to absorb more color away.

A considerable amount of overpainting was done to the foreground to create the tangle of undergrowth. I used a long-haired, size 0 sable brush and randomly laid in the thin lines over the surface, first with Naples yellow for the light-colored grass and then with burnt sienna and ultramarine blue for the darkest grass in the foreground. A lot more work was needed with the same brush to develop a background of twigs and fine branches.

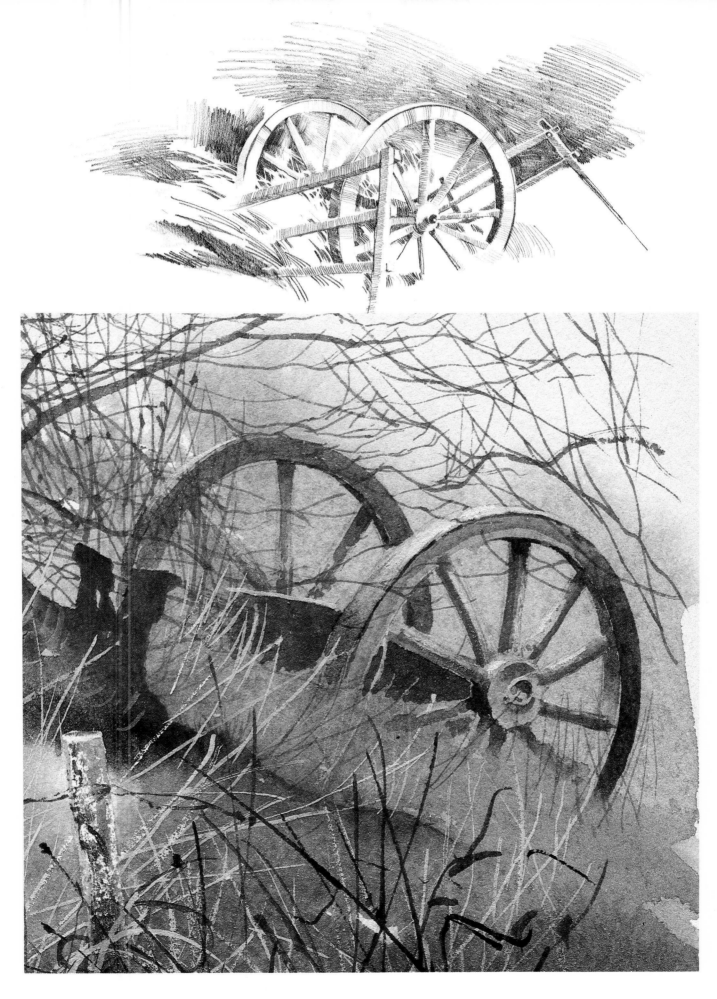

RUSTY TRUCK
Cameo Effects

Half submerged in a tangle of underbrush, this
abandoned truck made a most attractive painting
subject. The cameo effect of the surrounding
greenery was particularly appealing because it
strengthens and defines the outline of the truck,
which gave me the idea about just how I would
compose this picture.

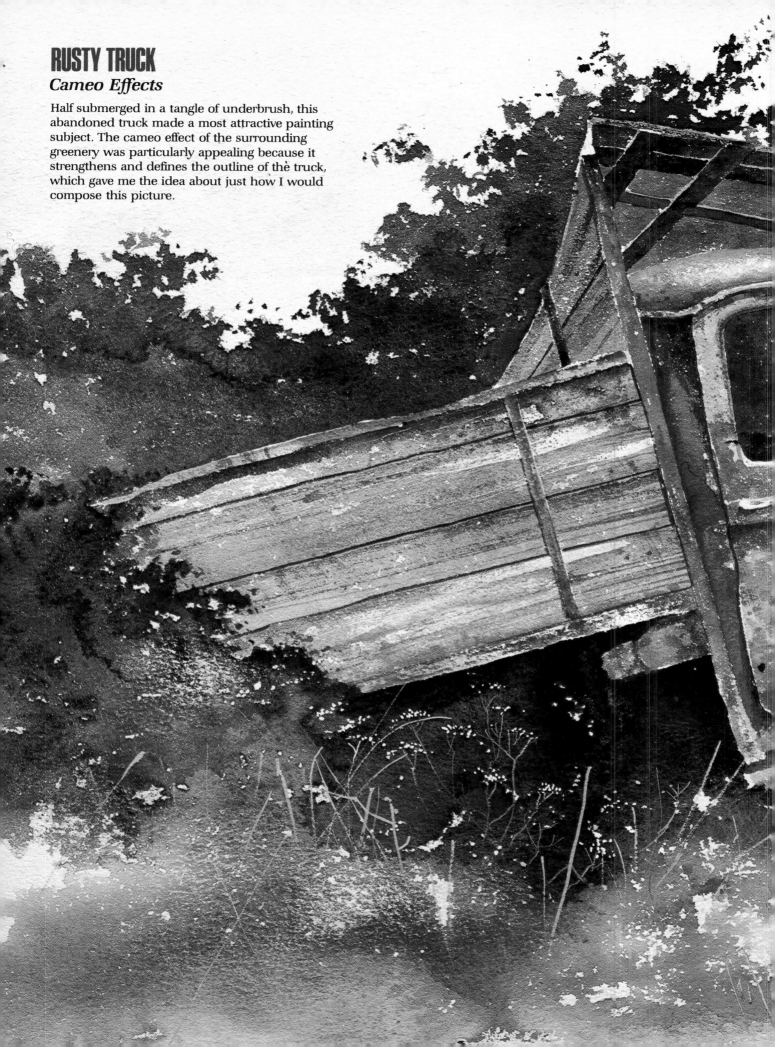

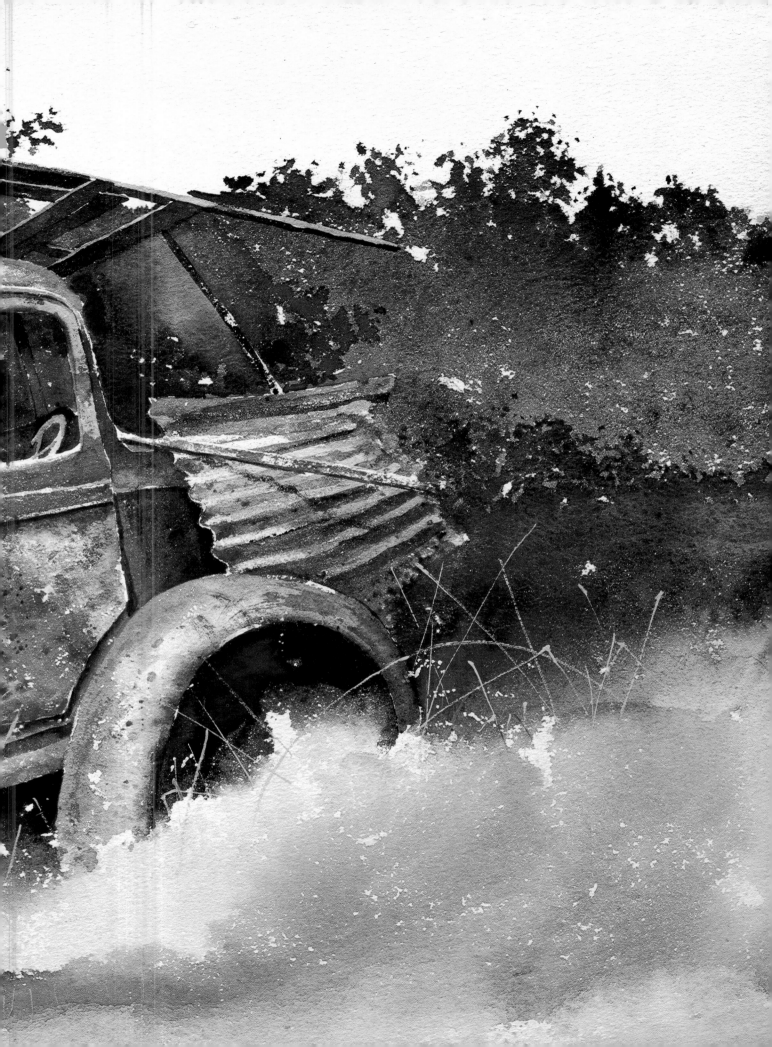

When I began to paint the truck, it was a white area in the center of the paper with a crisp, sharp outline. I started painting it at the top where some old planks were laid on top of the cab. Here, I used ultramarine blue and a touch of burnt sienna to create the shaded underside of the wood and thin beads of pure ultramarine blue along the facing edges. The planks on the side and back of the truck were painted in with quick sweeps of the brush; this caused the paint to break up on the surface, giving an impression of wood grain.

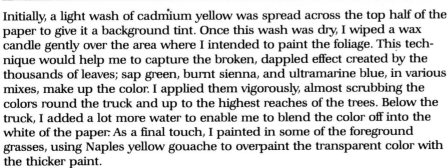

Initially, a light wash of cadmium yellow was spread across the top half of the paper to give it a background tint. Once this wash was dry, I wiped a wax candle gently over the area where I intended to paint the foliage. This technique would help me to capture the broken, dappled effect created by the thousands of leaves; sap green, burnt sienna, and ultramarine blue, in various mixes, make up the color. I applied them vigorously, almost scrubbing the colors round the truck and up to the highest reaches of the trees. Below the truck, I added a lot more water to enable me to blend the color off into the white of the paper. As a final touch, I painted in some of the foreground grasses, using Naples yellow gouache to overpaint the transparent color with the thicker paint.

The cab door and much of the bodywork were washed over in cerulean blue, which was the original color before the rust had set in. I made sure that speckles of white paper were left because there is a danger here of the picture becoming too dark and somber.

The rust texture was achieved in two stages. In the first stage, I wetted down the area I was working in and dropped colors into the wet surface. This gave me the soft effects of colors blending into each other. For the second stage, I waited until the paper had dried, and then, using drybrush technique, I carefully added more color; this gave the broken textured effects of rust—the small pits and blisters of the rough corroded surface. For these colors, I used cadmium orange, cadmium yellow, burnt sienna, rose madder, and ultramarine blue. Rust is surprisingly rich in color, and it is possible to use a wide variety of colors.

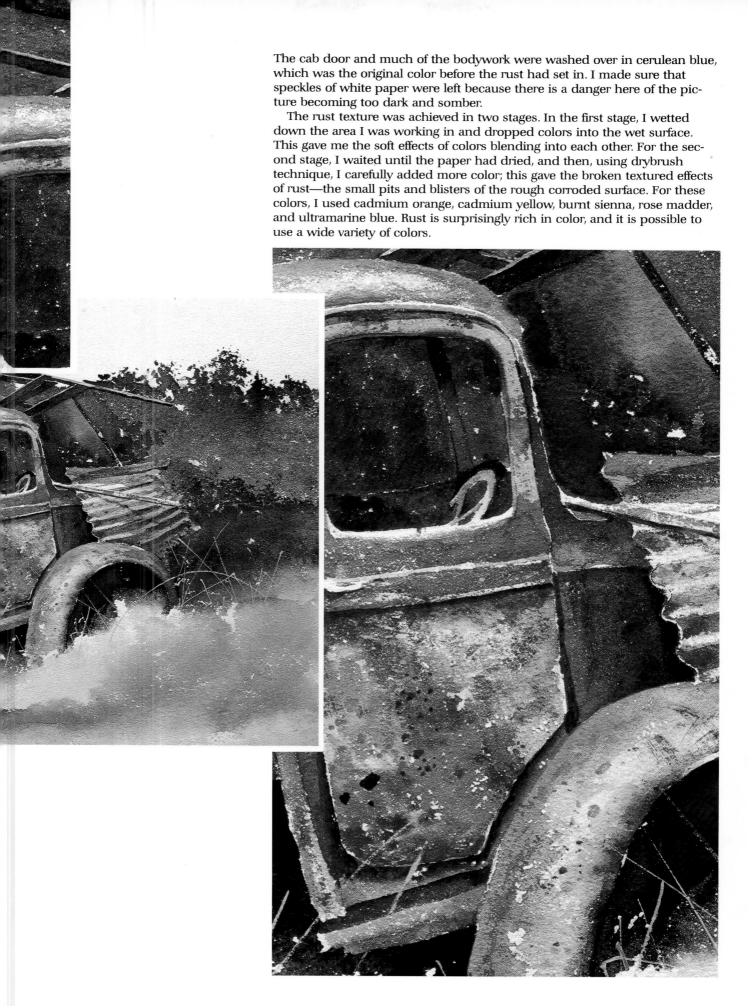

PART THREE
Painting Projects

This section of the book consists of sixteen photographs of weathered texture scenes and objects, most of them taken not more than a hundred yards from my backyard. They serve as real life references to many of the paintings shown throughout the book. Treat each one as a painting assignment, much like you would a still life or a landscape that you've chosen as a subject for a painting, incorporating all you've learned from parts 1 and 2. In each case, I've included specific techniques and suggestions on how to handle the painting problems presented in the scene. In some instances, I've included my own painting interpretation of the photograph, thus showing you exactly what approach was taken.

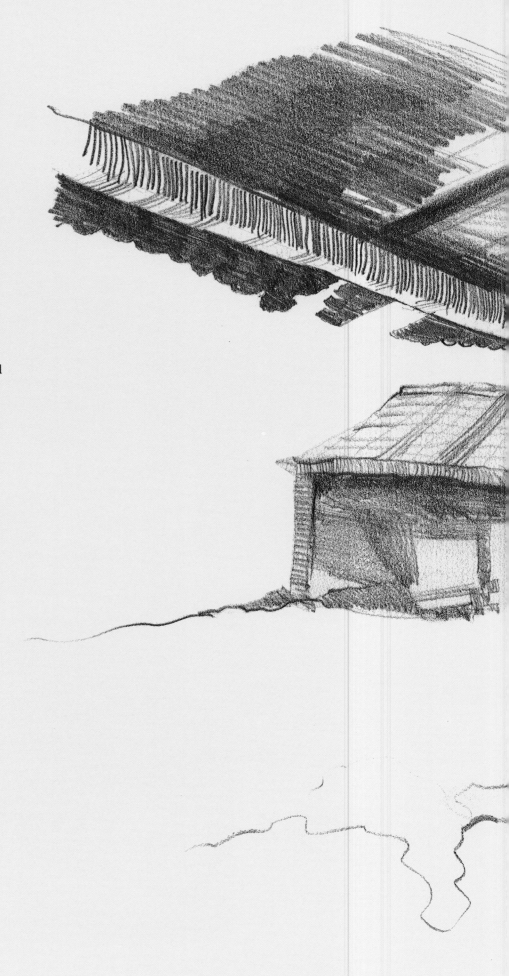

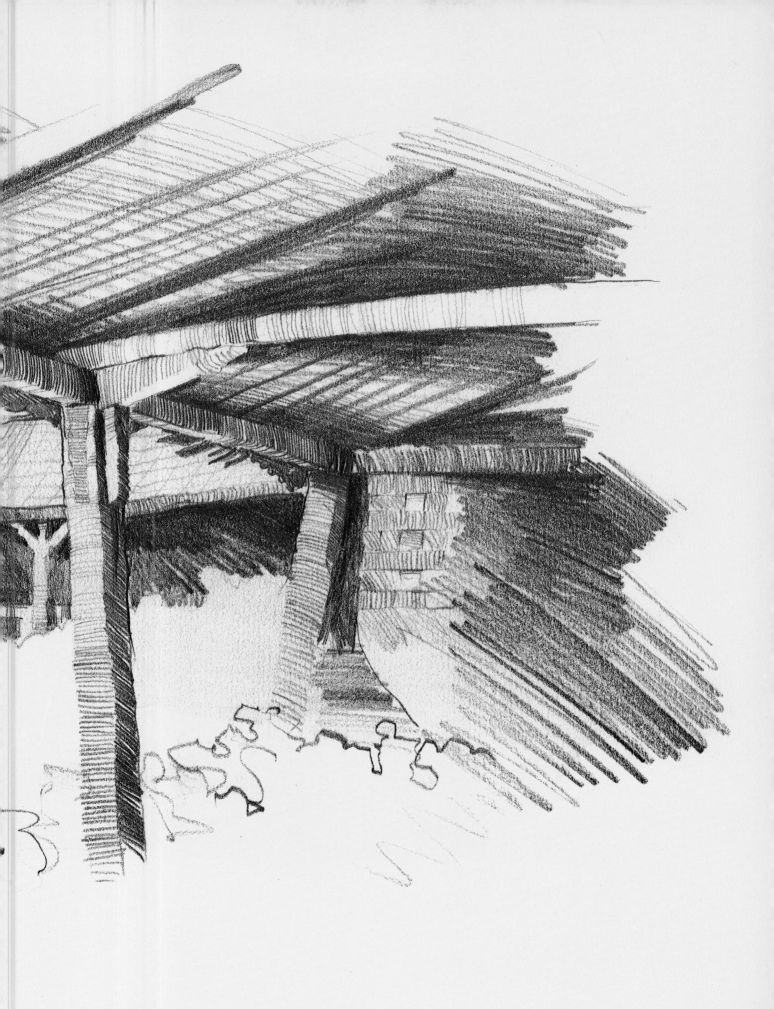

LATCH DETAIL
Subtle Colorings in Rusty Metal

Small close-up details like this dilapidated old latch can often form interesting compositions. In my painting, I treated the background very roughly, relying on memory as much as imagination, as I did not have the benefit of the photograph to work from.

The colors are subdued but nevertheless possess many subtle shades of gray and blue with small touches of orange rust. These soft colors should lend themselves well to the watercolorist's palette.

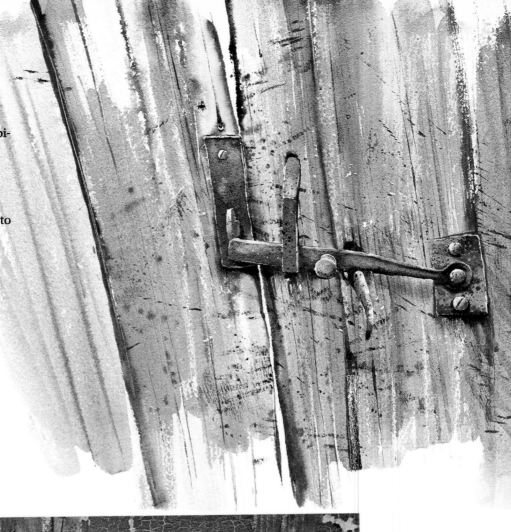

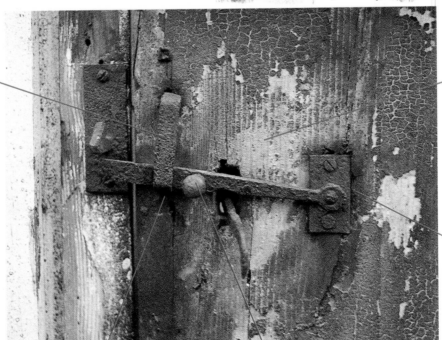

Note the many pits in the metal. The dots would be worth trying to capture. Dampen a small area of paper and then with a fine brush, stipple over the surface. The dots will soften out on the damp paper.

Candle wax rubbed in round here will help add texture to the surface.

Notice how the edges become dark around the fastenings. Use this quality to - project the components of the latch forward.

Paint in the shadows and then use a brushful of clear water to soften the edge.

Wipe away color with a wet brush to create soft highlights.

Light Washes for Creating Wood Effects

Paint the rusting hooks out in masking fluid first. This will enable the background of shutters to be dashed in with a few brushstrokes from a large flat brush. Try a little candle wax on the wood surface and paint out a few features of the grain in masking fluid. A few spots of white showing through a wash are very effective.

Keep the colors very light and use the luminosity of the white paper beneath the washes to its maximum. The blend of colors on the surface of the wood lend themselves to the watercolorist's brush. Note the staining of rust beneath the eye catch; burnt sienna is the ideal color for this, brushed in while the wash is still wet. On the left side is a large area of pale green; here sap green mixed with Naples yellow should work well.

Make the rusty hooks look as if they fit into the wood. Note the dark edge of a hole where it has been hammered in and the rust stains down the surface of the wood.

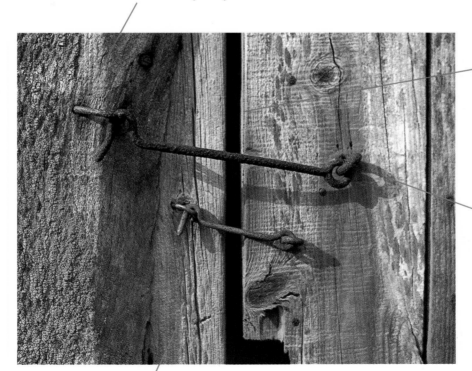

Don't lose this highlight. It defines the edge of the door.

The shadow is very interesting here, so use it for dramatic effect.

Fine cracks can be painted out with masking fluid to keep the fine white lines, then the dark line can be dropped in beside it.

FARM CART
Simplifying a Complex Scene

This is the same cart seen in the painting on pages 76–77, but viewed from the other side—so it provides a good opportunity to try to match technique and build up an original painting. The same problems exist with this view. It's a tricky, intricate structure, so be sure to have it well drawn out first. Concentrate on the wheels and get the ellipses right. The wheels are buried deep into the undergrowth, so the lower section can be omitted.

The background is disruptive; either omit it entirely or create another setting behind it. I think the most effective way will be to use the wet-into-wet technique to develop a subtle hazy background.

Note the tangle of dead grass stems. These can be masked out with a very fine brush or painted in afterwards with Naples yellow and permanent white.

The cart is covered in a rather brilliant green mold. Subtle control of colors will be needed to get it right.

Mask out the chains and highlights on the wheel's rim.

Remember while working that this is the darkest area.

To get the rounded effect, apply color at the base and then use clear water to wash the color upward.

Try not to overwork the foreground; use wet into wet and treat it as a haze, a carpet of loose flowing shapes and color. The detail work can be added later when the paint is dry.

Don't paint the wheels all the way round; let them fade off at the base by using clear water to soften edges.

CART WHEELS
Contrasting Form Against Detail

These old cart wheels form an intriguing yet simple study. The clear geometric structure of the spokes and the curving wheels contrasts well against the tangled brush of the background.

Start off by masking out the wheels and the remnants of the cart, then the background of weeds can be brushed in vigorously without obliterating the detail. Once the cart has been painted in, pay particular attention to the grass stems. Mix opaque Naples yellow, permanent white, and a little blue. Use your finest brush and build up the network of strands, intertwining them round the wheels and reaching up into the darker space above the wheels. Vary the colors and, if need be, brush a gentle wash over the strands to capture the gentle tints of shade.

There is not a lot of color in the cart, so take advantage of these touches of brilliant green stain in the wood.

Keep these edges as sharp as possible, otherwise there is great danger that the cart will become lost amidst its surroundings.

Make sure the background is dark enough. I would make it darkest where it drops behind the tall grasses; that way the contrast against the whiteness of the grass stems will be all the stronger.

Grass stems can be painted in as described above, or they can be scratched out with the corner of a razor blade while colors are still damp. Both methods are very effective and can be combined.

These leaves can be painted in with opaque white and a little leaf green. If you are a watercolor purist, then mask them out and wash some light green over them afterward.

TOY CAR
Imaginary Settings

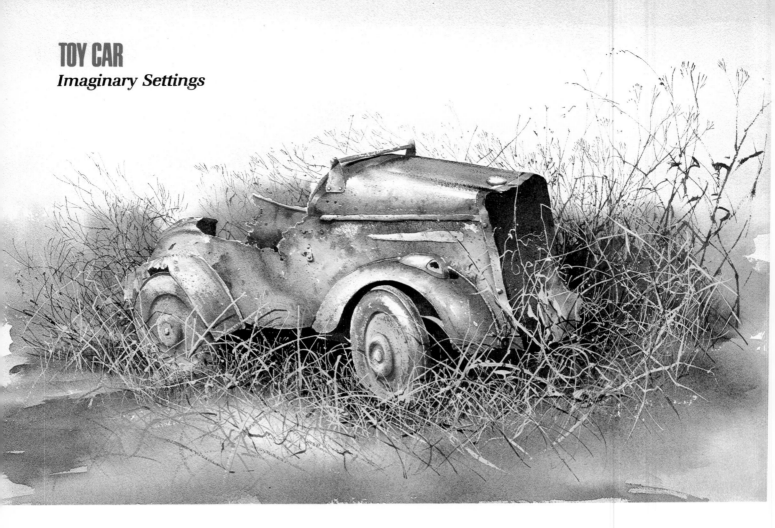

Wash some ultramarine blue over the hood to give it a shaded quality.

Make good use of cracks and dents. Exaggerate a little, if necessary.

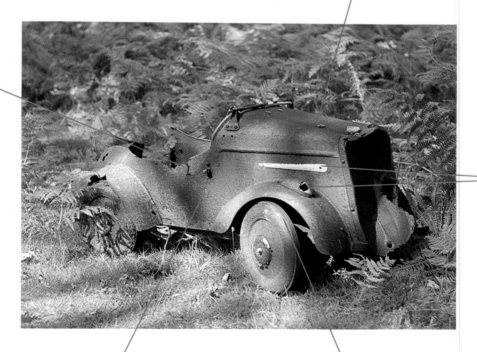

Mask out highlights and rivets and any other pieces that may get in the way of painting the bodywork.

Don't overmix the colors in the palette. Allow them to mix on the paper to catch the mottled quality of the rust colors.

Scrub out highlight with a wet brush and remove excess water with a paper tissue.

Note the richness of colors: burnt sienna, burnt umber, Indian red, light red, rose madder are all colors that could be used here.

Don't lose the thin lines of highlights. Mask them out, if necessary.

Mix burnt umber, ultramarine blue, and some rose madder for these dark areas.

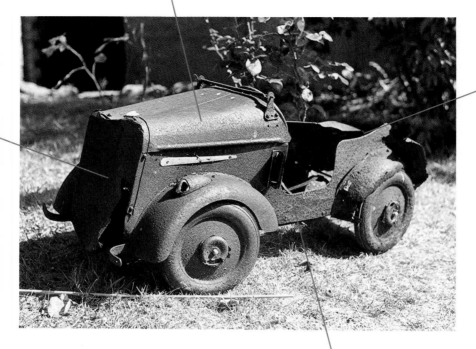

The bodywork has a pockmarked quality. Build this area up with the fine tip of a brush or, for a more broad treatment, lay the brush over on its side and rub the paint on with the drybrush technique.

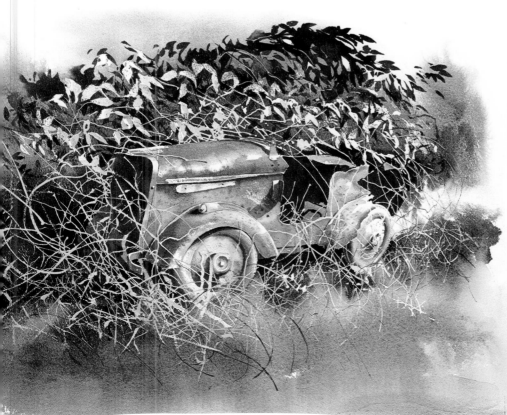

I have painted two versions of this old pedal car to see what difference a change in setting could make. The original settings in the photographs were not very exciting, so I painted two imaginary ones.

The first painting was completed with the car sitting among long stems of grass. In the second version, I decided to set the car farther into the undergrowth, so that it becomes almost submerged in the thick vegetation. Here, the undergrowth plays an important part in the painting, and greater attention is paid to the detail and shapes of leaves and grass.

The wet-in-wet technique was employed in both pictures to create the soft colors blending together on the paper. Using a lot of water, burnt sienna, cadmium orange, rose madder, Naples yellow, and cobalt blue are mixed into the paper. I divide the car into components: wheels, hood, fender, grill, taking each section in turn and thus keeping my painting in manageable areas. When dry, further detailed work can be introduced using the drybrush techniques.

BABY CARRIAGE
Using Imagination

I found this baby carriage along with the toy pedal car (see pages 132–133) in the woods behind my house. Its graceful lines blend well against the soft, lush background of ferns.

The carriage needs to be masked out first so that the background can be painted in. Try to see the ferns as a mass of color. To do this, try squinting through half-closed eyes; the blurred vision prevents you from seeing detail and only the masses of color and shade can be distinguished. Shapes of leaves and ferns can be carefully painted out first in masking fluid so that the highlights will remain after brushing in the colors.

In this scene, I would be tempted to let my imagination work a bit on the carriage, where I might add more color, or possibly paint in some logs or perhaps a couple of sparrows perched on the handle. To me, the great thing about painting is that you are not held to accurate depicting; the artist can bend and twist a subject to suit his or her imagination.

Mask out all these prominent sections; it would be difficult to paint round complex areas like this.

Keep two brushes charged with paint, one with sap green and cadmium yellow, the other with ultramarine blue and burnt sienna. Use another brush loaded with clean water to brush onto the paper to make the colors mix and run on the paper.

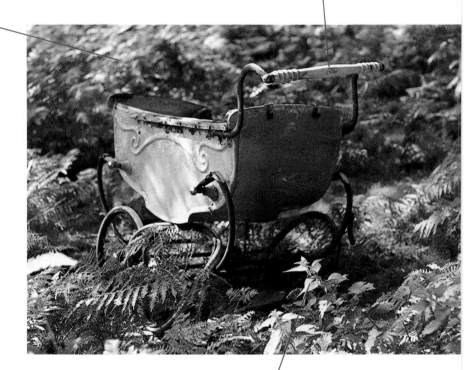

Mask out highlights on leaves and ferns.

This watering can will make a very attractive little painting, and there are many subtle colors and textures over its surfaces.

The dark backdrop of corrugated iron works well, throwing forward the image of the watering can, though the length of wood running diagonally through the picture would be best left out. Its presence would only detract from the picture.

The image of the watering can needs to be kept pin-sharp, so mask it out prior to painting in the background. To contrast the fine brushwork of the watering can, treat the backdrop broadly, possibly just a few large brushstrokes down the length of the paper.

Brush in colors and use a brush of clear water to soften edges building up the curved surfaces.

I would suggest leaving this piece of wood out. It does nothing to improve the composition.

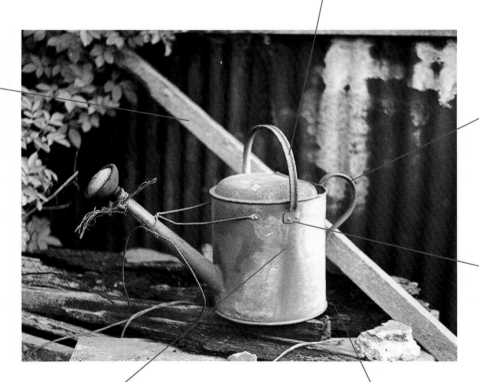

Highlights are vital to give the watering can sparkle.

Don't overlook rivets and other small details. Give them shape by brushing in the shadow underneath.

Focus in on this stain; make it look as if it is running down the can by brushing in color underneath the handle and then tilt the painting board-up. It will run down the paper just like the stain on the can.

Make the can look as if it has weight and is not just floating in air. Use this dark shadow behind. I would alter the base that it is sitting on to make it look more like a flat surface.

SHED ROOF
Dramatizing a Subject

This rustic shed forms an exciting subject to paint, with its wooden supports leaning at all angles and the corrugated roof rusting away to a lace effect at the edges.

The eye is drawn to the support in the foreground, with its jointing to the beam above, so this is the area that requires the most detailed attention. The warm reflected light highlights this area also, helping to draw more attention to it.

Treat the tangle of brush lightly and suggestively, with just some of the grass stems picked out. The great danger here is that it will be overdone, and end up swamping and overpowering the upper section of the picture.

The corrugations are very useful here; they give direction and will add strength to the picture.

Note the subtle variations in color from greens to browns.

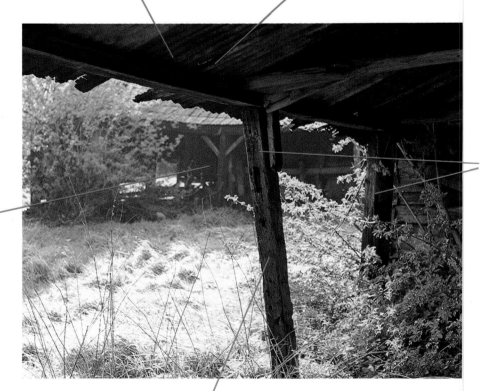

To achieve a sense of depth, paint the shed in the distance in much lighter tones than the foreground.

The dramatic angle of these leaning posts is an important element in the picture.

As a vignetted effect, let the back of the shed wash out into white paper at the base.

Pay particular attention to this large support post; use a fine brush to draw in all the cracks and holes in the wood.

Keeping a Loose Approach

Try to keep a loose approach to this study; use plenty of water and brush in the shapes. Be careful painting in the blades of grass. Again, use lots of water and allow colors from the logs to run into the green. There is no hard edge between the logs and the grass, and it will look awkward if a hard edge is formed between them.

When the colors have dried, further detail can be built up. Dry brushwork will impart a textured quality to the bark, though the highlights must not be lost on the rugged contours.

Mask out round the edges of the tree rings so that the background can be washed in with ease.

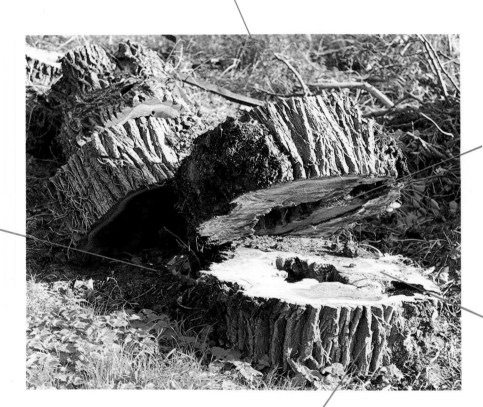

Mix burnt sienna and Cadmium yellow for this area of rich color.

This is the very darkest area; keep this in mind as you work through the painting, and do not allow other areas to become as dark.

This is the lightest area, so a very light wash of rose madder and cadmium yellow is all that is needed.

Mask out the highlights in the bark.

SHED IN THE WOODS
Building Up Foliage

This woody scene is built up predominantly of foliage. A favorite way of incorporating foliage is by dabbing a sponge, but I prefer to use a bamboo brush. To do this, splay the hairs apart by jabbing the brush into the palette a couple of times. The brush now has numerous fine heads and by repeated delicate dabbing will reproduce the dappled look of foliage.

When comparing the photograph with the painting, note that I have pushed aside much of the brush in front of the shed to give a clearer view of its structure, though the general effect has remained very similar.

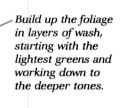

Pick out some of the leaves with a fine brush, using a mixture of sap green and opaque white.

Make the shed more defined; scale its size up a bit and clear some of the tangle of brush from its side.

A strong leaf green color would work well in this lower section of the painting.

Build up the foliage in layers of wash, starting with the lightest greens and working down to the deeper tones.

Mix opaque colors to dab in the speckle of leaves caught in the sunlight.

IVY-COVERED SHED
Capturing a Rustic Look

This old shed has character. The chief aim should be to capture its rustic qualities, paying close attention to the crude planking, the little nailed-on pieces, the cracks and openings. I would start by bathing the whole front of the shed in a wash of cobalt blue. This will help to unite colors that are subsequently brushed on. After that, take each plank one at a time, giving them shape by carefully brushing in the shadows underneath.

This is a straight-on view with no perspective or distant feature to contend with, so it should be one of the easier subject to tackle. Keep in mind though that it will require a sharp-edged quality throughout to be successful.

Brush in the pale green moss color. Be sure to keep the edges soft by brushing round the edges with clear water.

Leave out this cable, as it will not help the picture.

Soften the edges of shadow, or else they will look too harsh.

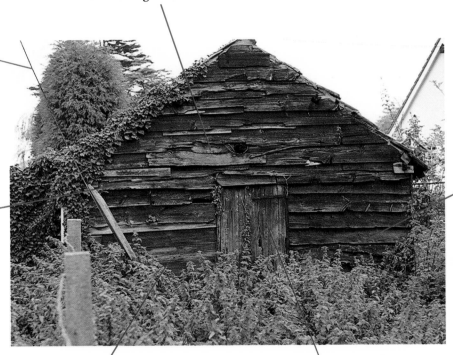

Many of the planks have their own individual colors. Try to catch this quality.

Allow this bottom edge of the shed to soften away into white paper by using clear water. Afterward, the weeds below can be brushed in.

Don't overmix the grays. They will very easily turn muddy.

MILK CHURNS AND WEEDS

Integrating Subject and Surrounding Foliage

This scene is an interesting blend of rusty surfaces and weathered wood. The biggest pitfall here won't be in the milk churns or the rickety shed but in the treatment of the surrounding weeds. These grasses can either complement the shed and milk churns or fight them for attention, so care is needed in their treatment. I would develop the weeds by mixing colors and brushing wet in wet to build soft flowing shapes around the masked-out milk churns, followed by close dry-brushwork to build up shape and shadow around the churns, and lastly, I would paint in the detailed work with a fine brush to build up the effects of leaves and stems.

Keep this background image faint in the distance. It can only detract from the composition.

Note the richness of color in the rain-rusted corrugated tin.

An interesting feature could be made from the chain of sheds leading off into the distance.

Do not lose the lacelike quality of this rusted edge; its delicacy is an attractive quality in the picture.

Mask out the leaf shapes and the milk churns for some free brushwork in the foreground.

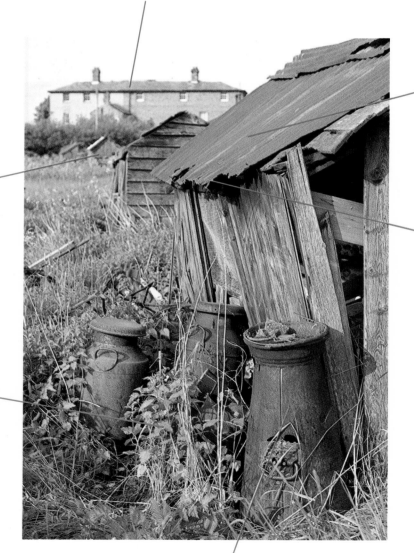

Concentrate on the variety of color but avoid overmixing and ending up with muddy colors. Try to let your colors blend together on the paper.

Avoiding Overworked and Muddy Color

Great care is needed with this subject to prevent it from becoming muddied and overworked. The colors are very dark, and I think it would be wise to paint them lighter than they actually are.

There are very attractive shadows where the crossbars pass behind the thick wooden posts, and these subtle shadows need to be gently washed in to give the whole structure shape.

I would start by bathing all the timbers in a wash of ultramarine blue and a little burnt sienna. These can then be worked over by introducing sap green and other tints afterward. The grasses and intertwining weeds can also be painted in afterward in opaque colors: blends of permanent white, Naples yellow, yellow ochre, and ultramarine blue.

The background is not very important here and needs only to complement the foreground, so treat it simply.

Note the gentle changes of colors on this post, ranging from blues to greens to rusts.

Contrast the light grass stems against the dark background of wood. Precise brushwork will be needed to build up the quality of dried grass stems. An alternative technique worth trying is to scratch out the stems with the corner of a razor blade; for this the colors need to be kept damp.

Make the shadows appear as if they pass round behind the posts. If painted convincingly, it will really push the posts forward.

TWO TREES IN A FIELD
Selecting a Focus

These trees provide a good basis for a painting, though the carpet of grass is a bit flat and uninteresting. Treat the grass sparingly and allow it to fade into the white paper as a vignette. This will allow the trees to be the focal point and prevent the grass from drawing attention away from them.

Around the base of the trees the grass can be more defined. Here I've used the drybrush technique and gently rubbed in shadow areas.

For the tree trunks, try rubbing in a little candle wax onto the surface of the paper; it will help to add texture to the broken surface of the wood.

To get the pale blue green of the foliage, mix Naples yellow along with sap green and cobalt blue.

Do not get caught up in the detail initially. Use quick vigorous brush-work to catch the twisted, gnarled shape.

Note the change in hue with distance and mix your colors accordingly. Adding Naples yellow or opaque white can help.

Put candle wax in the highlight areas before painting; it will also cause the paint to bead, adding to the textural effect.

FARM LANDSCAPE
Changing Seasons

The photograph and the painting make an interesting comparison. What I have done is to take a summer setting and change it into a winter scene. I did this to avoid painting in the mass of foliage which I felt would not work well in my painting, though it is very attractive in the photograph. All I have to do is visualize the setting in winter and replace the greens with grays and browns.

I have made much more use of the tree trunk in the painting, highlighting the bark with light glancing across the surfaces; mixtures of burnt umber, burnt sienna, and Naples yellow give it its rich warm hues.

The ploughed-up field in the foreground has been washed in with a highlight running down the center. This has then been followed by a lot of dry-brushwork, building up the texture of the broken surface of the soil.

The colors become grayer as they recede into the distance, so mix colors lightly or add a little opaque white.

Build up foliage by splaying the end of a brush and gently dabbing onto the surface of the paper. Burnt umber and sap green will work well here with traces of other colors.

Build up with washes, wetting the paper first so that the colors softly blend at the edges.

Work carefully round the edge of the field so that it looks as if the ground had been ploughed up. Use the drybrush techniques and rub paint up into the green area to create a broken effect.

See how light shines in under the tree. Make good use of this pool of light.

INDEX